Contents

Tate Liverpool Critical Forum, Volume 7

Art, Money, Parties

New Institutions in the Political Economy of Contemporary Art

First published 2004 by
Liverpool University Press
4 Cambridge Street
Liverpool L69 7ZU

Copyright © 2004 Liverpool University Press

The right of Jonathan Harris to be identified
as the editor of this work has been asserted
by him in accordance with the Copyright,
Designs and Patents Act, 1988

British Library Cataloguing-in-Publication data
A British Library CIP record is available

ISBN 0-85323-739-5 cased
 0-85323-719-0 limp

Typeset by www.axisgraphicdesign.co.uk
Printed and bound by Hartley Reproductions Ltd

List of illustrations

Sadie Coles HQ: Anatomy of a Gallery in the Age of Globalised Contemporary Art
SADIE COLES INTERVIEWED BY JONATHAN HARRIS

Public Art and Collective Amnesia
PAUL USHERWOOD

A Changed Experience of Space
WOLFGANG WINTER AND BERTHOLD HÖRBELT INTERVIEWED BY DANIEL BIRNBAUM

Acknowledgements

Critical Forum publications are always the result of a collective effort, sustained over many months of patient work. As editor of this book and the series as a whole, I would like to thank all contributing staff at Tate Liverpool, the University of Liverpool, and Liverpool University Press. Special thanks should go to Lindsey Fryer, Head of Education at Tate Liverpool, Sam Gathercole for his stint organising Critical Forum meetings, and Laura Britton, his successor in that post. Laura deserves special thanks for quickly producing her useful notes for the interview printed here between Daniel Birnbaum and Wolfgang Winter and Berthold Hörbelt. The latter I thank for agreeing to the edited reprint of their interview in this form. Lastly, Anne MacPhee, art historian at the University of Liverpool and a founding member of the Critical Forum board, deserves a very special 'thank you' for her work over more than fifteen years bringing together scholarship and museum education in Liverpool.

Jonathan Harris
Series Editor

1

Introduction:
Elements Towards a Historical Sociology
of Contemporary Art

JONATHAN HARRIS

Context and concepts

This collection of essays owes its existence to a conference held at Tate
Liverpool in November 2002, on the occasion of the second Liverpool
Biennial exhibition of contemporary art. Organised jointly by Tate
Liverpool and the University of Liverpool, as part of the Critical Forum
programme of public events and publications, this conference – titled
'Art, Money, Parties' – set out to identify and examine the kinds of new
institutions and social relations that have emerged and begun
significantly to influence the global organisation of contemporary visual
art over the past twenty-five years. These institutions and relations are
not simply implicated in the *exhibition* of art – though several of the
essays included here focus on the phenomena of biennial shows in
general and the Liverpool Biennial in particular. More than that, as the
Liverpool Biennial itself demonstrates, such emergent institutions and
relations have come to play important roles in commissioning art
production as well as mediating its *reception* in a number of ways.
Expanding from the more limited brief of the conference then, *Art,
Money, Parties: New Institutions in the Political Economy of Contemporary
Art* seeks to begin to map and critically assess what amounts to the
changed social order of the art world since the 1980s.

Within this undoubtedly ambitious analytic framework it is obvious that the set of concepts that the 'art world' can be thought with must be reviewed. This is because radical developments and transformations in, for example, patronage and managerial arrangements – on a global scale – have begun to outrun existing assumptions, categories and accounts. Indispensable terms such as 'institution', 'means of production', and 'art world' itself are invoked and critically scrutinised in all of the essays in this book. Some authors address these and other concepts via detailed empirical study (e.g. Rory Francis on the developments in government funding for art in England since the early 1990s); others via experimental application of recent theoretical treatise (e.g. Jeremy Valentine on the implications for contemporary art of Michael Hardt's and Antonio Negri's influential study *Empire* (2001)).

But this collection also includes discussion by those directly involved in the production and selling of contemporary art: German artists Wolfgang Winter and Berthold Hörbelt themselves re-articulate the meaning of numerous key concepts through an account of their own recent art practice – which is 'collaborative', 'site-specific', and 'socially interventionist' – in cities such as Hanoi, Berlin, São Paulo, and Liverpool in 2002. Sadie Coles, London dealer and gallery-owner, reviews the history of her own involvement in contemporary art over the last decade. While much of this overlaps with the history associated with the buzz-words 'YBA' (Young British artists) and 'Brit Art' – notions also subject to interrogation in this collection – Coles outlines the place of such artists beyond Britain, within the increasingly *internationalised* network now ordering contemporary art's conditions of production, mediation and consumption.[1]

In this introduction I have space only to outline some of the most important themes, debates and questions generated in the book and indicate how the concerns of its authors overlap in many ways. It will become obvious, however, that there certainly is no 'party' line here on the meaning or value of contemporary art: its currency, as far as these authors is concerned, is disputed, fluctuating, and for some – Stewart Home in particular – radically devalued, at least in some of its most familiar forms. Set Home *against* Coles, then, in their sharply

contrasting accounts of 'Brit Art'. Home, however, as art-producer as well as critic-polemicist, declares varied interests in these matters, as his discussion of his own 'Vermeer II' exhibition of photocopies of Old Master paintings and his 'Art-strike bed' – anticipating by several years Traccy Emin's own notorious *My Bed* (1998) – makes clear.[2] Home's critical belligerence is resolutely echoed in Paul Usherwood's near inveterately hostile assessment of 'public art' commissioned by local and national funding agencies in the north-east of England in the last decade or so. Both Home and Usherwood, at heart, believe that the corruptions and faults of much contemporary art in this country stem from economic and political iniquities within British social democracy: its claims to a genuine realm of public democratic values and rights vitiated by craven subservience to the mendacities of a global capitalism that maintains a suffocating grip on the possible forms and meanings that art made locally can hope to attain under contemporary conditions.

In opposition to what might legitimately be called this 'ultra-leftist' perspective, Lewis Biggs, Liverpool Biennial director, stands rather isolatedly optimistic, though he too half-acknowledges the egregious influences that corporations may bring to bear on contemporary art production and its exploitation.[3] The brewer Beck's, like the British state wishing to further its 'social inclusion' or 'citizenship' policies, inevitably extracts a price in exchange for its financial support of the visual arts. Francis makes it clear, however, that there is absolutely nothing new in this – Western art since the Renaissance has *always* been conditioned, shaped and limited by the interests of both capital and government. One of the aims of *Art, Money, Parties*, then, is to consider how the matrix of social conditions and relations within which contemporary art is produced and consumed has changed since the advent of Thatcherism and Reaganomics in Britain and the USA respectively. If varying ideologies of 'aesthetic autonomy' have attended art's commodification since the time of the Medici popes and princes, quixotically accompanying the evolution of art's societal functions – firstly, as propagandistic tool for church and state; secondly, as self-mirroring rebus for the aristocratic and bourgeois classes; lastly,

as vehicle of sundry alternative or oppositional avant-gardisms – then this book sets out some of the evidence and arguments showing the relational net of contemporary structures, forces and agents in which, and out of which, the art of the twenty-first century will be made. This task constitutes part of the work necessary in formulating what I have called in my title a 'historical sociology' of contemporary art. It will be evident that my essay includes some inevitable – and occasionally polemical – speculation and generalisation. I consider these components under the following headings: *institutions, formations, means of production, identifications, forms, reproduction, and organisation.*[4]

Institutions

The term 'institution' immediately conjures up images of buildings and the powers they have come to represent – be it the Museum of Modern Art (MoMA) in New York, or the National Gallery in London, or the Louvre museum in Paris. Certainly, new museums and galleries for the collection, curation and exhibition of modern and recent art have come to dominate the literal image of the art world over the last quarter of a century. The Centre Pompidou and Musée D'Orsay in Paris; Tate Liverpool, Tate Modern, and the Saatchi galleries in London (originally in Boundary Road, now at the County Hall building); the renovations and extensions of MoMA and the opening of DIA Beacon in New York; the Guggenheim museum developments around the world – all these indicate how the profile of contemporary art has grown exponentially throughout Western Europe and the USA. As Biggs, Coles and Home attest, this growth has been linked to the burgeoning of the market for contemporary art. Though this activity of buying and selling is still overwhelmingly centred, in quantitive terms, in Manhattan, it has expanded and extended to groups of dealing galleries, such as Sadie Coles HQ and Gagosian galleries in London, with significant further developments, for example, in Berlin, since the fall of the Wall and the re-unification of West and East Germany.

Buildings as physical and architectural symbols provide an immediate *visual identity* to the organisation and purpose for which the structures

were erected. It is notable, then, that many of the 'new' museums for the display of twentieth-century and contemporary art across the world have actually been hewn from existing buildings that served different purposes for many decades or even centuries. Tate Liverpool, Tate Modern and DIA Beacon, for example, are institutions housed in what were previously industrial structures: factories, warehouses, power stations. These museums retain many of the specific features and 'look' of these buildings – indeed, they have been intentionally renovated to emphasise dramatically in various ways these origins and how they have been combined with the new function of the building. While these original buildings have spatial characteristics that fitted the new exhibition function extremely well – for instance, large, open areas with high walls that could easily and appropriately house big paintings and sculptures – it is clear that renovation and adaptation rather than entirely 'new-build' met other important criteria. For instance, the cost of the former strategy was usually significantly lower than the latter, which included the additional problems involved in finding, or clearing, desired inner-city locations. But the decision to renovate and adapt former industrial buildings also meant a rejection of the traditional materials and architectural conventions used in art museum construction. In other words, the *meanings* of the new museums and galleries could not – and should not, many directors believed – be the same.

Recently built art museums in Britain have relied heavily upon state subvention – funding – either directly from taxes or via Lottery revenue directed into 'targeted' social and cultural projects identified by governments as worthy and necessary causes. Francis explores the history of the Arts Council of Great Britain, established after World War II, which, during the 1990s, went through a series of radical shake-ups linked to its reorganisation as an administrative unit within one of the departments of the 'New Labour' government elected in 1997. Not housed in or associated with a 'signature' building, the public profile of spending on contemporary visual arts through the Arts Council had never been high in Britain but was totally eclipsed during the later 1990s and early 2000s by the directly or Lottery-funded projects that built Tate Modern, the Baltic art museum in Newcastle upon Tyne, and the new

museum of art in Walsall. Two out of these three developments were renovation-and-adaptation – with Tate Modern rapidly becoming known as the most famous, most iconic modern art museum in the world. Coles, however, suggests that Tate Modern more reflected interest in modern and contemporary than was actually responsible for creating it. How, then, has the *public* face of art organisation in Britain and the USA been reordered by the prominence accorded to institutions such as Tate Modern and DIA Beacon, since the latter's opening, in upstate New York, in 2003? What effects did less *visible* features of art's changing organisational framework have on the artworks produced, where, why and for whom?

As Biggs explains, international biennials, such as the one he has directed in Liverpool since 1999, have become significant mediators in the contemporary art world. These events – held in cities including São Paulo, Santa Fe, Venice and Liverpool – exhibit new art, but they increasingly also commission it. Sometimes this is in partnership with other funding organisations (private or state in nature) but the effect is to help shape art production directly. Winter and Hörbelt, for instance, though their antecedents include Robert Smithson and Richard Serra – two artists highly protective of their absolute control over projects such as *Spiral Jetty* (1970) and *Tilted Arc* (1981) – have conceived projects intrinsically based on collaboration with distinct communities of people: those, for example, living in a certain district in a city, or on a university campus, or organising biennial art events.[5] Winter and Hörbelt's use of ordinary, 'non-art' materials such as bottle crates and food trays, symbolises their 'post-studio' production relations: their work is site-specific installation, meaningful within specific places at specific times for specific (and often non-art-museum-going) publics.

In terms of these features, Winter and Hörbelt's art made out of trays and crates might reasonably be defined as 'public' and 'socially interventionist' in nature and intent. But Francis and Usherwood, in their complementary accounts of public art commissioning bodies in Britain and specifically the north-east of England, cast serious doubt on the value of most recent 'public art' and the socio-political ends that, over the last decade or two, it has been reordered to serve. Usually not witty,

nor iconoclastic, nor directed at highly specific groups (unlike Winter and Hörbelt's work), recent 'public art' according to Usherwood has *tended* to result from 'lowest common denominator' thinking: it must not upset anyone, it must inoffensively ornament cities and countryside, and it should serve an official ideology of 'public interest' based on bland corporatist values. Such art, exemplified by Anthony Gormley's *Angel of the North* statue near Newcastle upon Tyne (1998), makes its viewers 'tourists', not 'citizens', claims Usherwood. It is usually linked to 'urban redevelopment' programmes based on public–private finance partnerships, so the public art it generates is often little more than advertising dressed up as pseudo-memorial.

Many contemporary artists now make a good proportion of their living out of such commissions, notes Francis, as policies of 'social inclusion' and 'citizenship' have come to drive national and local arts funding. Within this novel disciplinary regime, artists – as much as the 'public' for which they nominally produce art – are reordered and their mythic avant-garde, even 'proto-criminal', tendencies rehabilitated. 'Socially included' themselves, then, via their work for state commissioning agencies, public artists in Britain now bear some intriguing similarities to the model of the artist-as-citizen-worker generated in New Deal USA under the aegis of the Federal Art Project.[6]

The social relations of art administration, management and regulation – within the circuits of its production, mediation and consumption – preoccupy Home and Valentine in their essays. While Coles talks at length about her own gallery and its place in the international networks of the contemporary art world, Home and Valentine offer highly partisan, even eccentric, takes on this reordered system of structures and agents. Home discusses the place of Brit Art in this emergent field, taking a particular swipe at the 'multiculturalism' and celebrity-culture aspects of works by Sam Taylor-Wood, though the global currency of these elements is evident in the earlier art of, for example, Cindy Sherman, Jeff Koons and Mathew Barney. Valentine attempts, through his thoughtful discussion of the theses in Hardt and Negri's *Empire*, both to acknowledge the integration of contemporary art into a global capitalist order, and yet to suggest that there are spaces

within that field – coterminous with, or modelled in, the art world itself – where an authentically 'critical' art might still get made. Rejecting, however, the ideologies of avant-garde art and critiques of the 'society of the spectacle' associated with theorists such as Rosalind Krauss, Valentine uses the complex arguments about 'system' in Hardt and Negri's book to claim that many more opportunities for something like subversion exist than Home and Usherwood, in contrast, seem prepared to acknowledge.

Formations

The discipline of art history has always acknowledged and given significant weight to the role of public institutions in determining aspects of art production and consumption. Art academies and patronage agencies of various kinds – religious, royal, state, bourgeois – figure prominently in studies produced by scholars such as Arnold Hauser, Francis Haskell, Albert Boime, Patricia Mainardi and Thomas Crow.[7] Some recent accounts of museums of modern art have incorporated a dimension of theorised 'social order' analysis often absent in valuable empirical studies of pre-twentieth-century institutions. Carol Duncan and Alan Wallach's discussion of the role of the Louvre museum and the latter's essay on the history of MoMA in New York, for instance, have stressed the ideological functions of art exhibition in relation to both state narratives of national-cultural identity and the place of art in capitalist society.[8] Yet, if 'art institutions' in these more or less traditional senses – important buildings housing art collections; the relations between royalty and painters trained in a state academy commissioned to produce official portraits or commemorations of historic battles; the direct employment of 'war artists' by the British and US governments in two World Wars – have been recognised as active and influential in the development of art and artists, then far less attention has been paid to the ways in which artists have organised themselves (in the later nineteenth and twentieth centuries often *against* such official institutions) within what may be called their own *formations*.

Many of the studies dealing with such self-organisation are concerned with the nature of twentieth-century avant-garde groupings, and the orthodox art historical notion of a 'movement' (for example, Dada or Surrealism) approximates *some* of the meanings for formation. Over the last twenty years, however, artists have evolved relations and networks of self-organisation – in response to changing global institutional circumstances – that simply cannot be understood in terms of the received idea of 'movement'. These relations and networks, arguably, are far less about modernist commitment to a defined kind of style, or use of medium, or adherence to a socio-political perspective, than about adjusting to the new organisational conditions of art's administration and management adumbrated in the previous section.

Now, some elements of contemporary artists' general formation *are* in obvious continuity with earlier twentieth-century developments. These would include, for example, instances of manifestly 'politicised' and 'specialised' artists' groupings. Organised groups, like the US-based feminist Guerrilla Girls, exemplified the former, in their activities intended to publicise the absence or marginal place of women artists in US museum collections. In the 1980s and 1990s the growth of artists' groups using video, DVD and computer technologies indicated a continued focus on the innovative use of new, or *emergent*, media. This strand of 'specialised production' is traceable back to the earliest uses of still and filmic photographic technologies by artists in the early and mid-twentieth century. The period after 1975 has seen more and more artists mobilising and combining these relatively novel technologies which have become now, perhaps, the *dominant* means of production, making traditional painting, print and sculpture materials, if not *residual*, then simply one available resource among many for contemporary art. (Any such claim, though, remains highly tentative: quantitive analysis in art history is fraught with methodological and evaluative dilemmas that have hardly begun to be addressed. Yet without the attempt to deal with these problems and to construct principles for quantitive analysis, no adequate historical sociology of the contemporary art world, or indeed of any past art world, will be possible.)

Many of the specific formations of artists now, however, have emerged in response to, and indeed *as part of*, the kinds of 'networking' and 'para-institutional' developments that constitute the contemporary global art world. 'YBA' and 'Brit Art', for example, are names for the *loose* grouping of artists trained in English (predominantly London) art schools and universities in the later 1980s and 1990s. Coles is careful to explain the crudity of these labels and dispels the idea that those artists gathered under these rubrics belonged to a 'movement' in any strong sense, or ever shared, for instance, radical social or political views. Home's account of Brit Art is equally, though differently, iconoclastic, as he argues that Brit Artists such as Taylor-Wood are fully incorporated into a transnational publicity machine – a 'para-institution' of global capitalist elements yoking together advertising, celebrity culture, the fashion industry and the aggressive marketing of contemporary art.[9] The power of biennial and public art organisations, as commissioning agencies and players in the financial development of 'arts-business' culture, has also spawned, reciprocally, many artists' groups and partnerships – such as Winter and Hörbelt's – that cohere in order to take advantage of the kinds of opportunities such a new funding regime creates.[10]

While Usherwood is mordantly dismissive of most of the contemporary art this public funding produces, and Francis views it as a mechanism transforming the social role of artists according to social democratic policy diktat, Valentine claims that the regime may still leave lacunae in which artists can continue to act 'autonomously', if not, finally, outside the 'system' with which 'empire' effectively is synonymous. Either way, contemporary artists find themselves now within new economic, social and political relations of production and consumption, and having to fashion identities inevitably shaped and limited by these conditions. Any absolutely clear distinctions between 'institution' imposed from above and 'formation' created below become increasingly difficult to make: the contemporary art world is 'corporatist' and a *mechanism of assimilation* now by definition.

Means of production

Home describes contemporary artists, such as Taylor-Wood, as
'specialised non-specialists'. By this he means that the purposes and
materials of much contemporary art production are no longer 'medium-
specific' in the way modernist painting or sculpture was held necessarily
to be.[11] Nor are its purposes and materials intelligible without taking into
consideration the nexus of relations and contexts within which this art
is manifested. Home's own 'Vermeer II' exhibition, held in the East End
of London in 1996, for example, consisted of photocopies of Vermeer
paintings – the originals were intended to have formed a 'blockbuster'
show at the Royal Academy of Art – to which Home added dabs of pink
paint in order to 'personalise' and increase the financial value of these
cheap reproductions. The exhibition relied parasitically on the planned
Royal Academy show, which in the event never happened, to make
various witty points about qualitative and quantitive notions of value,
originality and meaning. The show had another purpose: to indicate that
the monetary value of past and contemporary art depends on a huge
disparity that Home believes exists *necessarily* between the wealth
accrued by a tiny number of successful, valued artists (including Vermeer
– long after the artist's death, however – and the Brit Art stars) and the
'proletariat' of artists whose work is, effectively, emptied of value.
Financial and 'aesthetic' values in contemporary art have less and less to
do with materials and skills in ways recognised even in the later part of
the twentieth century.

Similar claims, of course, have been routinely made about, for
instance, Marcel Duchamp's readymades from the first decades of the
last century (where the argument was supposedly clinched by his use
of *then* clearly 'non-art' materials) and about abstract art – such as
Jackson Pollock's drip paintings – where many critics and commentators
professed an inability to see evidence of skill or meaningful expression.[12]
But up until the 1970s, arguably, these cases were still, in quantitive and
market terms, anomalous: *most* artists continued to use traditional art
materials such as paint on canvas, and stone or wood for sculptures, in
traditional ways. The later 1960s, however, had seen the emergence of
many of the 'isms' – including Minimalism and Conceptualism –

associated with the *abandonment* of traditional materials and methods of fabrication. Terms like 'painting' and 'sculpture' themselves became problematic in ways that could never have been imagined before 'artists' (itself something of an anomalous term by the early 1970s), such as Donald Judd and Joseph Kosuth, began to exhibit objects made from industrial materials such as steel or words typed onto a sheet of paper.

The modernist critic Michael Fried attacked the products of Minimalism as 'literalist', claiming that they effectively did away with the proper role of art as a form of showing or representation, replacing it with crude objectification.[13] If this reduced art to a kind of 'theatre' – Fried's other key term of opprobrium suggesting a heightened, emotively exploitative presentation – then what later became known as 'mixed media' or 'installation' artworks took such theatricalisation much further. By the 1980s, much contemporary art shown in major galleries and museums was a combination of the two: a creation of 'environments' in exhibition spaces made from a diversity of materials, seeking to exploit the bodily presence of the beholder, and often questioning or abandoning the traditional display contexts. Much of this work had originally been made by artists affiliated, one way or another, to radical political perspectives – feminist, postcolonial, ecological, anti-capitalist – though by 2000 'mixed media installation' had itself become a predominant and orthodox 'medium' of contemporary art.

Coles explains that she never decides to take on an artist on the basis of what kind of physical materials they use in their work – though they may be painters or photographers in traditional terms, like John Currin and Wolfgang Tillsman. But the quality or value of the work, as far as Coles is concerned, has no *necessary* relation to any particular 'medium' in the usual sense. Winter and Hörbelt's site-specific use of resources such as trays and crates suggests that received conceptions of 'artistic means and materials' are woefully underdeveloped, given the relational and contextual changes that have driven developments over the last two decades. Though many physical materials and techniques of production are used and combined in contemporary art,

these in themselves no longer appear to *govern or significantly orient* the generation of meanings or values of the artworks out of which they are made. It is for this reason that contemporary art, certainly in its mixed media and installation variants, has increasingly become seen as essentially 'conceptual' in nature and purpose – though that label, with its complex legacies and relations to 1960s art, creates as many problems as it appears to solve.

How slippery, then, for example, is Taro Chiezo's *Superlambanana*, fabricated for the Liverpool Biennial in 1999? On the one hand, according to Biggs, its 'polyvalent' meanings represent the vertiginous 'gossip-led' interpretations of contemporary art dislocated from any history of styles or genres traceable back to intelligible pre-modern conventions and contexts. In that, the banana 'sculpture' fits the criteria Krauss established for 'postmodernist' art: it is anti-memorial and essentially 'placeless' (the banana, indeed, has been itinerant in the city of Liverpool over the past few years, and will never find a *necessary* place to be).[14] But is its enigmatic nature – as far as most people not 'in the know' about the circumstances of it commission are concerned – any better than either the trite figurative form of Gormley's *Angel of the North* or Anish Kapoor's obscure 'sculpture' *Tarantara* (1999), an amorphous giant red vinyl tube inserted into the Baltic museum to celebrate its opening?[15] How is anyone to decide?

Identifications
Given that the 'internal' forms (medium, style, expression) and 'external' relations (context, meaning, value) of contemporary art no longer cohere in a manner resembling the order established between these within modernist art and the critical interlocutors who proclaimed its aesthetic autonomy, then questions surrounding contemporary art's interpretation – and the purposes of its interpretation, for that matter – become particularly vexed. If mixed media installation dominates as a new orthodoxy undermining virtually all received notions of artistic purpose and the role of materials associated with modernism's medium-*specific* expression, then the contemporary situation is also characterised by a transformed field of art writing attempting, but as yet unable,

to understand – literally able to come to terms with – these new conditions. The urge to place scare-quotes around these terms 'internal', 'external', and, for that matter, 'art writing' indicates something of the confusion that exists.

The scare-quotes, that is, recognise the problem but cannot apprehend it. If Taylor-Wood's photographic self-portrait wearing a T-shirt bearing the legend 'Fuck, Suck, Spank, Wank' is as much an authentic component of her artistic oeuvre as is her being photographed for the London *Evening Standard* newspaper wearing designer fashion items at celebrity events, then Home's diagnosis of Brit Art's real provenance seems confirmed. Saatchi, among others, has helped make contemporary art into a form imitating/simulating the iconic rhetoric of advertising and 'public relations' imagery and events. The commemoration and institutionalisation of this conversion, represented by the opening in 2003 of his new museum – in the building that use to house London's city government until it was abolished by Thatcher because of its left-wing policies – led Damien Hirst, heavily represented in Saatchi's collection, to attempt to buy back all his work from the man who had provided him with what Clement Greenberg once famously called 'the umbilical cord of gold'.[16]

'Art-writing' is intended to suggest an amorphously diverse field of activities no longer reducible to the practice of 'criticism' in its traditional sense, the narrative of which goes: critic visits gallery, looks at paintings, decides if they are any good and writes a review trying to say why. Evaluation in *that* sense, as Fried observed in the mid-1960s, was on the way out – though, of course, it continues to be practised by some. But the leading critics of so-called Late Modernism (and 1980s 'classic' postmodernism, for that matter), though a few remain active, belong to a generation now several decades older than the great majority of artists they might be asked, or decide themselves, to write about. This is a profound schism. Arguably, something unpalatably called 'art theory' has replaced criticism in quantitive terms, illustrating, among other things, the academic transformation and occupation of a domain once dominated by amateur or 'jobbing' males like Greenberg and Fried –

the latter himself giving up on contemporary art and emigrating into academia at the end of the 1960s. Art theory developed in the 1970s and 1980s, partly as a result of the integration of art schools into universities in Britain, and, although a university education had been common for art students in the USA for many more decades before then, rhetorics and ideologies of 'professionalisation' bound up with making artists savvy about business, helped produce an art world academic class equipped with PhDs, theorising their 'practices' and 'readings', providing them with intellectual justifications, and relating them to social and political change.

All these features find opaque expression in much contemporary art: it is 'self-reflexive'; it demonstrates that its producers are knowing and ironic about, for example, myths of artistic genius and originality; it 'appropriates' art sources culled from its producers' university art history classes; it includes de rigueur multicultural or 'postmodern' references that, for example, public art commissioning agencies read as the sign of socially useful art. Above all, many contemporary artists produce work that intrinsically acknowledges, if not actually 'critiques', the gallery and museum – in the way, for example, that Emin's *My Bed* or her tent containing the names of *Everyone I Have Ever Slept With 1963–1995* (1995), may be said to challenge or invert assumptions about private and public space and meanings. Winter and Hörbelt's towers of crates and trays built for biennials around the world do a similar job: they set out to disappoint expectations about what can be art, where it may be found and who it might be for. Though these two examples are of work made from very different materials and methods, they share what might be called the generic *mixed media installation identity*. That is, they include within themselves an alertness to the signals and systems of meanings identifying the various contexts – ideological, physical, institutional – in which contemporary art is routinely displayed. They could, at the same time, also be interpreted as signifying some resistance to these conventions and contexts. (Usherwood's attack on public commissioning agencies, in contrast, suggests that state-funded art in the vast majority of cases manifests no such 'immanent' self-critique.)

I said 'could be interpreted'. Biggs believes 'polyvalence' in contemporary art is a given and seems to suggest that it is a good thing. Somehow multiple meaning has become built into the very condition of art produced now. If this is true, then accounts of meaning, intention and the working of related interpretative processes adequate to this condition need to be generated. Innovative theories of truth, authorial role, expressive communication and hermeneutic activity are required to make sense of this situation, and to contrast it with the classical and modernist theories of meaning and value inherited – and still active, if residually – from the late twentieth century. Begged in particular are the transformed meanings for, and contemporary value of, two linked terms that modernist critics made indispensable: 'aesthetic' and 'autonomy'.

Forms

The notion of 'aesthetic autonomy' – that a critical distance exists between certain modernist artworks and the socio-cultural realm in which these artworks are produced – depends absolutely on the maintenance of the distinction I introduced earlier between 'internal' forms and 'external' relations. All the twentieth-century critics, from whatever political persuasion, who articulated versions of the aesthetic autonomy thesis (for example Clive Bell, Clement Greenberg, Michael Fried, Barbara Rose and Charles Harrison) have proposed, one way or another, that the artworks possessing this autonomy did so through manifesting a perspicuous structure of marks or forms that somehow managed to close off the world outside that structure.[17] That closure also bracketed out the pictorial narrative and illusionistic conventions that pre-modernist painting and sculpture had relied upon for centuries in order to create 'readable' meanings. However, many of these critics, one way or another, acknowledged that though this distinction between 'internal' and 'external' had at all costs to be maintained, the critic – obviously external to the work – had an inevitably complicit role in propagating the distinction in the first place.[18] In this way 'modernism' as a discursive phenomenon had *always* been a matter of dialectically inter-related artworks and certain textual explanations, though its key interlocutors – critics, that is – attempted, following the inevitable logic

of their argument, to 'ex-nominate' themselves, claiming that the autonomy, the meaning of modernism, was invested immanently in the artworks.

Contemporary art in its now prevalent mixed media installation form scts outs deliberately and systematically to erode the 'internal'/'external' distinction and thereby undermines the basis for securing modernist notions of aesthetic autonomy. To say that contemporary art is 'postmodernist' means to acknowledge the force of the critiques of modernist aesthetic autonomy carried out by many artists and writers in the later 1960s whom Fried attacked at the time as 'literalists' and purveyors of 'theatre'. But these postmodernists, though sharing antagonistic positions vis-à-vis the dominant aesthetic autonomy thesis – so-called 'Greenbergian modernism' – were *as* diverse in their interests and perspectives as those who had defended the various versions of the autonomy thesis. These had ranged from critics who had earlier been committed to Marxist politics (Greenberg, for example) to those who had effectively assimilated autonomy theory to humanist or crypto-religious perspectives (such as Barbara Rose and Michael Fried).[19] The Minimalists, Conceptualists, land artists, kinetic artists and feminists – to name only five sometimes overlapping groupings – formed a substantial part of the development of mixed media installation practice in the 1970s. Art produced now can be mapped onto, seen in relation to, the work of these antecedents in a variety of rich, complex and sometimes contradictory ways. One legacy of that early rich phase of what might be called 'anti-modernist postmodernism' evident in contemporary art is the alertness to signals and contexts that Winter and Hörbelt's tray and crate structures manifest. Another is the apparent building-in to contemporary art of multiple meanings from the outset: a tactic, or condition, of practice that continues to undermine established assumptions about the role of criticism itself.

These two features of contemporary art – its mixed material installation means and in-built polyvalence – have both good and bad consequences. On the one hand, and, from my point of view, a good thing, the diverse forms and purposes of mixed media installation radically inhibit the deceptive rhetorical shift that modernist critics

habitually would announce from considering mere background context or society to examining 'the works of art themselves'.[20] Though the specific physical and conventional resources and compositions of mixed media installation pieces may certainly be examined in minute detail, these materials, both literally and metaphorically, confuse the 'internal' / 'external' forms and relations distinction upon which modernist critics based their defence of, say, abstract painting's aesthetic autonomy. Use of 'mass cultural' media such as video, film, DVD and internet technology – sometimes *combined* with traditional painting and sculptural materials – has further undermined the basic conceptual and experiential components of modernist criticism.[21] 'Performance art'-related aspects to contemporary art – though this notion is capacious now almost to the point of theoretical vacuity – again literally and metaphorically places the beholder in/as (part of) the subject of the work, eroding intellectually and experientially problematic, if not unsupportable, dyadic distinctions and oppositions, such as 'artwork–artist', 'artist–society', 'artwork–critic', etc.

Yet along with this, to my mind positive, erosion has surely come the decisive incorporation of much of contemporary art – in terms of its economic, social and ideological relations – effectively into the discursive architecture of spectacularised society. In 'aesthetic' terms this means, for example, that contemporary art (and I cannot avoid generalisation at this point), as much as advertising proper, or downloaded hardcore pornography, or television news, will routinely use ('appropriate') graphic depictions of sexual or violent acts, or fetishise design, or pastiche the inanities of the tabloid press. Telling the difference between the 'art' here and the rest is sometimes only a nominal matter of establishing what signifying context you're in: an art gallery, or in front your TV, or typing away in front of your computer. Surely no defence of a notion of 'avant-garde' resistance to capitalism or patriarchy or racism, or anything else, can be maintained if this radical dissolution of boundaries appears to take place. This I take to be Home's position. Or to put it another way: you might decide that, for instance, actual hardcore pornography – 'read' in the appropriate

manner, that is – has as much chance of being authentically 'challenging' or 'dissident' or 'avant-garde' as has any contemporary art object or installation or performance piece that attempts to manipulate or appropriate pornography's expertly honed and perfectly banal repertoire of effects. Contemporary art's 'immanent polyvalence', that is, implies that a corresponding relativisation of judgement accompanies and ratifies this condition: the critical evaluations as to what is 'good' or 'bad' (and as to what 'good' is good or 'bad' is bad, for that matter) are rendered equally ineffable.

Reproduction

Contemporary art, either in its currently prevalent mixed media installation or public art commission forms, occupies a significant, if marginal, place in the reproduction of the social order as a whole. That place has dimensions that are at once economic, social, political, ideological and aesthetic in character. Home, Usherwood, Francis and Valentine all agree that the conditions of production now for art make increasingly difficult, or altogether impossible, the generation of any authentic 'critical practice' in the visual arts (a realm consisting, that is, of dialectically related artworks and writings radically *opposed* to the global capitalist world order).[22] Although none of these contributors would wish to see a return to the era of modernist aesthetic autonomy theses, they do believe that the assimilation of contemporary art into either social democratic public policy (Usherwood and Francis) or spectacularised society (Home) represents *at least as bad a fate* for art as consigning it to a putatively 'transcendent' location claimed to lie outside, as a sort of mental *alternative* to, corrupting socio-political life altogether.

All modernist aesthetic autonomy theses, ranging from the neo-Marxist through to bourgeois-humanist variants, agreed that some kind of 'distance' existed, or should exist, between the best (avant-garde) artworks and the capitalist social order in which they were produced. That social order, they claimed, jeopardised the preservation of the highest aesthetic and 'human' values through its encouragement of degenerate forms of mass and 'middlebrow' culture: key pejorative

labels included, for example, 'kitsch', 'theatricality' and 'vulgarity'.[23] By the 1980s virtually no major critics maintained this position, though British writer Peter Fuller, no adherent of modernist criticism or devotee of Late Modernist art, was an exception.[24] The 1980s 'classical postmodernist' *October* magazine critics – Rosalind Krauss, Craig Owens, Hal Foster and Benjamin H.D. Buchloh among them – adopted versions of the 'critical practice' perspective and linked it to their own favoured artists (e.g. Gerhardt Richter, Cindy Sherman, Barbara Kruger) and forms of practice (e.g. photography, image-text composition).[25] Since then no succeeding generation of critics organically connected to a new wave of 'critical practitioners' has emerged as a distinct formation. Rather, the 1990s were characterised, in Britain, by the rise of Brit Art and the adoption of mass media techniques in a baroque reprise of Warholian Pop themes typified in the work of that arch-proponent of self-ironising kitsch, Jeff Koons.

'Reproduction', however, *always* involves new production and some changes in what is produced. That goes for contemporary art as much as for celebrity culture, the discourses of advertising, and the orchestration of the 'public theatre' of political life lived out on television and in the newspapers of all Westernised countries. Interest in techniques of replication and repetition has characterised modern art since the 1960s and became bound up with themes of 'simulation' and 'hyper-realism' in the later '70s and '80s, due particularly to the influence on art and artists of 'postmodern' thinkers such as Jean Baudrillard. Radically relativised accounts of truth, meaning and language accompanied (and presaged) this emphasis on duplicity and indeterminacy in representation of all kinds, from post-structuralist philosophers profoundly pessimistic about what modernity really amounted to by the end of the twentieth century – Michel Foucault in particular – to the body-fetishistic psychoanalytic hedonism of Gilles Deleuze and Felix Guattari. Mixed media installation work on themes of surveillance, human and animal body-fetishism, and body-violation, endlessly played and replayed through systems of ocular representation, mirror the concerns of this theoretical corpus that has come to dominate the curriculum of 'art theory' taught in art schools and universities since the early 1990s.[26]

Much of this art, still projected as 'cutting edge' – concerned, that is, with depicting the complexities of contemporary human identity and its psycho-corporeal states – is exhibited, or commissioned for exhibition, in biennials around the world. In becoming a new orthodoxy it reproduces the meaning of contemporary art and the value invested in the kinds of works that Saatchi collected and supported in the early days of YBA and Brit Art: explicitly concerned, for example, with themes of sexual activity, death, the mortality of the body, and the violation and degradation of bodies (both human and animal). Biennial and public art commissioning bodies, however, *tend* to hold back on such graphic radicalism: there is the sense that a restriction upon what could be shown, and how, must be operated as the art to be produced is somehow 'for' and 'belongs to' some 'non-art world' constituent groups that the biennials and public art bodies imagine, or claim, they are serving.

Usherwood's essay presents many examples of this: it is art, he notes, devoted to what Frederick Nietzsche in *The Use and Abuse of History* called 'monumental' and 'antiquarian' ends: essentially comforting, self-satisfied, reproductive. Chiezo's *Superlambanana*, whatever its polyvalence, is readable, in this sense, as intrinsically banal and non-challenging. Liverpool Biennial, understandably, is not in the business of alienating the local people it hopes will visit the site-specific art in the 'church' that the city constitutes at biennial time. Biggs's organisational metaphor is highly revealing: the Christian church was the institution in medieval society that commissioned the overwhelming majority of artworks, trained and licensed its artists, and provided the dominant ideological worldview for the reproduction of the social order as a whole. Perhaps, like Francis, Usherwood and Homes, Biggs too is hinting that the role of artists now is once again becoming one of a manifest subservience to the powers that be.

Organisation

The notion of an entity called the 'art world' remains rather vague, yet compelling. In its modern form it is associated with the rise of the 'critic

and dealer-system' in the mid- to late-nineteenth century in France. Its development was coterminous with the emergence of Impressionist art and the succeeding groups of avant-garde artists active in western and central Europe. The 'worldliness' of the art world resides in the distinctness and coherence of those agents, groups and institutions that formed this network or structure perceived to be significantly separate, or at least separable, from broader society. This art world was at once a geographical and spatial, as well as conceptual and abstract, notion. Paris might be described as the centre of the art world, then, in 1870, as New York would be in 1950.[27] But the relational network containing its agents, formations and institutions also constituted a structure of economic, social, legal, cultural and artistic activities, dependencies, conventions and values.

The modern art world in this historical sense was an entity that had come into existence by separating itself off from prior institutional regulation and sponsorship controlled by the state. Though the official Academy for training artists in France persisted through virtually to the end of the nineteenth century, as did annual exhibitions or 'salons' showing work accredited by the state, by the 1870s the power of these institutions – once virtually absolute – had waned to the point where their influence was clearly residual. So the emergent art world came into existence as an entity increasingly disconnected from, and often hostile to, the monopoly that the state had operated in France for over two centuries.

Separated and distinct from residually state-managed arts production and exhibition, the modern 'dealer-critic based' art world was a creature of the newly developing 'mass market' for art, and in that sense constituted a luxury sub-sector of the consumer capitalist economy that rapidly grew in western Europe and the USA in the period between 1870 and 1914. Dealers, sometimes also operating galleries and forming a variety of types of relationship with artists, acquired control of their works, and sold these to buyers both locally and, by the end of the nineteenth century, throughout Europe and North America as well. Critics, publishing reviews of exhibitions regularly in a whole new range of 'mass market' publications, became

influential intermediaries too, able to influence the financial and aesthetic values accorded to artworks.

However, if the most salient – and ideologically freighted – image of the conditions and circumstances shaping the art world in the twentieth century remains that of a 'free' market for contemporary art production and consumption, freed, that is from state-controlled academies and exhibitions, then it is as well to remember that states in the last century evolved many new related ways of organising directly, or at least heavily influencing, the kinds of art produced. These ranged from the contractual employment of artists as waged workers on the Federal Art Project in the US during the 1930s, through the contemporaneous institution and control of artists' unions in the USSR licensing who could work, to the varying forms of post-1945 'arms-length' or 'relatively autonomous' state subsidy of art, via bodies such as the Arts Council of Great Britain and the National Endowment for the Arts in the USA.

Art, Money, Parties draws attention to the activities of these more recent institutions, follows their complex historical development during the 1990s, and plots their relationship to novel private/public-financed organisational forms such as the biennial exhibition. Home and Valentine in their essays go further still, considering the much broader network of contacts and contracts enveloping contemporary art, artists, their dealers, critics and curators within a system that is now effectively global, if still massively centred in the US and western Europe. The art world has become, in this internationalisation, something of an 'empire' in itself, as well as part of the seamless 'empire' of capital and administration proposed by Hardt and Negri. Those wishing to propose the existence of any space for autonomy – 'aesthetic' or otherwise – in this art world need to take account of this organisation in its present totality.

Contemporary art, in its mixed media installation or public art forms, *may* be still relatively marginal, in terms of its dominant means of production and relations of distribution compared, say, to those of movie or television or internet 'content-providers'. This marginality, or 'market asymmetry', in relation to the dominant modes of cultural production in 2004, however, guarantees little – nothing, in fact, if one

accepts Home's claims about the assimilation of Brit Art, if not contemporary art altogether, into a spectacularised advertising and celebrity culture.

Notes

1 For a collection of searching essays on the implications of recent 'internationalised' art, see Jonathan Harris (ed.), *Critical Perspectives on Contemporary Painting: Hybridity, Hegemony, Historicism* (Liverpool: Liverpool University Press, 2003).

2 For a stimulating discussion of related social and philosophical issues, see Dave Beech and John Roberts (eds), *The Philistine Controversy* (London: Verso, 2002).

3 See T. J. Clark's illuminating discussion of, and affiliation to, this 'ultra-leftist' position in 'Clement Greenberg's Theory of Art', in Francis Frascina (ed.), *Pollock and After: The Critical Debate* (London: Harper and Row, 1985), 60–61 n. 2.

4 On commodification and aesthetic autonomy, see, for example, Renato Poggioli, *The Theory of the Avant-Garde* (Cambridge, MA: Belknap Press, 1982 [1968]) and Peter Burger, *Theory of the Avant-Garde* (Manchester: Manchester University Press, 1984 [1974]). I have borrowed the idea of a 'historical-sociology' from Raymond Williams' book *Culture* (London: Fontana, 1981), along with this group of concepts.

5 Ironically, Serra's *Tilted Arc* sculpture was a 'public art' commission installed in Federal Plaza in New York, later removed by its city council owners, and is known now for the subsequent court case held to adjudicate on the question of the ownership of the work. See Martha Buskirk (ed.), *The Destruction of Tilted Arc: Documents* (Cambridge, MA: MIT Press, 1990).

6 See Jonathan Harris, *Federal Art and National Culture: The Politics of Identity in New Deal USA* (New York: Cambridge University Press, 1995). Emile Zola had sardonically referred to art critics as 'policemen' in his 1867 hagiographic account of Edouard Manet, one of the first avant-garde artists. See Emile Zola, 'Edouard Manet', in Francis Frascina and Charles Harrison (eds), *Modern Art and Modernism: A Critical Anthology* (London: Harper and Row/Open University: 1986), 38.

7 See, for example, Arnold Hauser, *The Social History of Art*, 4 vols (London: Routledge, 1999 [1951]); Francis Haskell, *Rediscoveries in Art: Some Aspects of Taste, Fashion and Collecting in England and France* (London: Phaidon, 1976); Albert Boime, *The Academy and French Painting in the Nineteenth Century* (London: Phaidon, 1971); Patricia Mainardi, *The End of the Salon: Art and the State in the Early Third Republic* (New York: Cambridge University Press, 1994); and Thomas Crow, *Painters and Public Life in Eighteenth Century Paris* (New Haven, CT: Yale University Press, 1985).

8 See Carol Duncan and Alan Wallach, 'The Universal Survey Museum', *Art History*, 3 (December 1980), 447–69 and Alan Wallach, *Exhibiting Contradiction: Essays on the Art Museum in the United States* (Amherst, MA: University of Massachusetts Press, 1998).

9 An early attempt to identify these new alliances in 'advanced' or 'commodity-capitalist' society included C. Wright Mills, *The Power Elite* (New York: Oxford University Press, 1959).

10 The British company (with charity status) Arts and Business is a typical example of the new kind of quasi-public institution that attempts to generate sponsorship for artists and arts organisations. Its publicity material describes its purpose to be that of demonstrating 'the value of the arts to business and the value of arts/business relationships in the wider economic and social agenda of today' (information pack relating to advertisement for Head of Research, Evaluation, and Information, February 2004).

11 Canonical accounts of modernism depend upon the defence of this notion of medium-specificity as the guarantor of the meaning and value of specific arts such as painting and sculpture. See, for example, Clement Greenberg, 'Modernist Painting' [1961], in John O'Brian (ed.), *Clement Greenberg: The Collected Essays and Criticism. Volume 4: Modernism with a Vengeance, 1957–1969* (Chicago: University of Chicago Press, 1993), 85–93 and Michael Fried, 'Three American Painters: Kenneth Noland, Jules Olitski, Frank Stella' [1965], in Michael Fried, *Art and Objecthood: Essays and Reviews* (Chicago: University of Chicago Press, 1998), 213–65.

12 See T. J. Clark's challenging essays on the paradoxical 'successful failures' of Pollock and other contemporary painters, 'The Unhappy Consciousness' and 'In Defense of Abstract Expressionism', in Clark, *Farewell to an Idea: Episodes from a History of Modernism* (New Haven, CT: Yale University Press, 1999), 299–369 and 370–403.

13 Michael Fried, 'Shape as Form: Frank Stella's Irregular Polygons' [1966] and '*Art and Objecthood*' [1967], in Fried, Art and Objecthood, 77–99 and 148–72.

14 See Rosalind Krauss, 'Sculpture in the Expanded Field' [1979], in Hal Foster (ed.), *Postmodern Culture* (London: Pluto Press, 1985; first published in the USA as *The Anti-Aesthetic* Port Townsend: Bay Press, 1983).

15 Kapoor repeated this act in 2002 when he installed the much larger and equally enigmatic *Marsyas* – resembling a giant ear-trumpet – in the turbine hall of Tate Modern.

16 'Shark gets away as Hirst feuds with Saatchi', Timesonline/ www.timesonline.co.uk (26 November 2003). Clement Greenberg, 'Avant-Garde and Kitsch' [1939], in John O'Brian (ed.), *Clement Greenberg: The Collected Essays and Criticism. Volume I: Perception and Judgements 1939–1944* (Chicago: University of Chicago Press, 1986), 11.

17 For an attempt to undermine this entire tradition from a psychoanalytic perspective, see Rosalind Krauss, *The Optical Unconscious* (Cambridge, MA: MIT Press, 1994).

18 Greenberg, for example, candidly explained in 'The Identity of Art' [1961] that 'Too many people simply refuse to make the effort of humility – as well as patience – that is required to learn how to experience, or appreciate, art *relevantly*' (my italics), that is, according to his own preferred manner; John O'Brian (ed.), *Clement Greenberg: The Collected Essays and Criticism. Volume 4: Modernism with a Vengeance, 1957–1969*, 119.

19 See, for instance, T. J. Clark on Fried's religiosity in 'Arguments about Modernism: A Reply to Michael Fried', in Francis Frascina (ed.), *Pollock and After: The Critical Debate*, 85–87.

20 See Raymond Williams, 'Identifications', in *Culture*, 119–21.

21 For example, on Gerhardt Richter's photo-paintings, see David Green, 'Painting as Aporia' and on Fabian Marcaccio's 'paintant' artefacts combining painting with sculptural elements, see Jonathan Harris, 'Hybridity versus Tradition: Contemporary Art and Cultural Politics', both in Harris (ed.), *Critical Perspectives on Contemporary Painting*, 81–107 and 233–46.

22 See Catherine Belsey, *Critical Practice* (London: Methuen, 1980).

23 See Clement Greenberg, 'Avant-Garde and Kitsch'; Michael Fried, 'Art and Objecthood'; and T. J. Clark, 'In Defense of Abstract Expressionism'.

24 See, for example, Peter Fuller, *Beyond the Crisis in Art* (London: Writers and Readers, 1980).

25 See, for example, essays by these authors collected in *October: The First Decade 1976–86* and *October: The Second Decade 1986–96* (Cambridge, MA: MIT Press 1986 and 1996).

26 See, for example, Michel Foucault, *Discipline and Punish: The Birth of the Prison* (Harmondsworth: Penguin, 1975); Jean Baudrillard, *Simulations* (New York: Semiotexte, 1983); and Gilles Deleuze and Felix Guattari, *Anti-Oedipus: Capitalism and Schizophrenia* (New York: Viking Press, 1977).

27 See T. J. Clark, *The Painting of Modern Life: Paris in the Art of Manet and his Followers* (Princeton, NJ: Princeton University Press, 1984) and Serge Guilbaut, *How New York Stole the Idea of Modern Art: Abstract Expressionism, Freedom, and the Cold War* (Chicago: University of Chicago Press, 1983).

2

'Art, Money, Parties' and Liverpool Biennial

LEWIS BIGGS

In the context of a Tate Liverpool/University of Liverpool conference, the weight of the title *Art, Money, Parties* suggests three interacting entities. But 'art' refers to an imprecise set of objects, actions and beliefs within culture in the same way that 'party' refers to a wide range of activities; and 'money' encompasses both activities and beliefs. There can be no simple approach to how the three notions impact on each other: they are all part of the same continuum.

In certain circumstances both money and parties are understood to be art. Marcel Broodthaers is only one of many artists to have presented bank bills as art, while performance art since Tristan Tzara, along with masked balls and carnival, can claim to be a party art form. So, art can be both a token of economic exchange and a bit of a rave.

Art

Here's a list of some common ways of seeing, or engaging with, art. (The list is non-exhaustive and mutually inclusive: *polyvalence* is the most positive attribute of art if – as I believe – what matters in art is its ability to attract meanings).

1. Art as currency: used as a means to circulate and exchange cash, labour, ideas, beliefs.

2. Art as mirror: used to discover and explain ourselves (and our companions) to ourselves. Probably the most frequent reason people visit art galleries is to provide a moment of reflection for the self or the family; to find out something about their friends.

3. Art as lamp: used to throw light on or provide affectivity – an emotional charge – for that which we already know. It can also be an instrument for thinking. Although I doubt that art can tell us anything we don't already know, it can help us arrive at (or reinforce) a preference from among the things we already understand or feel. It can also put new things into the world.

4. Art as fashion statement: used to identify our own tastes with or against the taste of others.

5. Art as moral exemplar: 'taste' often has a moral dimension, so we say something is ugly or 'not art' when we and our tribe think that its message (which may be the manner of its making or the subject it treats) is immoral, bad, blasphemous, transgressive, subversive, demeaning or threatening. (Impressionism, that lazy, unfinished manner of painting, only found buyers as the bourgeoisie became less self-identified with the work ethic and more interested in enjoying themselves.)

6. Art as propaganda. (All art is propaganda, as Lenin, Eisenstein and many others have commented.) Power exists, and art is as useful a tool as any other for manipulating people.

7. Art as conspicuous consumption. Money exists. People who have money are often proud of the fact, and art/architecture is a more conspicuous way of showing off money than most.

8. Art as aspiration or bugbear: a screen onto which we can project our desires and fears. For instance, art is seen as glamorous by some people who would themselves like to be glamorous (comparable to the way some people view sport, television presenters, gambling, Royal Ascot, the Royal Academy and so on). Then again, some people who feel negative about glamour enjoy externalising their negativity through disliking art (or the royal family, television presenters, casinos etc.).

9. Art as redemption/salvation: like religion, art can't solve any
 problems but it may help us feel less despair. The aesthetic
 experience can provide a contemplative relief from the onward rush
 of life's narrative (Matisse's tired businessman using art as an
 armchair).
10. Art as sensual pleasure, like dancing. But perhaps this should
 include the sense of wonder, surprise, awe that attaches to spectacle,
 entertainment and sensationalism, by-passing the so-called higher
 faculties.
11. Art as club/network: a way of excluding most other people from our
 field of vision and so reinforcing our own identity/purposes/egos.
 Welcome, O Reader, to the academic art club.
12. Art as intellectual/commercial/political gamesmanship: setting
 rules through persuasive 'spin' then breaking them and setting new
 rules makes some of us feel good. Some people make money this
 way too.
13. Art as financial investment: this may be a dangerous and wasteful
 variant on twelve, but gamblers enjoy danger and waste, and the
 odds are better than the Lottery.
14. Art as celebration: for New Agers and others who have something
 to celebrate.
15. Art as list-making: collecting and categorising art – and not only in
 the museum – as a means to believing we are in control of what we
 experience rather than controlled by it

And so on. This brief approach to a complex subject suggests a
context for the subject I have been invited to write on: Liverpool
Biennial. As must be evident from the list, I am unable to believe that
money and parties are (now or ever in the past) separable from the
experience of art: art and money are comparable as belief systems, and
parties are the best means to organise ideologies.

Money
If you are not interested in money, please go straight to the third section,
'Parties'. Liverpool Biennial was founded in 1998 by James Moores,

Jane Rankin Read (the curator of James Moores' art collection) and myself. I had asked Moores for money to complete the building of Tate Liverpool. His response was that he didn't think the Tate needed his help, but he did want to use his money to support artists living or working in Liverpool, and to contribute to re-establishing the city as an acknowledged centre for contemporary visual art.

The aim of the Biennial was (and is) to promote and develop the visual arts infrastructure in Liverpool (artists, curators, critics, galleries, audiences) through delivering a world-class art festival every two years. (The name Biennial not only describes the frequency of the festival, but stakes a claim for it to be considered alongside the other exhibitions with the same title. It is a claim to be considered within the canon of exhibitions defining the current condition of art, globally.) The Biennial is responsible both for organising the *International* exhibition for the festival and for creating a marketing umbrella over a number of different exhibitions or programmes.

These programmes include two well-established and separately funded brands. First, the *John Moores* exhibition, founded in 1957 by James Moores' great uncle, Sir John Moores, and funded in roughly equal measure by the Walker Art Gallery (as it then was) and a trust set up for the purpose by Sir John. Secondly, *New Contemporaries*, at present known as *Bloomberg New Contemporaries* under a sponsorship deal with that company, but also funded by Moores family money through a trust called 'afoundation', on condition that the exhibition opens every other year in Liverpool as a part of the Biennial.

The Moores family fortune was generated from two businesses based in Liverpool under the name of the Littlewoods Organisation. One was gambling (the 'football pools' involves pooling money in a lottery based on the soccer results), the second a mail order retail business. (The business passed out of the control of the Moores family in 2003.) Without the personal commitment of various members of the Moores family, and in particular James Moores, it is clear that the funds available for visual art activity in Liverpool would be hugely diminished.

In 1999, Liverpool Biennial had a turnover of around £1.2m. Corporate sponsorship of £80,000 came from Citibell, who wanted to

1 Tatsurou Bashi, *Villa Victoria* (2002), commissioned by International 02, Liverpool Biennial, photograph by David Lambert/Rod Tidnam, Tate Liverpool. Bashi built a hotel room around the statue of Queen Victoria in Liverpool's Derby Square.

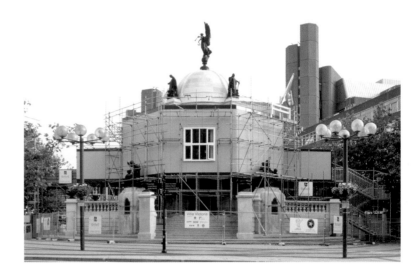

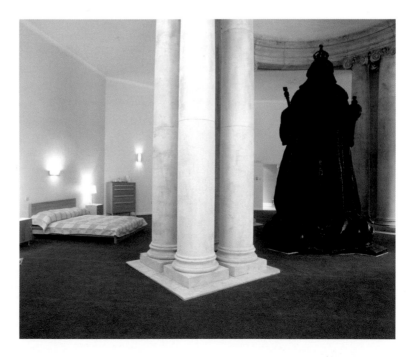

use the Biennial as an opportunity to distribute phone cards. A similar sum came from a dozen or more overseas government agencies: the cultural offices within embassies, and 'arms-length' agencies such as the Goethe Institute. Grants from trusts and charitable foundations provided the bulk of the funds, along with a very large loan from James Moores' 'afoundation'. The UK public purse (whether central or local government, or quango) did not contribute to this budget, although 'Tracey', the exhibition organised by and for local and regional artists, received support of about £10,000 in the form of a seconded Liverpool City Council employee. There was public money, it should be said, in the form of overheads of the Tate and Bluecoat galleries in which a part of the first International exhibition was shown, as also in the contribution made by the Walker to the John Moores.

Liverpool is in some ways an unlikely place to host a world-class art event, the UK's Biennial, since it is a poor city. During the 1980s and 1990s, it qualified for European Union Objective One funding, as its per capita income was less than 75 per cent of the EU average. This placed it in the same economic bracket as parts of Cornwall, the Highlands and Islands of Scotland, and rural Portugal. The largest employers are the city council and the universities. In these circumstances it was (and is) difficult to raise substantial funds from the corporate sector, but there are sources of public funding available for long-term investment.

Fifty years after the Arts Council was founded in the heyday of the Welfare State, central government now believes that neither the arts, health or education can be regarded as goods in themselves. Instead, these formerly self-sufficient objectives must be forced to carry social – and electoral – baggage (or, more kindly, be subjected to 'joined-up thinking').[1] Roughly speaking, you can only get funds to build a swimming pool if it is also a community health centre, and you can only get funds to be an artist if you contribute to core curriculum teaching. Fortunately, the arts are understood to be an efficient, popular and cost-effective way to deliver governmental social agendas (in health, education, community capacity building, neighbourhood renewal, etc.).

Knowing that James Moores would be unable to continue to fund the festival to the level of his initial 'pump priming' contribution, the

Biennial trustees' strategy has been to try to increase income from the public and corporate sectors in inverse proportion to the decline in contributions from James Moores' 'afoundation'. Or more accurately, as 'afoundation' increased its funding to those parts of the Biennial programme with which it is directly involved – the 'independent' or 'fringe' programme – it has reduced its funding to the Biennial organisation itself.

The Biennial had to use the success of the 1999 festival to convince both the corporate and public sectors of the return on their potential investment. Fortunately, the 1999 event, although it had required a steep learning curve and a degree of trauma for those involved, had sufficient actual success (as well as clear potential) for the organisation to begin to build a reputation for delivering other agencies' agendas (Arts Council, Regional Development Agency, City Council, Mersey Partnership, Liverpool Housing Action Trust and many others). The forms of success include positive promotion (image building) for the city of Liverpool; creation of communications paths within communities and a consequent increase in confidence; and the generation of tourism and of economic benefit deriving from this.

The 2002 Liverpool Biennial had a cash turnover of around £1.7m, of which the UK public sector contribution was around 33 per cent, up from less than 1 per cent, with 33 per cent still coming from 'afoundation' and the remainder coming largely from other foundations and trusts, and foreign governments. A particularly welcome sign was the beginnings of a market for art in Liverpool – collectors attracted by the Biennial who bought not only from the major set piece shows but also from the Independent exhibition. This commitment by individuals may in the longer term attach itself to the funding of the event.

Business sector funding is a response to a number of different corporate agendas, including public relations, promotion (where there is brand synergy), client entertainment, community programmes and so on. The Biennial earned £5,000 from corporate sources in 2002. The unfavourable comparison with the £80,000 cash sponsorship in the 1999 event can be characterised as dot.com confidence having given way to post 9/11 prudence. There appears to be little likelihood that the

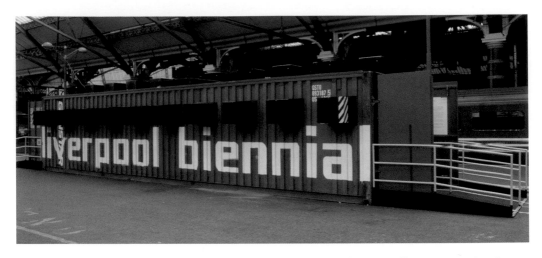

2 LOT-EK, *Welcome Box* (2002), Lime Street Station, commissioned by International 02, Liverpool Biennial, photograph by David Lambert/ Rod Tidnam, Tate Liverpool

climate for corporate sponsorship of the arts will improve in the short or medium term. One reason is that the stockmarket is unlikely to recover the confidence, bordering on lightheadedness, associated with the dot.com phenomenon of the late 1990s. A second is that the climate for corporate promotional spending on the arts appears to have changed permanently. Increased shareholder participation in decisions concerning spending favours health- or welfare-related charities rather than the arts. There is greater transparency in accounting rules. The chairman is less likely to be able to support his favourite art form through entertaining his friends and clients. The number of companies seeking opportunities for client entertainment (parties), or using art as a means of raising their brand profile through direct PR, for which art is very useful, seems to have diminished. Those that continue to work this way often simply cut out the middleman.

The German brewer Beck's, for instance, was regarded 15 years ago as a white knight for the art world. It gave money to exhibitions in return for brand promotion in the gallery's advertising and at the opening party, and it promoted artists' work on bottle labels. In the 1990s Beck's realised, following the example of the Turner Prize, that it could get more focused and greater value for money by organising its own competitive art prize than by sponsoring art galleries, exhibitions or individual artists. The Beck's Futures Prize is unapologetically a promotional campaign for beer using the 'coming trends' in art as cheap publicity. (I am not diminishing the value of cash prizes to the artists selected – just commenting on the fact that the cost to Beck's is very slight as compared with either investing cash in a longer term

support system for artists – such as a gallery, for instance – or buying an equivalent level of promotion through conventional advertising.)

The tendency to cut out the middleman is equally evident with foundations such as the Jerwood, which prefer to keep their brand identity separate from that of museums or galleries (the Jerwood runs its own gallery). Another way of putting it is to say that they place themselves as organisations directly within the art support system rather than giving their funds to other organisations within the system. With both the example of Beck's and the Jerwood this process of direct subsidy to the artist might be seen as beneficial (to the artist). But then the question has to be asked as to whether the long-term interests of an artist are better served by a one-off cash prize or a longer term relationship with an arts organisation dedicated to promoting artists' work.

3 Barry McGee, *Untitled* (2002), Pleasant Street Board School, commissioned by Henry Moore Foundation Contemporary Projects and International 02, Liverpool Biennial, photograph by David Lambert/ Rod Tidnam, Tate Liverpool

It remains to be seen whether the corporate sector will in future align itself with the approach now increasingly favoured by government – some support for the arts conditional on the arts fulfilling policy objectives (as outlined above) for education, social inclusion, and health. While the Biennial finds the current climate challenging, as a partner organisation in essence it is well placed to deliver – at least in part – the policy objectives of others, and it can consolidate its approach to both the corporate and public sectors by finding the areas of overlapping concern.

However, like most arts organisations, the Biennial's *raison d'être* is art. There is a risk that it will be able to find 'project' funding for all the 'outcomes' (side effects) of the festival it organises, such as civic image building, regeneration, education and social inclusion but will be unable to find the funding for its core programme, the art itself, the foundation upon which the rest is built. This is the eventual consequence of art being seen as a tool in the delivery of a social and economic policy agenda rather than as one of the benefits of, or prizes to be gained by, social and economic well-being.

Parties

Broadly speaking, private sector funding (from individuals and the corporate sector, but also overseas government agencies) for the arts can be generated because the funder sees the arts as an opportunity to have a good party. In fact, a party was the catalyst in the conversation between James Moores and myself that led to the founding of Liverpool Biennial. Tate Liverpool's building schedule slipped and opened a gap in the exhibition programme in the spring of 1997, filled by New Contemporaries. James paid for a dinner in Liverpool Town Hall for exhibiting artists to meet local artists. It was a good party, creating the kind of energy that we were looking to build in the city.

The multiple meanings of 'party' are important. Along with a sociable 'good time', it means 'sharing a position' (*parti pris*; also in the legal and political senses). As a convention, art has no meaning outside a shared position, or set of beliefs. The 'party line' is essential to it, and, of course, a critical or oppositional party is equally useful in creating 'currency'.

4 Stephen Powers,
Waylon Saul (2002),
Pleasant Street Board
School, commissioned by
Henry Moore Foundation
Contemporary Projects
and International 02,
Liverpool Biennial,
photograph by David
Lambert/ Rod Tidnam,
Tate Liverpool

Neither art nor money has any existence without currency, and currency depends upon the faith of the interested 'parties'. This is why an exhibition usually has an opening party: quite simply so that the artist, or the gallery, or the artists' 'party' can try to establish a shared position among the guests. These are the people who are about to go away and give the art currency, ascribing meanings to the work that will probably then take root and provide the pervasive interpretation (as well as the monetary value) for that set of artworks.

For artworks not made in a studio, the creation and currency of its meanings go back even before the opening party, to the group of people involved in its production. This process was described as 'the first audience' by Robert Hopper and I in the context of our exhibition *artranspennine98* (Tate Liverpool and Henry Moore Institute 1998). One of the public artworks we commissioned for that show, Taro Chiezo's *Superlambanana* (fabricated by the Liverpool-based artist Andy Small) is a good example of how an artwork's meanings can escape the intentions of the artist or 'first audience' but still find a potent symbolic currency.

I had been aware of Taro Chiezo's interest in hybrids since seeing his combination of a deer and a TV satellite dish in Tokyo in 1994. I was interested to see whether he could conceive an iconic response to the fact that biotechnology is possibly the most prosperous sub-sector of Liverpool's economy. Along the way, I showed him the wonderful 'futurist' decorative stone reliefs on the Mersey Tunnel ventilator shaft at St Georges Dock, and he conceived *Superlambanana* as a futuristic homage to the city to stand in front of that amazing building. This had to be a temporary site, since the building is Grade I listed, but we entrusted Liverpool Architecture and Design Trust with the long-term siting and maintenance of the sculpture, and discussed with them its placement in Wavertree Technology Park (home to several biotechnology laboratories).

But while the 'party line' set of meanings had currency among the artwork's production team, and in the exhibition literature, the dominant orthodoxy was established by the local newspaper, the *Liverpool Echo*, and by BBC Radio Merseyside in a broadcast set of *vox pops*. These established that *Superlambanana* referred to the main postwar imports to Liverpool's dock system, when Caribbean bananas became the UK's favourite fruit and New Zealand lamb helped to end meat rationing. Very soon *Superlambanana* was used as an icon (for instance in the property magazine *Your Move*) to designate the 'contemporary' nature of the city centre, then undergoing extensive conversion to 'loft apartments'; and when in 2001 I first visited the office of the chief executive of the city council to ask for money for the Biennial, I found the walls decorated with large photographs of *Superlambanana*.

So an unintended (dock-related) literal meaning of the artwork had ousted its intended (biotechnological) literal meaning. But its metaphorical meaning (a homage to the future prosperity of the city) had remained intact and potent. This meaning even survives the current siting of the work, with characteristic Liverpudlian wordplay, outside Lamb's chandlery on the Strand.

In this perspective – the power of *vox pop* given currency through the media – it becomes clear that the composition of the opening party guest list, the comments of the information assistants in the galleries, and perhaps the opening speeches, are more important for the creation of meaning for an art exhibition than anything written in the catalogue, handouts or reviews. (Those things may come into their own as the archives of art history gradually take over, in supplying contextual criteria, from the lived experience of art. But only, of course, if the art has survived long enough to become a subject for art history. Most art doesn't.) This message may not be very welcome to those who work in galleries or universities, and to whom the 'public' at large turns for the 'authoritative' interpretation of art. For serious-minded people who entered the art world hoping to find some original, true, essential, or authoritative meanings in art, it is not comforting to be told that the meanings by which the artworks will live or die have been generated

precisely by a species of gossip. But, as marketers know, word of mouth is what matters.

The huge rise in the numbers of people today, as compared with the 1960s or 1970s, that take a passing interest in contemporary visual art has given a volume of currency to art undreamed of by the small number of art followers in those decades. And currency creates money. So there are now a much larger number of artists able to make a living out of their art than then. When the Sunday magazines began to characterise the 1990s art world as being party mad, to some people this was unwelcome, as if the parties somehow mattered more than the art. But the parties and the art are Siamese twins, joined at the hip (or maybe the lip). The parties are needed to create the currency (both the meaning-rumour and the money) to sustain a larger, more income-generating art world.

Liverpool is a great place for a party. It may be its nature as a Catholic city marooned in a puritan country that gives its late night street life that whole-hearted spirit of carnival. It may be that, as a city almost wholly inhabited by immigrants (Anglo Saxons make up around 20 per cent of the population), parties have played a vital role in creating a sense of community. It may have a 'Celtic' culture more attuned to performance than to visual art, but the love of performance translates into an engagement with culture epitomised by its celebrated skill with repartee. Here, 'spin' is something entered into willingly by consenting adults on the street instead of being imposed by politicians or media. It is a great place for the generation of meaning, and artists love this. Despite its economic poverty, then, Liverpool is not so unlikely a host to a large-scale international exhibition.

Liverpool Biennial has sought to work with the city's party and street culture in recognition that it is in the gaps between the 'art spaces' that the most influential meanings for art are established. Ideally, the Biennial aims to choreograph the siting of its exhibitions and exhibits around the city centre in such a way as to reveal the character of the place. Think of the city as a cathedral, for a moment, and the Biennial as a liturgy designed to extrapolate meaning from the built surroundings. The Biennial involves a kind of pilgrimage for the visitor, treating the

5 Taro Chiezo,
Superlambanana (1998),
commissioned with funds
from the National Lottery
by *artranspennine 98*,
photograph © Tate
Liverpool

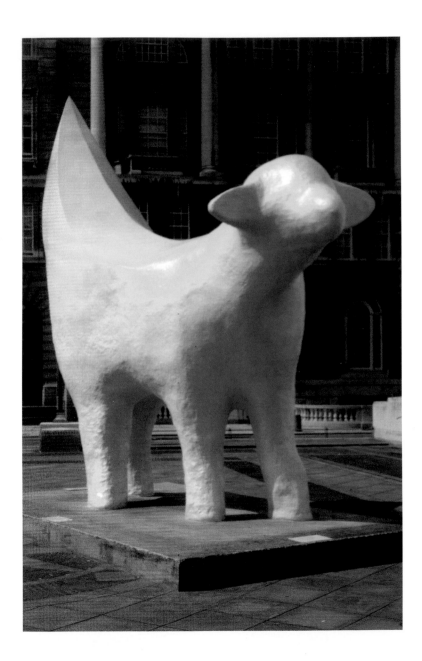

sites of public art through the city as if they were 'stations of the cross'. The event organisers are the equivalent of church wardens, and the artists the priests of this party/congregation, but it is essential that the art itself remains the 'host', because it is only the host that can give a true sense of art-communion.

The Biennial was founded to work closely with artists in Liverpool, and remains dedicated to that end. Everything else is subsidiary. But it is not artists, or even the people who work directly with artists, who ultimately decide which art is going to increase and multiply its meanings and which will not. As I hope the above list of possible uses for art made clear, money and parties are inextricably contained within the body of art itself, and anyone who can party or has money can force their claim on art. So if the Biennial seems to spend a lot of time and effort on these things, it in no way diminishes its prime objective of enriching art activity in Liverpool through enabling art to generate significant and multiple meanings.

Note

1 See Tessa Jowell, Secretary of State at the Department of Culture, Media and Sport, *Government and the Value of Culture*, May 2004.

3

Cannibal Hookers from beyond the Grave Meet the Art Crazies at Zombie Island (aka Ralph Rumney's Victory in Venice Revisited)

STEWART HOME

One has only to visit the pseudo-jamborees organised under titles such as 'Biennial' or 'City of Culture' to understand that art is the new anarchy. Art it has been claimed will regenerate our cities, provide jobs for the 'boys' and by implication transform the so-called 'underclass' into bourgeois subjects; and this despite the drop in art sales and closure of galleries during recent periods of recession. These market failures demonstrate well enough the ways in which cultural production is tied to more general economic misfortunes. There was much newspaper coverage of the effects of the recession of the early 1990s on the London art world and 'Brit Art' has been widely perceived as a response to this. Despite falling far short of the economic cure-all that crude hucksters will from time to time claim that culture constitutes, what art and anarchism do very well is bolster the self-image of their adherents by providing them with the illusion that it is possible to live differently in this world while simultaneously failing to pose any kind of threat to commodity culture. Art and anarchism remain among the most favoured ideological products of capitalism because one of the more salient characteristics of these discourses is their deliberate avoidance of how our world might be radically transformed. Art in general and biennials in particular are thus best understood as being simultaneously about the production of ideologies

and the exchange of cultural commodities. According to such a view biennials are far more than mere art markets, since their structuring reflects networking practices and class hierarchies as well as straightforward commodity exchange.

In the bland journalese of Rosie Millard and much recent coverage of the art world, the networking component of high culture is so massively over-emphasised that it is rendered incomprehensible to anyone who accepts such hype at face value. Millard's book *The Tastemakers* (2001) might leave someone from outside the overdeveloped world with the impression that there is no longer any effective opposition to the dominant culture of England and that the tastes of the tastemakers themselves spring fully formed from nowhere.[1] Millard ignores the rich histories of cultural iconoclasm that have yet to exhaust themselves in the endless restagings of their own death, and of which Brit Art is merely one type or example, opting instead to cover the Stuckists. This loyal opposition is absolutely the worst product of Brit Art and it should go without saying that the Stuckists contest conceptualism with reactionary rhetoric about a return to painting. Since genuine criticism of contemporary culture is unwelcome among its boosters, Millard opts instead to eulogise an artist-based micro-celebrity culture in which the actual work produced by its stars has little bearing on their broader cultural reception as icons of bourgeois-bohemian good living.

In an essay accompanying Sam Taylor-Wood's 2002 retrospective at the Hayward Gallery, Michael Bracewell suggested that she is able 'to respond to Pop as a situation, rather than rhetorical event'.[2] Likewise, according to Julian Stallabrass in *High Art Lite* (1999), in the realisation of an early work Taylor-Wood 'fly-posted the Brick Lane area of London, an area where the population is largely Asian, with a picture of herself wearing a T-shirt bearing a swastika and the name of the symbol written in Sanskrit... the swastika was the original kind, not the reversed version used by the Nazis...'.[3] Given the long history of Hindu–Muslim conflict on the Indian subcontinent, of which the predominantly Muslim population in the Brick Lane area with its close ties to Bangladesh is overly familiar, what Taylor-Wood may have conceived as a pop gesture of reversal and self-

1 Sam Taylor-Wood,
Fuck, Suck, Spank, Wank
(1993), C-type print, 145 x
106 cm, courtesy the artist
and Jay Jopling/White
Cube (London)

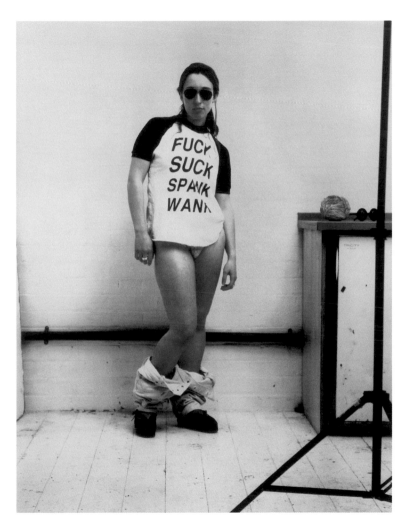

promotion (which might be compared to punk idol Sid Vicious
of the Sex Pistols parading through Jewish neighbourhoods wearing
a T-shirt bearing Nazi insignia) would have been experienced by
many of those who encountered her work in the street as pure racist
aggression. Here was a middle-class English artist placing among

working-class Muslims an image whose main feature was a symbol used by Hindus and Nazis. This early piece of presumably unintentional racist intimidation was not included in Taylor-Wood's Hayward retrospective. In the instance of this particular work at least it would appear Taylor-Wood was not operating at a critical distance from the pop culture with which she grew up, but rather was uncritically reproducing its tropes. In doing this Taylor-Wood tapped into forms of racism that are endemic to the whole of contemporary British society, but which find their most insidious expression within high culture and among those privileged white liberals who mistakenly believe themselves to be free from bigotry.

Interviewed by Clare Carolin in the catalogue accompanying her Hayward retrospective, Taylor-Wood comes across as an ingenue, inanely saying of a photographic 'self-portrait' in which she wears a T-shirt bearing the slogan 'Fuck, Suck, Spank, Wank': 'the language is confrontational but I'm in a vulnerable state with my trousers around my ankles. The sunglasses shield me completely – so you can't get beyond the image.'[4] The fact that virtually everyone who has viewed this photograph would be unable to get beyond the image regardless of whether Taylor-Wood was or was not wearing sunglasses is disarmingly overlooked. If such slippages are deliberate then Taylor-Wood may be making an almost subliminal critique of a world in which subjects appear as objects and vice versa, since the two-dimensional nature of the image necessarily imbues the final term 'wank' with greater weight than the three words that precede it and as such it might be praised as an example of Bataillian abjection. Obviously the pornographic material that this image invokes is produced with the explicit intention of encouraging its consumers to 'wank' or, to use a non-vernacular term with the same meaning, masturbate. The jury is still out on whether Taylor-Wood was deliberately lining herself up with a hoary tradition of post-porn hustlers ranging from Joe Dallesandro to Cosey Fanni Tutti who self-consciously prostituted themselves for their art. Micro-celebrities from the outer fringes of cultural production – and Taylor-Wood is a perfect example of one – are necessarily a two-dimensional

deformation of what it is to be human. For example, a series of photographs featuring Taylor-Wood appeared under the heading of 'Fashion Stalker' on page 37 of *ES Magazine* (given away with the *Evening Standard* newspaper) on 21 March 2003. The journalistic copy included the following:

> Sam Taylor-Wood may be part of the BritArt pack, but she certainly doesn't dress like it. Grotty dungarees, bird's-nest hair and a hungover complexion? Not our Sam. Here's a woman who loves her labels. The 35-year-old artist adores Alexander McQueen and Marc Jacobs, teamed with lashings of Stella McCartney (who's a good friend). She's also a bit of a shoeaholic, favouring strappy sandals by the likes of Christian Louboutin and Manolo Blahnik. But then, as she also hangs out with London's glitterati, such as Sir Elton John and Elizabeth Hurley, she can hardly be seen in a smock and Birkenstocks. Her best accessory? Jay Jopling – together the two are art's ultimate power couple.

Jopling, it is probably superfluous to add, is the impresario behind the White Cube gallery and a major dealer of so-called Brit Art. Here Bracewell's notion of Taylor-Wood responding to pop as situation is completely eclipsed by pop rhetoric about her iconic status.

The charm of Brit Art micro-celebrities such as Sam Taylor-Wood lies in the way they present themselves as having uncritically absorbed and accepted a peculiarly warped pop cultural discourse about art and artists. This is a world in which 'genius' manifests itself as 'madness' and where celluloid exploitation comedies such as Roger Corman's *A Bucket of Blood* (1959) and Herschell Gordon Lewis's *Color Me Blood Red* (1965) are consumed as if they were not overly self-conscious parodies of misplaced artistic ambition. In *A Bucket of Blood*, Walter Paisley dreams of becoming an artist although he is actually the socially inept hired help at a beatnik cafe called The Yellow Door, and also the butt of endless bohemian jokes. After accidentally killing his landlady's cat, Paisley covers it with modelling clay and is acclaimed for his return to realism. Paisley's increasingly gruesome artistic activity culminates in a work called 'Murdered Man', literally a man Paisley has killed covered in clay. Paisley aspires to being as groovy as Maxwell H. Brock, a beat poet who hangs out at The Yellow Door and rants poetry with lines such

as: 'Hydrogen is a gas. Life is an obscure hobo bumming a ride on the omnibus of art... Burn gas buggies and whip your sour cream of circumstance and hope... Creation is. All else is not. What is not creative is Graham Crackers. Let it all crumble to feed the creative....' Likewise in *Color Me Blood Red*, a commercially successful artist called Adam Sorg is inordinately frustrated by his lack of critical acclaim. Indeed, Sorg's paintings are slammed by a local Florida art critic until the artist beefs up the colouration in his works through recourse to human blood. In the movie Sorg transforms himself before our eyes from a demented artist into an insane murderer who will coldly kill others in order to realise his aesthetic vision.

The cinematic representation of the mad artist as a murderer reached its apogee in Abel Ferrara's *Driller Killer* (1979). In this film the director plays Reno Miller, a New York painter living in squalid conditions with the endlessly noisy rehearsals of a punk band distracting him from the completion of a masterpiece. Before long Reno's psychotic episodes have got completely out of hand and he takes to the streets where he butchers the homeless with his battery-packed power tool, apparently as a means of creating solid boundaries between himself and deadbeats. Taylor-Wood specifically tells Carolin that Abel Ferrara has influenced her work. *Driller Killer* illustrates how within pop cultural discourse psychosis might become synonymous with freedom; and for those who adopt such positions there is little to distinguish Mad Tracey From Margate (as Brit Art celebrity Tracey Emin sometimes styles herself) from gangland hardman Mad Frankie Fraser, whose ongoing series of autobiographical books are 'non-fictional' bestsellers in the British Isles. To those who give themselves over to such perspectives the appeal of both art and crime as 'alternative' career options emerges from an adolescent and essentially anarchistic desire to live differently in this world, and even to ascend above it into absolute elsewhere courtesy of one of the many varieties of mystical cretinism. Rather than struggling to overthrow the reigning society, individuals who adopt such positions invariably end up by actively embracing the inequities of the dominant culture, since these serve

to buttress a fragile and completely illusory sense of superiority over those more obviously embroiled in 'the rat race'. Taylor-Wood tells Carolin perhaps parodically: 'I believe in an essence of life, a spirituality'.[5] Tracey Emin, who has claimed she prays to God, as well as many other beneficiaries of the Brit Art hype, appear to suffer from similar delusions.[6]

In a free information leaflet accompanying Richard Billingham's summer 2000 Ikon Gallery show in Birmingham, he is quoted as saying: 'It is not my intention to... be political... only to make work that is as spiritually meaningful as I can make it...' The very notion of spirituality is bogus, and so it is unlikely that Billingham's mystical pretensions influence viewers who are mature enough to reject silly superstitions about unmoved movers and divine substance. Billingham may not want to produce images that are going to be read politically, but given his use of pastoral motifs, this is something that will occur regardless of his wishes. To state the obvious, any work of art is redolent of particular (critical) definitions of 'reality' and 'art' and these definitions are all ideological. The dubious nature of a particular cultural artefact – that dimension of it which seems out of the control of its supposed creator – constitutes an area of struggle. This is not necessarily something which should be resolved: indeed, as soon as efforts are made to resolve it as a problem the artefact tends towards meaninglessness. While Billingham was not necessarily responsible for the inept theoretical commentary accompanying his show, he has not – as far as I know – objected to it. The Ikon curators suggest that a net curtain becomes an abstract pattern and a picture of Billingham's mother doing a jigsaw puzzle is an example of her filling in time. Most net curtains are, in fact, deliberately manufactured with abstract patterning, probably in order to distract attention away from their functional purpose of creating a sense of privacy on overcrowded housing estates. Likewise, rather than viewing Billingham's mother Liz doing a jigsaw puzzle as simply a means of filling in time, she might be seen as wrestling with form and colour in a way that mirrors what goes on in art galleries.

Returning to Taylor-Wood, she reveals to Carolin that one of her works, *Wrecked*, emerged from her sense that everyone she knew in the

art world was 'going completely wild'. Regardless of whether this is done with any seriousness, while Taylor-Wood presents herself and her friends as freewheeling bohemians doing their own thing, even the most cursory analysis quickly reveals that this apparently chaotic world is structured by personal working networks, which alongside various forms of organisational support from galleries and government bodies form the bedrock of cultural careers. Social network or relational analysts such as Granovetter, Burt and Powell have attempted to develop descriptions of the effect such structuring forces have on purposive actions.[7] According to the theories of these sociologists whose 'research' mirrors anarchist propaganda about 'affinity groups', the ways in which an artist's or curator's activities are socially embedded by their network of contacts will throw light on the twists and turns of their art careers. Thus the relational structuring of the assorted ventures of artists and their gallerists may be taken as Granovetter has suggested with regard to a different milieu as crucial to engendering trust and discouraging malfeasance within a specific network or affinity group.[8] The network, alongside the market and class hierarchies, is a governance structure shaping the actions of individual artists and those who work with them, particularly now that the appellation 'gallerist' has been appropriated by those dealers who wish to lay claim to a curatorial and perhaps even a creative role in the ongoing commodification of culture. It is also worth noting in passing that one of the more notorious cultural landmarks of the networking culture within which Brit Art celebrities operate is Tracey Emin's *Everyone I Have Ever Slept With 1963–1995* (1995); a tent internally covered with the names of Emin's boyfriends, family members, teddy bear and an aborted foetus.

Although networks can be complex they do not necessarily involve the active propagation of free market ideology, nor the overt paternalism of a hierarchy. At the root of network relationships is the assumption that one party is dependent on resources controlled by another, and that there are gains to be made from pooling resources. Powell claims that

[n]etworks are particularly apt for circumstances in which there is need for efficient, reliable information. The most useful information is rarely that which flows down the formal chain of command in an organization, or that which can be inferred from shifting price signals. Rather, it is that which is obtained from someone whom you have dealt with in the past and found to be reliable. You trust best information that comes from someone you know well.[9]

Burt in his structural hole argument asserts that the ability of some networkers to realise a competitive advantage over their peers stems from an ability to enrich their personal affinity group with a proportionally higher set of entrepreneurial opportunities or structural holes. Because network ties, particularly in a cultural industry context, require time and energy to make and maintain, some contacts, in a sense, are better investments than others. Burt claims: 'What matters is the number of non-redundant contacts. Contacts are redundant to the extent that they lead to the same people, and so provide the same information benefits.'[10] The term structural holes is used to grasp 'the separation between non-redundant contacts' or the voids between unconnected players that are available for seizing.[11] Fitting into a hole puts one in a position to broker a deal between previously unconnected players. It is therefore through one's capacity to broker and seize the information benefits needed and sought after by others that certain networkers achieve more control of opportunities within the affinity group than others. However, because the network that constitutes the institution of art is not particularly large, there are relatively few structural holes and all that filling one of them accomplishes is an information loop. The same information is fed through to different parts of the bureaucracy that constitutes this affinity group, and the main interest of those involved is in preserving their cultural capital by restricting the number of new networkers who are allowed to enter the institution of art.

Working as a network, the institution of art is not controlled by any one individual and no one can be decisively excluded from it. That said, and as should be clear from the work of the sociologists summarised above, affinity groups are always predicated on social separation. Likewise, the majority of individuals who make up the network that

constitutes the institution of art share a core of ideological values, including a superstitious belief in the superiority of art to whatever is arbitrarily labelled as 'non-artistic'. Those who challenge such beliefs are unlikely to penetrate quickly to the heart of this network and their failure to do so will surprise no one. Gustav Metzger serves to exemplify this situation, and according to Matthew Collins, I do as well. Collins writes that I have

> recently become a sympathetic figure for the art world. Previously he was an outsider, but because his writing and self-presentation are iconoclastic and against the establishment – and art now wants to flatter itself that it is incredibly liberal and radical – the art world now acknowledges him. I think he's a good artist but in the tradition of artist-outsiders. He's often much funnier than the insiders, but he doesn't bother enough with the object side of art...[12]

The bulk of art critics who are less given to ironic sophistication than Collins generally dislike groups and individuals who attack not just the institution of art but the very existence of those specialised non-specialists called artists. Likewise most critics and 'gallerists' remain hostile to the suggestion that the high prices paid for favoured works in the art market are justified by the sum total of cultural products that

2 Stewart Home,
Demolish Serious Culture
(1994), demonstration/
performance Brighton

have been and are still being produced. In other words, the enormous amount of labour power expended by the mass of impoverished cultural producers is not simply wasted, since this waste simultaneously serves to valorise the work of a tiny coterie of rich artists. Given that the smooth operation of the cultural industries requires that their rewards should be doled out in an unequal and arbitrary fashion, forthright criticism of this system will be dismissed by some of its defenders as petty jealousy, while frontal assaults on art (such as the slashing of paintings) tend to reinforce the hegemonic position of the dominant culture (those who vandalise art works usually believe that their 'opponents' see what they attack as worth preserving, and thus of some value). Although any given object at any given time may or may not have an exchange value, all have a use value (linked – but not restricted – to ideologies of prestige).

Responding to this situation, my own strategy for many years has been to autonomise the negative within artistic practice; and one of the ways I have done this is through an absurdist remaking of not just works but even an entire exhibition. Thus when Norman Rosenthal was unable to bag Vermeer for the Royal Academy, from July to September 1996 I brought him to the East London gallery *workfortheeyetodo*. Rather than mounting an expensive blockbuster with the original paintings, I exhibited degenerated photocopies of Vermeer's work. Thus blockbuster conditions were effectively simulated without spectators having to suffer the inconvenience of being pushed and shoved by a milling crowd. Vermeer's work was distorted far more powerfully by cheap copy technology than through the opera glasses used by those visitors unable to get anywhere near his paintings at the Mauritshuis gallery in the Hague. However, my exhibition *Vermeer II* did far more than simply raise questions about authorship, the institution of art, the relationship between a copy and an 'original', the commodification of culture and the status of painting in post-industrial society. Since art objects gain their appearance of ideological autonomy from their commodification, marketing is obviously a crucial component in the production of a successful work of art. Naturally, unique works command higher prices than multiples. Thus while cheap copy

technology enabled me to produce the work for *Vermeer II* in the course of approximately twenty minutes, it was necessary to introduce an element that made the pieces on display appear both unique and considerably more sensual. By adding pink paint to manipulated black and white xeroxes of Vermeer's output, I was able to inflate the price of 'my' work. And again, since a relentless interrogation of the notion of ideological autonomy constitutes an important element of my practice, the pricing of the pieces reflected the disruptive intent of the exhibition. The price for one picture was £25, the price for two £100, the price for three £400, and so on. With each additional piece purchased, the price was multiplied fourfold. Thus, the cost of all 22 pieces was a prohibitive £10,865,359,993,600, which prevented any institution from snapping up the lot. As Karl Marx observed, the only basis on which we can verify an anti-capitalist politics is the analysis and critique of the capitalist form of value: the commodity, the elementary form of wealth in societies governed by the capitalist mode of production.[13] However, *Vermeer II* was to an extent recuperated by the market, since this show marks the only occasion on which I have sold my visual work in any quantity; albeit made up of 17 single sales and with only the artist–writer– musician Bill Drummond really entering into the spirit of things by buying two paintings for £100 and framing his receipt.

Similarly, I used a one-week art residency at John Moores University in Liverpool in April 2002 to make three feature-length films which emerged from my interest in montage and détournement. *Has The Litigation Already Started?* was a loose remake of Maurice Lemaitre's 1951 work of expanded cinema *Has The Film Already Started?* mainly using copyright notices from DVDs which are made to dance before the audience's eyes with elements from the 1922 *Nosferatu* cut in. Shortly after its release *Nosferatu* was suppressed by Bram Stoker's widow for infringing her copyright on *Dracula*. The soundtrack to my film consists of both silence and different realisations of a piece I did called *The Bethnal Green Variations: Turning Silence Into Noise (Cage Caged)* (1999) which was created specifically to stimulate debate around the issues of plagiarism and copyright. The piece was realised on 31 July 1999 by placing a beat box programmed to repeat play Wayne Marshall's version of John Cage's

3 Stewart Home, *Holborn Working* (1994), photograph by Marc Atkins

4'33" (1952) on a windowsill of my flat on the Avebury Estate in Bethnal Green, East London. I had the window open so that the noises of the inner city drifted in (youths arguing and later a thunderstorm), and I recorded the results with a Sony MZ-R50. *4'33"* is Cage's silent piece for which the pianist sits at his instrument without playing a note. Rather than taking the little sound that was on the Wayne Marshall CD (silence being notoriously difficult to record) directly from it in digital form, I wanted to drown this out with the noises of the city. In a way I was invoking *Cheap Imitation*, the piece of deconstruction Cage did to bypass the extortionate fee demanded for use of Satie's *Socrate*. I recorded 32 versions of *4'33"* being drowned out by urban noise with the intention of superimposing them over each other. In the event I've created different montages from this recording for the soundtrack of my film. Obviously, I performed this détournement on Cage and published my intention to realise it commercially (with a little help from the Arts Council of England) before the court case about the 'plagiarism' of *4'33"* in autumn 2002 involving Wombles producer Mike Batt. The Cage estate claimed that Batt had infringed their copyright because he had included a minute of silence on a record he had released. As well as my anti-realisation of *4'33"*, *Has The Litigation Already Started?* also incorporates the noise of the audience's movements into its soundtrack *à la* Cage. That said, given that the first half of *Has The Film Already Started?* is silent, Lemaitre had quite intentionally done this before Cage; and rather more significantly in terms of the development of lettrist cinema, before Debord.

Screams in Favour of De Sade was an English-language colour remake of Guy Debord's iconoclastic classic from 1952. Like the original, my film has no images but whereas Debord's consisted of black stock with silence and white light with dialogue in French, mine has black with silence and TV colour bars with dialogue in English. The original dialogue is not simply translated since in a number of places it has been rewritten.

However, while Debord had five voices reading his script, I have one voice with an additional spoken indication of which voice is speaking. The periods of blackness and silence in Debord's film are strictly adhered to with the final twenty-four minutes being entirely black and silent. Although Debord offered no fully elaborated theoretical explanation for the production of *Screams in Favour of De Sade*, I believe his intention was to transform cinema into theatre, turning the audience into actors rather than treating them as passive spectators. If this is the case then it should matter little to viewers whether they watch Debord's original or my remake; what is important is what happens among the audience, not what is on screen – which in a classical gesture of avant-garde iconoclasm is essentially nothing.

The third film I remade I entitled *The Golem*, although it was actually Sergei Eisenstein's 1928 cinematic celebration of the Bolshevik revolution, *October*, with the intertitles taken out and replaced by those from Paul Wegener's silent version of *The Golem*. There are fewer intertitles in *The Golem* than in *October*, which enabled me to use repetition to good effect. This piece was partially inspired by my liking for Rene Vienet's *Can Dialectic Break Bricks?* (1973) in which a Hong Kong kung fu film of the 1970s was redubbed to give the story a revolutionary spin. However, I'm also aware that Debord and Wolman theorised the most effective forms of détournement as being those that showed their contempt for all existing forms of rationality and culture, whereas those that simply inverted pre-existing meanings (as is the case with Vienet's détournement of an ethnic Manchu against Ming conflict, a staple plot device of Hong Kong cinema at the time, which he substitutes with a class war between proletarians and bureaucrats) are viewed as weak.[14] So if my détournement of *October* is a homage to Vienet, it is simultaneously a critique of him – and even more obviously an attack upon the reactionary anti-working-class politics of the Bolsheviks. A blazing rock soundtrack by Finnish punk act The Dolphins has been dubbed onto my reworking of *October* – although it was also my intention that at some screenings very different live realisations for the sound might be achieved, which is why I used a live rather than a studio recording of The Dolphins on the dubbed soundtrack.

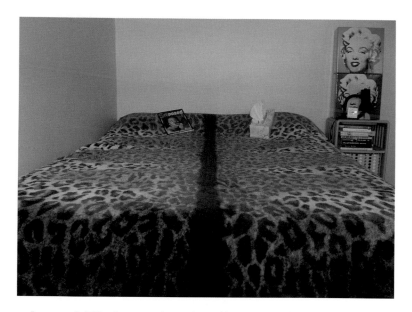

4 Stewart Home,
Art Strike Bed (1990–2004)

It proved difficult to get these three films screened since they are a
critique rather than a celebration of the type of culture biennials exist to
promote, but they were eventually shown as a part of the exhibition
100,000 Newspapers at the squatted T12 Artspace in East London from
January to March 2003, after the curator Wolfe Lenkiewicz and Gustav
Metzger, who he was working with on this installation, asked me to
contribute to the show. However, perhaps rather more surprising than
the difficulties I encountered in getting these movies screened is the fact
that I continue to interface with the art world. Having set out in the
1980s to demonstrate that despite the lack of an art school background
I could attain a certain level of success within the art world, I had not
intended to continue working in art spaces in the 1990s. Indeed, I had
announced in 1985 my plan for an *Art Strike* between 1990 and 1993
during which I would cease all cultural production. However, after the
Art Strike I was pleasantly if somewhat relentlessly pursued by artist-
curator Matthew Higgs who wanted me to participate in some of his
shows. Eventually I allowed Higgs to premier my *Art Strike Bed*
(1990–2004) at *City Racing* in 1994. The *Art Strike Bed* was crisply made
up and it was my intention that every time I exhibited this work I would
use a different bed to ironise any aura of either authenticity or militancy
I might be misperceived as giving off. When I exhibited the *Art Strike
Bed* in a group show called *Yerself Is Steam* curated by Jane Pollard and
Ian Forsyth in a temporary gallery in Charlotte Street in the West End

of London in 1995, it was shown alongside work by Tracey Emin among others. Emin it would appear was so enraged by my work and the polemic accompanying it that she set out to recuperate what I was doing by producing a piece of her own, entitled *My Bed*, which in its dishevelled state is intended to signify trauma and authenticity. Matthew Higgs then further subverted my intentions by including the *Art Strike Bed* in his *City Racing* retrospective at the ICA in 2001; rather than following my instructions and finding a water bed for the show, Higgs retrieved the actual bed that had been displayed at *City Racing* in 1994 which his then assistant Paul Noble had taken for his own domestic use, after I made it clear I did not want it returned when the original exhibition closed.

We all live out the contradictions of capitalism and Higgs has proved particularly adept at sardonically exploring this situation by including my work in various shows he curated. I would certainly like to see more curators following his example by asking themselves in what ways they might use cultural platforms both for renewing the possibilities of revolt and simultaneously illustrating how capitalism recuperates radical activity. After Higgs, curators might ask themselves if it is more subversive to consciously select and promote theoretically

5 Tracey Emin, *My Bed* (1998), mattress, linens, pillows, rope, various memorabilia, 79 x 211 x 234 cm, courtesy the artist and Jay Jopling/ White Cube (London), photograph by Stephen White

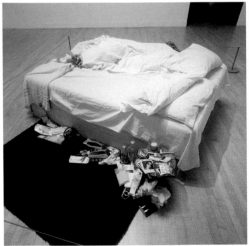

rigorous works at the expense of trash aesthetics, or whether self-consciously puffing 'bad' art does greater damage to the dominant culture? Likewise, when it comes to bigger shows and biennials, should one aim for a balance between international 'stars' and local artists or is it better to crudely unveil the stark inequities of capitalism by focusing exclusively on so-called big names? And again, to what extent is it possible for curators operating from within restrictive institutional positions to take on and even take over the role of the artist? These are not questions that can be answered definitively since tactics depend on the terrain in which we find ourselves fighting, while

I Support Sexual Liberation

necrocard

I want to help others experiment sexually after my death. Please let your relatives know your wishes.

I request that after my death
A. my body be used for any type of sexual activity ☐
or
B. gay only ☐ straight only ☐ I do not wish my body to be dismembered or disfigured during necrophiliac sex ☐ (tick as appropriate)

Signature _____ Date _____

Full name _____
(BLOCK CAPITALS)

In the event of my death, if possible contact:

Name _____ Tel ()

Issued by Neoist Alliance, BM Senior, London WC1N 3XX. Send British Stamps or IRCs for further information.

6 Stewart Home,
Necrocard (1999)

strategy is hammered out by continually reforging the passage between theory and practice. That said, negotiating the death of art may yet mean embracing the art of death and elsewhere I have written in favour of cultural necrophilia. As long ago as 1968 the King Mob group commemorated the shooting of Andy Warhol by Valerie Solanas with the following words: 'The death of art spells the murder of artists. The real anti-artist appears.'[15]

At the time of writing the micro-celebrities of Brit Art have only been symbolically slaughtered by the media, and none more so than Sam Taylor-Wood, whose Hayward retrospective was seized upon by the liberal press as an opportunity to slate her for being fashion-conscious and married to an art dealer. Clearly the majority of Taylor-Wood's critics are at least as naive as the object of their approbation since how else would they expect someone like her to live in our alienated society? The positions of Brit Art's more visible boosters and detractors from Stallabrass all the way down to Millard ultimately implode and become indistinguishable. Since Baudrillardian obscenity is omnipresent within contemporary culture it is well worth recalling the description Stephen Koch offers of Andy Warhol's efforts to realise absolute legibility within his art, and then apply it en bloc to Taylor-Wood: 'Here the picture surface discloses its meaning instantly. But it is the afterglow of the instant that matters... a special region where cynicism and naivety cannot be distinguished, where populism and romantic decadence merge...'[16]

Those who in effect denounce Taylor-Wood for failing to live up to their expectations of a great artist reveal only their own critical inadequacies. The *Evening Standard* newspaper is the new Dada and although Taylor-Wood functions as the movement's second Julius Evola, her literalism – like that of Tristan Tzara's Italian pen pal, the future 'Marcuse of the far-Right' – still invites interpretation. Taylor-Wood's world-view is undoubtedly repellent and her cool immersion in celebrity

culture is about avoiding rather than confronting alienation. What she has done is produce a body of work in which her social role and her art have become inseparable, and through which she addresses our collective fascination with corruption and death. Which is why the ridiculous howls of protest that greeted Taylor-Wood's retrospective were an integral part of its auteur's art of non-living. And yet no one and nothing, not even Sam Taylor-Wood, is completely transparent. Indeed she may yet prove to be an unavoidable manifestation of the inscrutability of our excremental culture. Anti-art is not only what can be reproduced, it is what is always and already reproduced. Anti-art is hyperreal. It is necessarily a simulation.

To double back and reuse the words with which the Up Against The Wall Motherfucker collective commemorated that famous neo-Dada event of 1968, the attempted assassination of Andy Warhol: 'Non-man shot by the reality of his dream – the cultural assassin emerges – a tough chick with a bop cap and a 38 – the true vengence of DADA...'[17] But Taylor-Wood's anti-art murders Warhol far more effectively than the gun toted by Valerie Solanas. Fuck. Suck. Spank. Wank. She looks like Warhol, she speaks in mutist non sequiturs like Warhol, and she is famous for being famous. Despite this the code has mutated and as cancerous pure image Taylor-Wood obscenely exposes herself simulating a two-dimensional Delacroix to Warhol's mono-dimensional Duchamp. The end of art goes on and on because anti-artists from Taylor-Wood on down to Rachel Whiteread are hallucinating black acts of necromancy. Negative space. Art and its double have reversed into a future of romantic revolt, superstition and sorcery. Commodity culture can only go backwards, it has nowhere else to go.

Notes

1 R. Millard, *The Tastemakers: UK Art Now* (London: Thames & Hudson, 2001).

2 S. Taylor-Wood, *Sam Taylor-Wood* (London: Steidl Publishers for the Hayward Gallery, 2002), 205.

3 J. Stallabrass, *High Art Lite: British Art in the 1990s* (London: Verso, 1999), 143.

4 Taylor-Wood, *Sam Taylor-Wood*, 215.

5 Taylor-Wood, *Sam Taylor-Wood*, 213.

6 Stallabrass, *High Art Lite*, 41.

7 M. Granovetter, 'Economic Action and Social Structure: The Problem of Embeddedness', *American Journal of Sociology*, 91 (1985), 481–510; *idem, Getting a Job: A Study of Contacts and Careers* (Cambridge, MA: Harvard University Press, 1974); *idem*, 'The Strength of Weak Ties', *American Journal of Sociology*, 78 (1973), 1360–80; R. S. Burt, *Structural Holes: The Social Structure of Competition* (Cambridge, MA: Harvard University Press, 1992); W. W. Powell, 'Neither Market Nor Hierarchy: Network Forms of Organization', *Research in Organizational Behavior*, 12 (1990), 295–336

8 Granovetter, 'Economic Action and Social Structure'.

9 Powell, 'Neither Market Nor Hierarchy', 324.

10 Burt, *Structural Holes*, 104.

11 Burt, *Structural Holes*, 9.

12 M. Collins, *Art Crazy Nation* (London: 21 Publishing, 2001), 35

13 K. Marx, *Capital*, Volume 1 (London: Lawrence & Wishart, repr. 1974 [1887]).

14 K. Knabb (ed.), *Situationist International Anthology* (Berkeley: Bureau of Public Secrets, 1981), 8–14.

15 I. Blazwick (ed.), *An Endless Passion... An Endless Banquet: A Situationist Scrapbook* (London: ICA and Verso, 1989), 70.

16 S. Koch, *Stargazer: The Life, World and Films of Andy Warhol* (London and New York: Marion Boyars, (2002), 130.

17 Blazwick (ed.), *An Endless Passion...*, 70.

4

Sadie Coles HQ: Anatomy of a Gallery in the Age of Globalised Contemporary Art

SADIE COLES INTERVIEWED BY JONATHAN HARRIS

The Sadie Coles HQ gallery* in London has been at the forefront in the exhibition and support of contemporary artists associated with 'Brit Art', or those in the 1990s who were deemed 'YBA' – the Young British Artists. Ten years on Sadie Coles, in conversation with Jonathan Harris, reviews the history of her gallery, the relevance to it of her own background and gender, the gallery's activities and purposes, and its links to organisations around the world that constitute the now globalised contemporary art market. The interview was recorded at Sadie Coles HQ in January 2004.
* 35 Heddon Street, London, W1B 4BP. www.sadiecoles.com

Origins and background: the late 1990s
SC Sadie Coles HQ is a primary market contemporary art gallery and we opened in 1997. We represent, exhibit, buy and sell works by youngish international artists to private collectors, museums and institutions. When I say youngish, the gallery basically is centred around artists who tend to be my age [40], but we also have done historical shows, like a recent Andy Warhol exhibition, and our next show is Carl Andre, so it's not exclusively generational. My youngest artist is 28. We also publish catalogues and books, help our artists with production if they need it, help them with their museum shows,

promote their work at art fairs, all with the intention of raising their profile internationally and building their collector base.

JH Was the gallery always based here in the West End of London?

SC Yes. I made a definite decision to locate the gallery in the West End. I felt that it was essential to be here because a lot of clients or museum curators visiting London might have half a day here. To get to the East End can sometimes take too much time. Although in 1997 when we opened, it was a less surprising choice as there were fewer galleries in the East. The decision has obviously had an economic impact on the gallery's development. If I was in the East End I'd have a much bigger space. There is a trade-off but actually it suits me better to be in the West End.

JH Are there other galleries selling contemporary art near to you here in the West End?

SC Yes. Gagosian are just down the street and Sprovieri is in the building next door.

JH They opened after you?

SC Yes, I'm very close to Cork Street here, where there were many important contemporary galleries in the '80s, though almost nothing contemporary happens there now. The West End gallery scene went through a bit of a dip two years after I opened.

JH Why was that?

SC In 2000 some of the important contemporary galleries, some of my colleagues, moved to the East End [the area of London around Whitechapel towards the docklands, several miles from the centre of the city] and many new younger galleries opened around there. Then Tate Modern [located to the east of central London, on the south bank of the

Thames near the Royal Festival Hall] opened in Southwark in May 2000 so there was a shift of energy away from the West End. But that seems to have balanced itself out now with Hauser & Wirth, Haunch of Venison, Gagosian and Sprüth, Magers, Lee all opening here and now Jay Jopling will open a new space back in St James's near the original White Cube.

JH Can you explain why the East End became so immediately popular?

SC Space and artists.

JH It was just cheap to rent or buy there?

SC Yes. It was cheap, or cheaper than here at least, but also it already had a strong community of artists and therefore an audience. When Tate Modern opened in 2000 we rented a space for three months in Hoxton [in the East End], and organised a show because I nervously wanted to see what it was like. It gets a different audience [the East End remains the poorest part of London, though parts of it are now gentrified and attract younger professionals with high potential earning power – JH] from the West End. It was very interesting because many students and artists live there, so it was very busy, whereas here I feel you get a more consistent 'business' audience. Visitors will drop by because we are near their hotel, whereas they might only go east if there is a show or shows they specifically want to see.

JH So you encourage people to come in off the street here?

SC Up to a point, but the gallery space is on the first floor. That's to do with economics because a ground-floor space rent for a similar size would be something like £120,000 [$230,000] a year. My rent is about half that. But as a next step I would like a ground floor in the West End.

JH How confident were you in establishing the gallery? Was the money side of it daunting?

SC To be honest I had very little confidence to begin with. I didn't really feel like a business person when I opened the gallery. Two factors led to it. My previous jobs had been mainly in exhibition organisation and curating. I had been director of exhibitions at the Anthony d'Offay Gallery, so I basically liaised with the artists and managed the exhibition programme. The pressure was not on me to concentrate on sales. I *did* sell for the gallery, but that wasn't my primary function, which was to work with the artists. When I left, I left because I wanted to work with artists of my own age. So I went and worked with Jeff Koons in New York, got incredibly homesick, and came back. Then, my friend [and artist] Sarah Lucas kept saying 'I want to work with you'. In addition I had a friend who had a lot of faith in me and offered to lend me money. He lent me £100,000, though in the end I only spent £50,000 which was paid back plus interest. The £50,000 was basically spent on my initial 'key money' for the lease of the building, and on refurbishments. They cost something like £30,000. My first show was an exhibition by John Currin [April 1997] which sold out, and since then we've thankfully been in the black.

JH Can you tell me a little bit about being in New York? How long were you there for?

SC Six months in 1996.

JH What was your experience of working there?

SC Well, I liked New York. It is a fantastic place. It's a place of enormous energy and, obviously, it is the business centre of the art world – just in terms of the scale of the art market there. But because New York is probably the most professional city in the world everything is about business and work. There's very little opportunity to truly relax because people want to be seen to be active and professional all the time and to be truly engaged with the pace of the city – so even on Sunday people arrange appointments for themselves at the gym, at brunch, at a museum, instead of feeling guilty lying around, sitting on the sofa, or

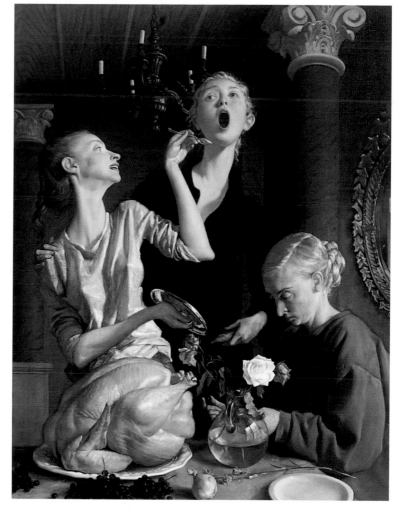

1 John Currin,
Thanksgiving (2003),
© the artist; courtesy Sadie
Coles HQ

going to a bar or the park or something. I got homesick for that British Sunday. In terms of the art world, because the market is enormously dominant there, there's less room – certainly since the early 1990s – for artist-led experimentation or 'left field' activity. New York is all about business and everyone tends to be more self-consciously social there than here. I think one of the great strengths of London is the sense of community among artists, dealers, and collectors. People *do* literally hang out with each other and that's a very special thing.

JH Is that sense of community or common purpose a 1990s development?

SC Well, I am only referring here to my generation. The sixties seem to have had a similar sense of community.

JH And were you immersed in that from an earlier moment?

SC Yes, from the late 1980s, I would say.

JH Could I ask you some questions about your background? What was your visual arts education?

SC I did an undergraduate degree in art history and film theory at Middlesex Polytechnic [now Middlesex University] between 1982–85.

JH Then did you do an MA?

SC No. I regret that I didn't, but I didn't. I needed to be earning money by that point. I went to work in management, for the Royal Opera House and then for the National Theatre. My degree at Middlesex offered very little on *contemporary* arts – and that was what interested me. So I worked for the National Theatre's press office and then after about nine months of doing that I wanted to kill all actors. Realising then that I wasn't really in a good position to get a job at a gallery or museum in London I applied for a job at the Arnolfini Gallery in Bristol.

JH How was that?

SC It was a good opportunity to learn fast. I was there for eighteen months and became assistant director. We did a show with Richard Long, a Bristol-based artist whose dealer was Anthony d'Offay. At that point I really didn't have much consciousness of the difference between the commercial and public art world and certainly not much experience of commercial galleries other than just visiting them. Anthony d'Offay came to the opening and asked me to come and see him for lunch the

next day in London. I was terrified in case I'd done something to offend him or upset the artist. Anyway, I walked into his office and he said: we want to offer you a job. I was so desperate to come home to London that I just took it without really thinking about the implications of moving from the public sector to a commercial gallery (a move that is supposed to be irreversible) and within two days of starting I was on a plane to New York with Anthony and visiting Jasper Johns, Jeff Koons, Carl Andre and their other American artists. It was incredibly exciting.

JH Can we backtrack for a moment? I'd like to ask you some questions about Middlesex which you may or may not think are relevant to your later career and your gallery. In the 1980s and early 1990s Middlesex was one of the centres of what was called the 'new art history' and they published a magazine called *Block*.[1] Were you aware of the magazine and the teaching of Marxist and feminist art history when you were there?

SC Yes, I was aware of the Marxist slant of the criticism but not of *Block*. Maybe that was just for the tutors or MAs, not us dumb undergraduates. My experience was that you had to really push to get outside of super-conventional stuff like reading [Ernst] Gombrich or the obvious stuff like John Berger and Susan Sontag! Also I was more interested in clubs, bands and hanging out with my mates, like all students. I wrote my final paper on Joseph Beuys and that was considered quite 'out there'. And I was frustrated because I wanted to know about contemporary art and artists.

JH Was your interest linked to feminism?

SC Yes, but mainly through the film theorists at Middlesex, like Claire Johnston, who were excellent and encouraged our reading of Peter Wollen, Andrea Dworkin, Laura Mulvey and others.

JH How big a factor has feminism been in terms of your involvement with the art world?

SC It has been important at a subconscious level. I mean, to be honest, when I first started working if you'd asked me I'd have stubbornly denied that it's different for women in that I felt empowered by feminism in some ways. But at 40 my view has changed and I know that it is different because basically there aren't as many top-ranking female artists and there aren't as many successful female dealers. The same is true in all kinds of business. There are more women on all the lower levels of arts management but it *is* different and harder for women. In the mid-eighties there was a sense of recognition that this was the case and women responded by saying 'I'm just going to make it'.

JH Did you know then about, for instance, the Guerilla Girls?

SC Yes, but that was mainly to do with my own reading and my own visits to the ICA [the Institute of Contemporary Arts, in London] and places like that.

JH But you don't think you deliberately tried to make questions around women or feminism part of how you established and ran the gallery? That is, you didn't and don't have a particular interest in women's art per se?

SC No. I don't make those kind of distinctions as they would end up being restrictions. However, I probably *do* respond to art that has quite a strong emotional core to it in some ways, but that doesn't mean it is defined as women's art or is made by women.

The artist–gallery relationship

JH Tell me about the artists you are currently representing.

SC I have a dynamic relationship with Sarah Lucas and I definitely responded to the feminism in her work.

JH You're probably friends with Sarah as well?

2 Installation view, Sarah Lucas, *Bunny Gets Snookered*, Sadie Coles HQ, London (May 1997), © the artist; courtesy Sadie Coles HQ

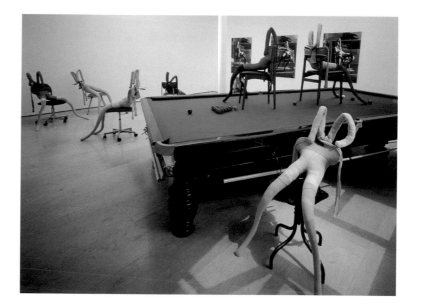

SC Yes.

JH I was wondering about that: whether some distinctions have to be made between 'artist' and 'dealer' professionally, and social relationships outside the gallery?

SC There are artists that I see more of, mainly because they're here in London. But I'm also close to my artists who live abroad, like John Currin, for instance. You just have to travel a lot to maintain those relationships. But it's like life: there are some people that you're more in touch with and other people less so. But for a dealer the relationship with your artists is intense and you do spend a lot of time with them. A lot of it is social time, when you can talk about ideas and the bigger picture. So the professional and social aspects get very muddled up.

JH Do you have any models, based on reading, of how dealers have related to artists in the past? There is a lot of literature now on dealer

and critic relationships with artists – like Clement Greenberg with Jackson Pollock or Michael Fried with Frank Stella. Do you think about, or 'theorise', how you deal, or should deal, with an artist?

SC I feel it's such an instinctive job that you just do it according to what works on an individual basis within the parameters of good business practice; I don't think the basic relationship has changed that much. And each dealer has their particular way of doing it.

JH Can we talk a bit more now then about how you actually *do* deal with particular artists? Looking at the gallery's website, it seems that you've always had shows of individual artists? No group shows.

SC I never ever do group shows.

JH (laughter) Why is that?

SC Well, I *do* take work to international art fairs which are like group shows. But basically I think group exhibitions are extremely hard to do well and I think you need a hell of a lot of time to do them. I'd rather leave them to museums who have the time and resources to do the proper research. I also think they're quite tough for artists because, unless somebody spends really a lot of time and energy on the concept of a group show, a group show can place the artists together inappropriately, particularly in a commercial context when it sometimes feels quite mercenary. For a group show to be a meaningful thesis that reveals something about the work takes a lot of clever thought and energy. I've done two for museums. I did one, before I opened my gallery, with Eva Meyer-Hermann at the Kunsthalle in Nuremberg, *Ein Stück vom Himmel – Some Kind of Heaven* in 1997. This then went to the South London Gallery and then I did another one for SLG called *Driveby – New Art from LA* in 1998. I liked doing them but the time involved is extensive, and the schedule of a commercial gallery is so brutal. We have a show every 4–5 weeks so I simply don't have the time to do group shows well and museums are better at it.

JH OK. How do you actually formally organise the professional relationships you have with individual artists? Is it the case that you have a number of artists 'on the books', as it were, with ongoing contracts?

SC I'll just give you the bare bones of it. There are no formal contracts with my artists. Some big galleries have signed agreements often related to a stipend, but with me, when I take somebody on, it's with the idea that we'll continue to work together over a long period – maybe ten or fifteen years.

JH As long as that? So you see it as a long-term commitment?

SC Most artists on my list have been with me since we opened and then I've just gradually added artists. In business terms you initially make an agreement about the commission percentage and establish consignment terms. With a more recently established gallery and with younger artists it tends to be a 50/50 split on sales of work. With older, more established artists there's some negotiation within that model, in favour of the artist: when artists have got to a certain price point or are taking care of their own production percentages can be renegotiated.

JH How do the younger artists react to the 50/50 split?

SC Well it is fairly standard so it doesn't feel like a total shock. From me the artists get 50% and obviously they have their costs. But in my 50% I have all my running costs, staff, insurance, start-up, building expenses, plus things like framing, photography and shipping and storage, and sometimes production and publishing, none of which we re-charge the artist for, except in special circumstances.

JH You pay for everything, basically?

SC Yes. Generally primary galleries run on, I reckon, about 20% profit if they're working well. So, I'm very conscious that 50% sounds like an enormous amount, but we also plough that money back into production costs and other things, especially if artists are, say, making large works for a museum show. We also put money into books – a first monograph, say, can help to promote an artist's work which will result in sales and establish a bigger market and may help us get the work into museums and good collections.

JH Would you say the business relationship works well?

SC It's really just one of trust in that you trust the artist to make good work and they trust you to be financially responsible and to work hard promoting them. If you get it wrong, for instance in terms of pricing work, it can be disastrous. If you overprice something then a sort of 'Chinese whisper' goes around the art world that something's too expensive and it can be very damaging. And if you underprice it can weaken its status.

JH Do you require exclusive control of your artists' work?

SC No. I encourage them to have relationships with other galleries. I prefer them not to have *too* many galleries because then there's not enough work to go around. It's quite important for an artist to have a gallery in New York, because often it helps their work to be taken seriously in the market. My ideal is that my artists would have me in London, somebody in New York, and somebody in Germany – probably in Berlin or Cologne, or elsewhere in Europe.

JH And that encourages sales generally, to have that profile around the world?

SC Yes. Because obviously galleries are exhibiting them, and talking about them, and whatever.

JH But you can't go too far, in case it's going to undermine the price?

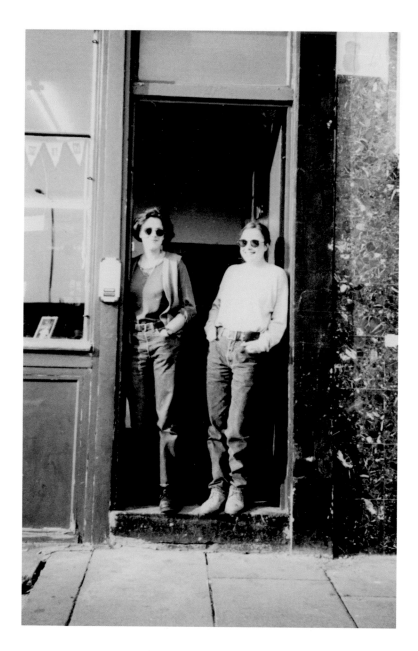

3 Tracey Emin and Sarah
Lucas outside The Shop
(1993), photograph ©
Pauline Daly

SC It does depend on what the artist is making. Each artist requires a different situation. Somebody like John Currin makes 10 paintings a year, if you're lucky. He's now with Gagosian in New York and with us in London. But other more prolific artists might have more galleries around the world – this is especially viable, say, for a photographer whose works are 'editioned', then obviously there's material enough for more galleries.

JH On the range of artists that you've dealt with and deal with now, obviously you met some of them in different ways. Sarah Lucas, how did you come across her originally?

SC I met her at a party and we just became friends.

JH In London?

SC Yes. She's an artist who likes to have a response to her work from quite an intimate circle of people. She had The Shop with Tracey Emin for six months in 1993, around the time I met her. I completely loved her work and wanted to try and do something with her. She wasn't represented by anybody then, and she didn't want to be represented by anybody. I persuaded Anthony d'Offay to let me do a programme of younger artists' work within the new space that he'd got underneath the old gallery, and Sarah was one of them. These shows were supposed to be projects without an idea of long-term representation. Sarah's exhibition there (1994) was one of the first of those projects and once I'd started doing the projects with artists I really liked I decided that this was what I wanted to do. I wanted to have my own gallery and work with people my own age really.

JH What about Carl Andre, how did you come across him?

SC Carl Andre was represented by Anthony d'Offay at that time until sometime after I left. When I opened my gallery he was one of the first people who rang me up and said 'if you are ever interested in showing

my work...' and I actually said 'no' because I wanted to work with younger artists and have a clean sheet so to speak. So Carl and I just stayed friends. Then two or three years ago I decided I *would* do an Andre show because his work remains so radical and his position is so important. Luckily for me he still wanted to work with me.

JH How old is he now? He must be around 60.

SC Yes he is. He did a first show with us here in 2001 and all the works were sold to younger people including to younger artists which was really good. We also did a show with the Andy Warhol Foundation of drawings from the 1950s. Again the works were mainly bought by people who've never bought Andy Warhol before but for whom he makes enormous sense in terms of his influence on the art being made now that is in their contemporary collections.

JH Dealing with the Andy Warhol Foundation in the United States is obviously very different from dealing with an artist.

SC It's very different as the Foundation curates the exhibition as opposed to the artist – but it's good because they have such extensive knowledge of his work and they help you achieve an exhibition that is great – for Warhol and for you.

JH So you wouldn't rule out showing any artist if you thought the work was worth showing?

SC No. I'm constantly thinking about new artists, old artists, forgotten artists.

JH Can you talk a little bit more about the support you give artists? You enter into a relationship with them which is not formal, but, nevertheless, you expect it to last for a long time during which you would split half-and-half the money made on selling the artworks. How do you continue the relationship over such a long period? You can't be

showing them *that* often. How do you go about maintaining the relationship?

SC Since we represent 28 artists they rotate and have an exhibition here about every two to three years. Outside of that there are all sorts of different activities that go on. For instance, just in terms of sales you continue to sell work between the artists' exhibitions, and you do that by various means. As Richard Prince told me, you can tell the dealer is working for you and thinking about you if there is a work hanging in their office or viewing rooms between shows. And museum shows obviously create activity. Also we go to three international art fairs every year.

On the global art market trail

JH Where do you go?

SC London, Basel and New York. Each time we take a different representation of our complete programme. In this way the gallery continues to generate sales for the artists, but it also advertises to people that you represent John Currin, for instance, so clients come back to you later. I also buy work, so if I have a client who wants to sell some of his collection, then I would buy back items, or buy work from auction, so that I constantly have material. The day-to-day relationship with an artist between the exhibitions is really important to maintain so that you have an on-going dialogue with them about what's going on in their studio. They want to feel that you're working for them so you need to be on the 'phone to artists and travel to see them, their gallery or museum shows. Artists are close to their dealers because they hopefully feel that, first of all, that person knows both their market and their work in depth and can give them quite sound advice or interpretation about how the new work relates to previous things they have made or give them ideas about how to generate new interest in their work. You've entered into this relationship with them which is a real partnership so that partnership has to be maintained – it's a bit like being married.

JH I was going to ask you whether there was ever jealousy within these more 'promiscuous' relationships?

SC Yes. You do have to be quite careful to make sure that everybody feels they get the attention they need, which is harder with such a geographical spread. Having said that, if you analyse it, in most established galleries there will be one or two relationships that are the key relationships – that early on defined the programme and the profile of that gallery. With me it's probably Sarah Lucas and John Currin who were my first two shows. John because my gallery is well-known for representing a fairly international selection of artists (I didn't want to be seen as just being a British gallery) and Sarah, I suppose, defines in a way my manifesto and way of working. Other artists are conscious of these special relationships. I would say that all of my artists would probably be aware that I spend a lot of time with Sarah. But part of the reason why they like the gallery is that they like Sarah's work. Artists will often join a gallery because of the context their work will be shown in.

JH Do your artists mix together very much?

SC Yes to a greater or lesser degree, especially the English ones.

JH Is it hard to avoid some form of hierarchy, given that some are going to be more successful than others? Do you, in effect, subsidise some artists?

SC Yes, although that is never a static hierarchy. When you're planning your programme you will very consciously work out a balance so that some elements are going to support others.

JH Do you have a medium- or long-term idea of planning for what you want to do?

SC Yes. I have a programme now eighteen months in advance, but there will be one or two changes and last-minute changes because an artist may have a problem completing the work on time or might want to throw something new in at the last minute, so you have to be fairly flexible. You also have a long-term idea of how you want the gallery to grow and you are always tweaking that.

JH And has it ever happened, or if it did happen, that one of your artists work just stopped selling, what would you do?

SC Work harder!

JH If you'd supported them for a long time, would you drop them, say, after fifteen years?

SC Well I've only been going seven years so I can't really say at this point. Artists *do* get dropped by galleries, but often it's for other-than-business reasons.

JH Drop themselves maybe?

SC It's often to do with personality issues, like you are just not right for each other, you know, so it's an open door and it swings both ways.

JH Are there gender issues relevant to these personal dynamics?

SC Yes, as there are in all relationships, along with other issues.

JH You talked about the relationship being like a marriage. It's kind of polygamy, then, isn't it, with a matriarch in charge! I can imagine that's quite interesting!

SC Coming back to the longevity of the relationship, there can be a point at which you've sold to every single client who's going to want that particular artist and they're not necessarily going to buy a second

and third work. So you need to find strategies to 'reposition' somebody. Museum shows are a good tactic, and a development in the work can be another one.

JH I want to come to your relations with museums later, but can we consider this question of publishing and propagating artists' work. Do you think there is an educational function to the gallery? In any sense at all?

SC Yes. You are promoting new work by artists, exhibiting and publishing it, often introducing something new to your audience, and often finding new audiences.

JH Publicly financed museums, for instance, are required now to have social and educational aims and objectives.

SC Well realistically I am not in the museum business. But in addition to the gallery activities I do quite a lot of talks for students and we send out free catalogues (if we have them) and packages to students who ask us about our artists.

JH Do you employ art students as well?

SC Yes, we do sometimes employ 'interns' who do casual work.

JH But you don't mean an 'internee programme' for training art students to develop certain skills in relation to gallery management?

SC No, as my gallery is still quite small and couldn't really support an education department. I would leave that to institutions but I do look to employ people from MA arts management courses.

JH Do you pay them? If you don't mind me asking!

SC Yes. It's a smallish gallery with a relatively slow staff turnover. If we get a lot bigger I would definitely have an internship programme but, generally speaking, we just employ people. People send me their CVs and if they've done an art history course or had some gallery experience, then we'd probably see them.

JH Can we talk a little bit about your gallery's link with Tel Aviv? Are you planning a show there?

SC That was part of an international 'exhibition exchange' programme. We've done six or seven now. Originally, I think I simply had a gap in my programme. So I decided to do an exchange with Contemporary Fine Arts in Berlin – we swapped galleries and apartments. It helped me get my artists to a different place and also to see how things work elsewhere and we've now been to Los Angeles, Istanbul, Tel Aviv, Madrid and Athens.

JH Just on the Tel Aviv exchange – how did that come about? Do you have friends who work in the visual arts there?

SC There's a commercial gallery there, one of the few truly international ones, called Sommer Contemporary Art and they show people like Wilhelm Sasnal, Ugo Rondinone and Rineke Dijkstra alongside their Israeli artists. The director is very keen to forge links with other dealers because there's so little business there at the moment and to get her Israeli artists out into the world.

JH What did you make of Tel Aviv and Israel?

SC I did a lot of talking and had quite a lot of meetings with museum people there. I did find it a bit bleak.

JH No doubt you're aware that most of the artists are fairly left-wing or liberal over there and want some kind of just peace settlement with the Palestinians. Does the political situation in Israel enter into the exchange in any way?

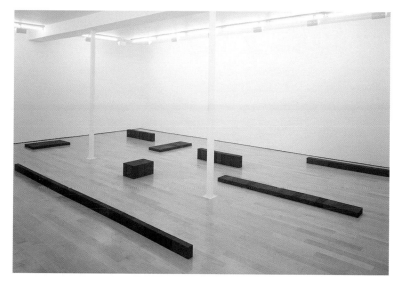

4 Installation view, Carl
Andre, *BLACK WHITE
CARBON TIN*, Sadie Coles
HQ, London (February
2004), © the artist;
courtesy Sadie Coles HQ

SC Several people – really surprising people – said to me 'you can't,
you shouldn't go', people on both sides, in some ways.

JH There has been an attempted academic boycott of Israel, of all
kinds of contact between academics.

SC I'm absolutely against that because I think cultural exchange is one
thing that you shouldn't interrupt. You've got to just keep talking. I don't
think, to be honest, I would have had such an accurate picture of what
life's really like there without going. It's the same whether you are an art
dealer or something else.

JH You're right. When you go to Israel – to anywhere outside Europe or
North America I think – you get an image of what the West is like, don't
you? Their sense of it isn't what it's like living within the arts culture of
London or New York, or wherever in the West.

SC I think they feel enormously patronised.

JH They're effectively colonised culturally, aren't they, by Western
European and American notions of avant-gardism.

SC In a way you can be more subversive in that non-Western situation. I think that New York, being market-dominated, has no place left really for subversion, except around gender perhaps.

JH Can we move on now to the question of this amorphous thing called the contemporary 'art world', or art since about 1970? Like me, you're probably too young to remember the 1960s in terms of art, yet that's often represented as a really pinnacle moment, isn't it? 'Late modernism'?

SC I do remember things like feminist art – Judy Chicago and all those sort of people in the 1970s.

JH Since about 1980, around that time when you went to Middlesex, you've had consistent involvement with, and knowledge of, the art world and the art market, particularly in London. How would you describe the changes that have gone on in that period? What is your sense of how it's developed, or shifted, since, say, the beginnings of 'Thatcherism'?

SC Until the early 1980s there was a very stodgy local feeling about everything, so you would get shows on Cork Street very much dominated by English artists. It felt very English and even the 'new British sculptors' thing (Tony Cragg, Bill Woodrow and Anish Kapoor) didn't feel that radical to me. I think it is just a generational thing. To be honest I had no real interest in it because it seemed quite academic and almost directly related to the influence and legacy of Anthony Caro. But I think that one of the biggest things that happened was Charles Saatchi opening his gallery in Boundary Road, North London in 1986 which meant that art students in London, and the regions, started to see new things from Charlie Ray to Jeff Koons, Julian Schnabel to Cy Twombly.

JH This led to an internationalisation of the London art world?

SC That was a contributing factor certainly. I think that seeing that work, whether those students were reacting against it or reacting positively towards it, was just enormously influential. It led to a kind of Thatcherite, do-it-yourself, opening-up of art here.

JH Entrepreneurial?

SC Yes, entrepreneurial.

JH The positive sides to entrepreneurialism?

SC Basically everybody wanted to get into it. But it wasn't the established Cork Street galleries they wanted to get into, it was New York – international, you know, the world. And the way to do it was to actually 'do it yourself', rent a store-front as Sarah and Tracey did, and just do your own shows.

JH Did you go to the Boundary Road gallery as soon as it opened? Was it something you knew about right from the start?

SC I think so yes, you know, it was exciting.

JH Was there a perception at the time of the relationship between Saatchi's advertising business and the kind of art he would show at the Boundary Road gallery? Was that something that perhaps seemed anachronistic at the time?

SC Not really no. It was in the papers that this was what this man did to make his money but I think the first things he showed were so sort of aesthetically 'hardcore'.

JH Stripped-bare minimal stuff?

SC Yes. The show that was probably most influential on my generation, or the 'Goldsmiths generation', was *New York Art Now* – parts 1 and 2,

showing Ashley Bickerton, Ross Bleckner, Robert Gober, Peter Halley, Jeff Koons, Tim Rollins & K.O.S., Haim Steinbach, Philip Taaffe, Meyer Vaisman, Carroll Dunham, Tishan Hsu, Jon Kessler, Alan McCollum, Peter Schuyff, Doug & Mike Starn. And then there were the 'minimalist' shows in 1995–96, featuring Donald Judd, Brice Marden, Cy Twombly, Andy Warhol, Carl Andre.

JH What about art criticism at the time?

SC Stuart Morgan's criticism in *Artscribe* and *Frieze* magazine was important.

JH Did you sense, then, a changing critical culture?

SC Yes definitely.

JH How was it changing?

SC There was a feeling of 'well we're going to have our own critics, and our own audience, and our own magazines'.

JH So a major shift was taking place in the middle of the 1980s in terms of galleries, criticism, and politics, of course, was in some sort of turmoil as well. What about the dealing side of the art market?

SC Well, at that time, there wasn't so much business here. You know, the development of the market here in London has been quite unbelievable because essentially there were few contemporary clients – there were probably three or four people at the very most, like Charles Saatchi obviously, who then started collecting locally. There were very few collectors and very few galleries to represent the younger artists. That started to grow and most of the galleries showing international art realised very quickly that they couldn't rely on the market here so they had to bring the market to London.

JH The two terms 'YBA' and then 'Brit Art'. How important are those ideas to the history of what you've been involved with, would you say? Was the 'YBA' thing an important part? In the sense of the changing culture that you've been involved with? From about, say, 1987–88?

SC It's undeniable that there was a particularly strong group of artists that all emerged at that moment so to deny the 'YBA' phenomena is not really appropriate, despite the fact that most of the artists hate the generalisation that term imposes on them. At the same time it's not terribly accurate because it's a blanket term for something that was much more diverse and much more international. Having said that it was a useful marketing tool to get the generation out there internationally and there were several key shows, like *Brilliant! New Art from London* at the Walker Art Center in Minneapolis in 1995, or the show at the Barbara Gladstone Gallery, curated by Clarissa Dalrymple in 1992, featuring Lea Andrews, Keith Coventry, Anya Gallaccio, Damien Hirst, Gary Hume, Abigail Lane, Sarah Lucas, Steven Pippin, Marc Quinn, Marcus Taylor and Rachel Whiteread, that really launched the artists in the USA. Basically the 'YBA' tag just gave people a subject for their articles.

JH So it was a marketing term?

SC Yes. And they're all 40 or so now!

JH Did you know the 'YBA's?

SC Yes.

JH And they were a 'group', were they?

SC Some of them were part of a group. The majority of them were students at Goldsmiths College, so Gary Hume, Sarah Lucas, Angus Fairhurst, Damien Hirst, Angela Bullock, Liam Gillick, Anya Gallaccio, Michael Landy and Gillian Wearing were all at Goldsmiths around the

same time. That created an extraordinary kind of competition and collective energy that just made something really good happen. They encouraged each other. The biggest example of that would be the Freeze show in 1988, curated by Carl Freedman and Damien Hirst. There were also artists who were important who were not at Goldsmiths – Jake and Dinos Chapman were at the Royal College, so was Tracey Emin and Sam Taylor-Wood, Rachel Whiteread was at the Slade. There were lots of players who were at other colleges but who have since been lumped in together and there are other people who were in those groups who've now faded away a little bit.

JH It was around this time [mid-1990s] also, it's been argued, or claimed rhetorically at least, that London became the centre of the art world, that things shifted away from New York.

SC I would say that New York at certain moments in the 1990s was eclipsed by London in terms of new and exciting artists. Matthew Barney was an exception of course as were many other US artists. There are many New York-based artists who have emerged since then but there *was* a certain stodginess to it and it was partly to do with the dominance of the market and the auction houses. In the very early 1990s galleries had taken a big hit when the art market dipped. By the mid-1990s they were still recovering from the dip and they didn't really want to take risks, so there was a lot of caution. Basically New York got a bit boring and the art world just shuffled over here to look at what was going on. It was a lot of factors all coming together at the same time.

JH Well, what about other places in the world apart from New York and London? You talk about going to shows and you know the fairs in Germany. Is there an art world culture in, say, Berlin?

SC Yes definitely.

JH Have you got a status as important there as in London?

SC No, not yet. London is a newish market, I mean it's a new and
growing thing, it's organically getting bigger and bigger, but New York is
still far ahead of us in terms of scale and finance and collectors. London
is very significant now because there is a sense that you can trade here
internationally incredibly effectively, and the problem with, say, Berlin
is that you can't really because it isn't a city that gets a lot of 'walk-
through' traffic all the time and London is. Berlin has very consciously
decided that it wants to be the new German centre for contemporary
art, and this is centred around a core of about five or six excellent
galleries. It wants to be a new place for young emerging art, which it is.
It has managed to attract and develop a very strong community with
really good galleries and lots of artists, particularly German artists
moving there because it's cheap. It does have all the ingredients for it to
happen but the problem is that you don't have many collectors – though
London, compared with New York, doesn't *either* – but Berlin doesn't
have the same capacity for international trade. But the market there will
develop rapidly in response to the galleries, museums and artists, so it
could look very different in ten years.

Modernism to postmodernism

JH I wanted to ask you about the links between 'economy' and 'culture'
and their relations to accounts of 'modernism' and 'postmodernism'.
What is your sense of how these terms became relevant or irrelevant in
the 1980s and 1990s? Between 'postmodernism' as a culture or as a set
of artists or styles, and 'postmodernity' as a new organisation of global
capitalism, considering we were talking about New York still being this
incredibly important financial centre. Do you have a sense, for instance,
that artists 'belong' to cities still in the way that, within Modernism, the
Impressionists were supposed to 'belong' to Paris, and after World War
II, the Abstract Expressionists to New York?

SC No I don't think so. I think this has changed enormously. I think
that a lot of artists now feel that they can go and live and work in Berlin
for a year or Mexico City or wherever.

JH The art is no longer conditioned by the artist living in a certain geographical and cultural place any more, that somehow the artist becomes him- or herself internationalised in some basic sense?

SC Yes. Though it does depend on the artist. A painter like Wilhelm Sasnal who's a Polish artist, although he's very aware of trends in art and very intuitively interested in what's going on worldwide, he definitely is making work that relates to a Polish sensibility and his response to Western art history, politics and pop culture. Everybody comes from a place and it informs them and their work, but some work has an intentionally international feel about it, say like the work of Liam Gillick for instance.

JH How does the issue of identity relate to the use of materials or medium? Do you think the fact that a lot of artists now don't work with traditional media mean that, in a way, the work cannot be located in a traditional historical way?

SC Well. Some do and some don't. It depends on the individual artist really.

JH How important to you is the question of materials and media when you work with artists?

SC Not important at all. It's just to do with how *good* the work is.

JH OK. On the relation between these two terms – 'modernism' and 'postmodernism' – do you think that the latter still has any value or use now?

SC No, not really.

JH It appears to have dropped out of critical discourse.

SC Yes. But you might be better off asking someone who is a critic as opposed to a consumer

JH Do you have any idea why that might be?

SC Well, like 'YBA', I think the terms became tired and somehow historicised.

JH OK. Do you think there is any useful way in which you could categorise or identify what main trend or trends – if there are any – exist in contemporary artistic production?

SC I think it's much harder to do that now because there's so much going on. The whole thing has gotten so much bigger – there are more artists, there are more collectors, there are more galleries. In a way it's harder to see clear trends because anything goes. For instance, you could say 'figurative' art or 'narrative figuration' is making a comeback. There is currently a wave of painters who are doing that but in diverse geographical locations with no obvious link. Then there is also quite a strong group committed to installation, and a whole trend in site-specific 'biennial'-type art, if you know what I mean.

JH Presumably, one of the reasons why the term 'postmodernism' remained useful for as long as it did was because it implied something valuable about the relationship, the connections, between contemporary art and art before 1970. Do you think that most of the artists you deal with do or do not see art before 1970 as particularly relevant to their concerns?

SC Again, it completely depends on the artist. Some artists make art that reacts to what went before in a highly informed and conscious way. Others are more interested in what contemporaries are making.

JH You have such a diversity of artists. Would you say that the younger ones, however, who were trained in the 1980s, seem to have an 'art-

historical' notion of art? Because they've all been through university or art college education. Would you say that's a change in the way younger artists think about their relationship to past art – through the way that they encountered it in colleges?

SC For the most part I think they decided 'fuck it'. That's a reaction against their education in some ways. I think it's a 'reaction against' and goes back to what I was saying about why Saatchi was so important – because, basically, these artists decided to look at something else.

JH So the visual culture and the graphics of advertising became more important than references to art in art history?

SC No, they were looking at the work in his museum, not at his advertisements. But I think for that particular generation – the 'Goldsmiths generation' – one thing you can say about them is that there's a certain direct 'readability' to their work.

5 Installation view, John Currin, Sadie Coles HQ, London (September 2003), © the artist; courtesy Sadie Coles HQ

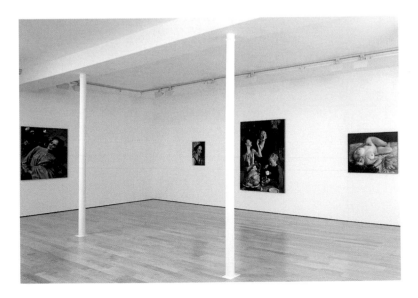

JH The relationship to 1960s Pop was obviously quite important in some ways, for Saatchi as well, wasn't it? On the political side, there's a way in which 'YBA' and 'Brit Art' still got represented in the media as 'avant-garde' and somehow 'dissident'. Would you say that was true, knowing the artists, and having looked at the work over a long period of time? Would you say that there was any kind of implicit or explicit political or ideological message in it?

SC Not in very many cases, no. Sarah Lucas has a very strong feminist element to her work but I think very few of them are politically motivated, although there is a sense of rebellion against a conservative authority that you can read in the work of Jake and Dinos Chapman or Damien Hirst.

JH Is that then, in some ways, a reaction against 1970s feminist and 'agit-prop' art?

SC No. It was a reaction against a local political situation – Thatcherism. In the late 1980s in New York there was all that work made around Aids and gender politics – like the Guerilla Girls and others who were making overtly political work. That didn't happen here, or at least not in the same way.

JH OK. Can I ask you some questions now about your gallery's relationship to other organisations? These do relate to changes in the art world. What kind of relations do you have, for instance, with the media – in terms of journals, newspapers, TV and the internet?

SC Well, it's a similar relationship that museums have really. You set up interviews, you encourage reviews, and you want your artists to get the right kind of publicity. I'm quite conscious of making sure that they don't do the wrong kind of publicity, because I think, particularly in this country, there's a lot of crap that passes for art coverage and I don't really like the 'cult of personality' stuff that so many newspapers and magazines here like to pursue. It doesn't suit my particular artists. In

terms of other media the internet has really revolutionised the business When email first started practically all art dealers didn't believe that art would be sold through email, because the purchaser would need to see the unique object, but that's what has happened. We all forgot that the purchaser could make an informed judgement based on knowledge of the artist's work and the provenance and reputation of the seller. It has speeded up the business so much – that's partly why the market's got bigger and bigger and bigger.

JH And internationalised it too.

SC It's incredible.

JH I thought your gallery's website, however, is 'toned down' – not a high-profile showcase at all. Hardly any illustrations of work at all, for example.

SC No, it is very restrained. The reason for that is because, although I *could* have works for sale on the website and it *could* be much more of a market place, I'd rather people called me up so that I can start a dialogue, to establish the level of their interest and that is what it is supposed to encourage. One of the things all primary dealers worry about is how to place the work of their artists responsibly to ensure growth.

JH Tell me about your gallery's relations to Tate Modern and the Saatchi Gallery. How does the relationship work? Obviously it's designed to be of mutual benefit isn't it? Presumably you sell work to Tate Modern?

SC Yes.

JH And so you must have on-going relations with them all the time?

SC Yes, talking to them about my artists and helping them with the shows that they might be doing with my artists or drawing their attention to exhibitions or new books, finding collectors to donate works and so on.

JH What big changes did Tate Modern's inception bring about, do you think?

SC The big change was, *is*, basically the interest of the public in contemporary art. Tate likes to tell everybody that Tate Modern is the reason that there's more interest in contemporary art but actually Tate Modern is a *result* of more interest in contemporary art! But now it is open, Tate Modern continues to encourage more and more interest and it's given the British art world real international significance and focus. It's yet to have, however, a really important contemporary programme. Tate Modern does fantastic twentieth-century art shows but it's yet to really deal with younger contemporary art, although I believe that is coming. Most of that (for British artists) goes on at Tate Britain.

JH Do you think it ever will?

SC Maybe there actually needs to be 'Tate Contemporary'!

JH What about links with galleries in the United States? Do you have links with the 'modern' and 'contemporary' museums around the US?

SC Yes. In a similar way to Tate. There are so many active institutions in America that, in comparison, we're really seriously underfunded.

JH What about links to the Museum of Modern Art (MOMA) in New York?

SC We sell to them and their curators come by here when they're in London. Many of their Patrons buy from us.

JH MOMA is a private museum in New York. Do you have a sense of the difference between dealing with state and private organisations?

SC Yes, it's completely different.

JH What's the difference?

SC Well, the American private museum is dominated by 'the Patrons' and the 'Board members' who buy art for the institution. So as a dealer you will have equal relationships with both the curators of an American institution and with the collectors who donate to them. I know many of the Board members of the Museum of Contemporary Art in Los Angeles for instance. Many of them buy from me and some of the things they buy will get 'gifted' to the museum. Here it's completely different, there's not the same situation. If the government changed the 'tax gift' rules then it would make an enormous difference, meaning that British collectors could buy something for the Tate and receive a tax break. But that hasn't happened here and therefore there isn't collector support for state-funded galleries in the same way as in the US.

JH What about the new Saatchi Gallery in London here on the Thames, up from Tate Modern? Is that more like a private American gallery?

SC Yes. I mean it's more like a business.

JH Yes, it is in enormous contrast with the Tate, isn't it, in terms of layout and how people behave. Do you think it's a good development for Saatchi?

SC I think it's got its place and, because it's one man's vision, its 'authorship' is very clear, which I think is good. It reflects Charles's particular interest of the moment.

JH Damien Hirst has wanted to buy all his work back from Saatchi to get it out of his gallery, hasn't he?

SC You should ask him that.

JH He was really angry about the whole museum, wasn't he? The idea of it being a kind of 'museum' even though it's called a 'gallery'. I suppose Hirst saw it as 'historicising' his work: putting it in the past in some way.

SC Yes perhaps, and of course the author of that history is Charles. Maybe some of the artists feel that they're being 'taken over' by it which I think is all well and good, but to be honest I think Charles has every right to make his point about his version of what happened, other people can make other statements.

JH When I first went I was very impressed. I didn't want to be in some ways, but I was when I first saw it. The work looks good in the spaces in that building. Particularly the main chamber room.

SC And of course we're all slightly uncomfortable with the overtly aggressive commercial way it's presented because what we've assumed since the 1970s is that museums should be quiet, white, discreet and you know, money's never mentioned.

JH What about international 'biennales' and 'art fairs' – aren't they really simply vehicles for the art market?

SC Art fairs are completely commercial trade fairs. Biennales have a commercial side, in that they are part of the 'event-led' art market. But they both perform another function in that they underpin the economy of the city that holds them, create a buzz for the local market and have an educational element. They present a lot of artists to a lot of people, not all of whom are buyers.

JH So you think they're good things basically?

SC Yes.

JH In relation to government policy – because you're a private organisation you don't really have anything to do with this in museums now, at Tate Modern, and institutions like universities, policies on 'access' and 'social inclusion' have come, in a way, to dominate the way these places now are run. Do these social policies underpinning public gallery funding have any influence at all on how you think about what you're doing?

SC Yeah I think it impacts on me a bit.

JH How?

SC Well, I'm conscious of it. I don't programme my exhibitions to fit into it but obviously I respond to how the museums are doing.

JH What about European Union commercial and social laws and regulations? Does the legal structure of the EU have an impact on your organisation?

SC Definitely. The tax implications of import and export of artworks. Also the Euro currency has had an enormous effect on business. It's brought more European clients to London. And legislation related to secondary market, the *droite de suite* issue, is of great interest to me and my colleagues.

JH OK. On another issue: Do you think the arts colleges are getting it right now or not, in terms of how they educate their students? Presumably the system in England *has* got better – Goldsmiths being an example of that? Students are being taught more about the business side to art?

SC I don't really know if it has got better, although I hope it has. There is a downside to being too conscious of the business side, in that sometimes people make the mistake of thinking *too much* about the market and so they have a 'career plan' and they forget about the work

in some ways. They're just making work that fits their idea of what the market wants and you definitely see that kind of self-consciousness at some art school exhibitions.

JH When you visit degree shows what do you think of the general quality of work?

SC It differs enormously so I can't really say. One year it can be really great and another year...

JH Do there appear to be any trends or patterns that you can map over the years or anything like that?

SC Not really no.

JH That's both in London and outside London?

SC This is going to sound really awful but I sometimes think that, because of government policy that rewards colleges for accepting foreign students, the art schools have so many foreign high-fee-paying students that it erodes the sense of kind of cohesive community that used to exist.

JH It's an indication of what interests dominate higher education now, isn't it? What about the relationship between what you do and outside London? You deal with New York and Berlin and places, but do you have any interest or sense of how you connect to outside London in England or in Britain?

SC Well, I do talks in regional colleges and I certainly visit other cities, like Edinburgh, Glasgow, Dundee, Liverpool, Birmingham, Oxford, Cambridge, Manchester and so on, usually in response to museum activity, with the exception of Glasgow which has an incredibly vibrant scene around the Modern Institute. I go where there's significant activity really.

JH There are still very few commercial galleries anywhere outside London aren't there?

SC Yes. Most of the business is here. Somebody said to me that they thought it would be a really brilliant idea to open a gallery in Manchester which has good art schools and universities and a museum plus a lot of money and people with money. But I think it would be an uphill struggle to try to trade from there.

JH Do you think Britain in that sense is the same as other European countries? The US is completely different, isn't it, because there's the West coast and the East coast metropolitan centres and you've got other places now as well. Do you think Britain in particular has got a problem about 'centre' and 'periphery', or metropolis and region? The resources are too stacked in London?

SC Yes.

JH In relation to Germany even?

SC Yes, definitely. Most medium-sized German cities have important contemporary museums as well as temporary exhibition spaces, their own cache of local collectors and in response a good art gallery or two. But if I were a young artist graduating from Manchester, the first thing I'd do is get on the train.

Notes

1 See *The Block Reader in Visual Culture*
(London and New York: Routledge, 1996)
and Jonathan Harris, *The New Art History:
A Critical Introduction* (London and New
York: Routledge, 2001).

5

Public Art and Collective Amnesia

PAUL USHERWOOD

'Everybody needs his memories. They keep the wolf of insignificance from the door.' Saul Bellow, *Mr Sammler's Planet*[1]

Why is recent public art so often so timid and unambitious, so concerned not to offend those who happen to live nearby? The answer, as the critic Patricia Phillips realised long ago, is that such art is not, as is customarily supposed, the civic art of the past in modern guise.[2] It is an entirely new field or specialism that differs from previous public art in not having any clear definitions, constructive theory or coherent objectives beyond that of 'making people feel good about themselves and where they live' – beyond that of embellishing the environment, or entertaining the citizens of our cities in accordance with the needs of commerce.[3] Nor should it necessarily be called 'public' for in truth, as Phillips explained, its 'publicness' all too often consists not in 'the nature of its engagement with the cacophanous intersections of personal interests, collective values, social issues, political events and wider cultural patterns that mark out our civic life', but simply in the fact that it is located outside the confines of the conventional gallery.[4]

One might, then, have thought that Phillips's points would have put paid to public art. Yet clearly they have not. On the contrary, the juggernaut rolls on, and nowhere more so than in those former docklands and industrial areas where urban renewal programmes set

up in the 1980s have had effect. In particular, the conurbations of the North-East of England have seen an extraordinary proliferation of such work in the last ten years with no fewer than 180 new sculptures erected. Indeed the North-East can now claim to possess the greatest concentration of recent public art in Britain and as such offers a useful case study.[5]

The North-East is rich in recent public art for various reasons. In the first place, early in the 1980s Northern Arts, one of the best-funded and most energetic regional arts boards, decided to capitalise on the popular and critical success of the sculpture-in-the-open-air scheme at Grizedale Forest in the Lake District that it had helped to initiate in 1977. Secondly, at about the same time, Gateshead Council resolved to make new public art its special enthusiasm: partly, it has to be said, because at the time it had little to boast of in the way of gallery-based art. And this had a knock-on effect. The acclaim Gateshead received for, in particular, erecting Antony Gormley's *Angel of the North* (1998), a major 'landmark sculpture' (funded largely, as all such works tended to be, by the newly established National Lottery), gradually led to almost every other local authority in the region commissioning new work themselves.[6]

A further factor was the impact of Tyne and Wear Development Corporation, a quango set up in 1987 by the then Conservative government to 'kick-start' the areas where shipbuilding had formerly flourished. During the eleven years of its existence TWDC spent £2.5 million of its own money and £3.5 million of the Lottery's on various public art projects in the 48-kilometre stretch of derelict riverside under its control. These were huge sums if one bears in mind that Gormley's famous *Angel* cost little more than £800,000 overall.

As one would expect, all this activity has been celebrated locally as a great success. There has even been talk of public art being the driving force of the North-East economy.[7] But is the art itself any good? This is something that few, it seems, care to ask, perhaps because the answer is so obviously no. Most of what has been installed is every bit as ill-advised and unnecessary as the new public art in America that Phillips had in her sights when she wrote her withering article in 1988. In particular, far from giving passers-by a sense of identity as is often

claimed, much of it is actually helping to rob them of any sense of what they were in the past and thus might be in the present or in the future.

Now of course it might be argued that we should not expect new public art to engage with the past. After all, as Rosalind Krauss has argued, part of what makes modern sculpture modern is exactly that it eschews the commemorative role that sculpture generally once possessed.[8] Works like Rodin's *Balzac* (1897) and Brancusi's *Cock* (1924), she says, take the viewer across 'the logic of the monument into the space of what might be called a monument's negative condition, into a kind of sitelessness, of homelessness, an absolute loss of place'.[9] However, it is important to note that Krauss is talking here about canonical works; she is not referring to the general run of humdrum and little remarked upon objects that we come across in our streets and squares. And the fact is that with such works the logic of the monument still prevails; that is to say, they continue to speak in a symbolical tongue about the meaning or use of the sites they occupy.

Monumental history

Yet in saying that recent commemorative public art is robbing people of their sense of history it is important to make clear that I am not referring to all recent public art. It may be helpful therefore to think of such art in the terms provided in *The Use and Abuse of History* (1874), Friedrich Nietzsche's searing criticism of contemporary German historiography, in which he distinguishes between various kinds of history writing. Essentially, he says, there are three ways of contemplating the past: the monumental, the critical and the antiquarian.[10]

It is not hard to find public art that functions like the first of these, the monumental, the kind of history that in Nietzsche's words inspires us to great thoughts and great deeds, that proclaims that 'a great thing existed and was possible, and so may be possible again'.[11] One such, for instance, is Thomas Eyre Macklin's South African War Memorial (1908, Fig. 1) in the centre of Newcastle, a florid but otherwise not untypical, early twentieth-century war memorial, consisting of an obelisk with a twice life-size, semi-nude figure personifying Northumberland climbing

1 Thomas Eyre Macklin, *South African War Memorial* (1908), photograph by the author

up the steps at the base and Nike, the winged goddess of victory, standing on top. This is a representation of the county being honoured for the way she (sic) has willingly given up her sons in the nation's cause and as such is clearly intended, in the words of the Lord Mayor of Newcastle at the inauguration ceremony, as 'an incentive to all to put their country's claims as one of the first objects of their lives'.[12] For sure, one can imagine modern viewers having reservations about the selective, even triumphalist gloss that it puts on the messy and controversial events in South Africa to which it refers. And indeed it is worth noting that on one occasion in the 1970s a number of leftwing members of Newcastle's Labour-controlled council made an unsuccessful bid to have a small bronze version of the Roman symbol of the fasces on the side of the obelisk removed. However, that episode aside, there is no record of anyone in recent times taking exception to it or, for that matter, taking the names of the dead that it displays as some kind of cue to embark on a debate about the purpose and conduct of the war it commemorates, as, say, is the case with Maya Lin's Vietnam Veterans' Memorial in Washington (1982, Fig. 2).[13] Perhaps not surprisingly: after all Macklin's memorial is very different from the Lin

2 Maya Lin, *Vietnam Veterans' Monument* (1982)

in various ways. Not only are the names of the dead arranged by rank rather than by the date on which each man fell, but also the symbolism of the obelisk form and of the two allegorical figures gives little scope for any kind of oppositional reading.

Is it relevant here that the Macklin memorial is nearly a hundred years old? I don't think so. For it is not hard to find examples in the region of recent commemorative public art that deserves to be called 'monumental'. For instance, there is Susanna Robinson's *Wor Jackie* (1991, Fig. 3), a life-size statue of Jackie Milburn, a famous Newcastle United and England football player of the 1950s standing beside a newly constructed dual carriageway in the centre of Newcastle. Although modelled in a stylised and relatively modern (that is to say, post-Rodin) manner and based, as regards the pose of the figure, on modern newspaper photographs, this work is clearly monumental, the reason being that, like the Macklin, it is clearly intended to honour, and perhaps even make us think of emulating, the person commemorated. Also, it does what Krauss says sculpture-as-monument always does: namely, celebrates the place in which it stands and the people and values connected with that place.

Which brings me to the most famous public artwork in the region, Antony Gormley's *Angel of the North* (1998, Fig. 4). This also qualifies as

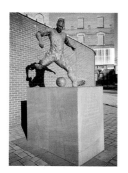

3 Susanna Robinson,
Wor Jackie (1991),
photograph by the author

4 Antony Gormley, *The Angel of the North* (1998),
photograph by the author

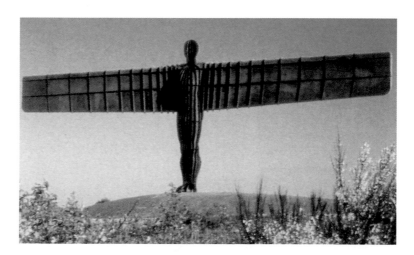

a monument. But, it should be noted, that was not always the case.[14] For initially, in 1990, when it was commissioned, it was talked about in the same terms as the artist's famous 'body-case' pieces for a gallery setting: as a personal rumination on the human condition and what it means to be locked in a human body and yet aspire to realms beyond one's reach. But that was not what Gateshead's Art in Public Places Panel had in mind when they commissioned it; they wanted something that would look suitably impressive on a site they had earmarked beside the main motorway into the town. So it changed. To be precise, the figure's body thickened up and the wings grew more Spitfire-ish. And as that happened new meanings emerged. No longer, in the artist's words, 'an image of a being that might be more at home in the air, brought down to the earth... of somebody who is fatally handicapped, who cannot pass through any door and is desperately burdened', it now became, as the new title it was given suggests (a title, incidentally, coined by the Art in Public Places Panel rather than by Gormley himself), something heavenly: although whether 'heavenly' in a Christian or a mythological sense has never been quite clear. And this in turn meant that it began to embody the hopes and history of a never-quite-defined place known as 'the North'. That is to say, people now looked at the vertical ribs strengthening the figure and the wings and the 'weathering' corten steel used in the fabrication and saw these as referring to the great shipbuilding and coalmining traditions of the area, conveniently forgetting as they did that the work had actually been fabricated in Hartlepool forty miles away and all traces of the derelict mine on which it is sited had been carefully removed before it was installed.

Eventually, soon after the Angel was erected, even the artist himself began to talk of it as a monument as well. In an essay significantly entitled, 'Of coal and iron and ships and planes', he referred to it as 'a dark angel': dark, he explained,

> not because it is evil, but because it comes out of the closed body of the earth. It is made of iron, a concentrated earth material that carries the colour of blood. It is a carrier of the new nature: a body extended by technology, yet actually and metaphorically rooted in the earth and the compressed geology of shale and carbon that lies there.[15]

In effect, then, it was now an engagement with the past that, in Nietzsche's terms, met people's need for 'examples, teachers and comforters'.[16] It was suggestive not just of the natural forces that produced the material from which it was made but also of the hardship, skill and pride of all those who in former times had worked in North-East mining and manufacture. In other words, to quote Nietzsche again, it showed the people of the region 'how to bear steadfastly the reverses of fortune' and then move on to further achievements.[17]

Critical history

Critical history is very different. In Nietzsche's words, it brings 'the past to the bar of judgement where it can be interrogated remorselessly'.[18] It is a way of using the past that is both liberating and progressive. But as one might expect, it is relatively rare in public art terms. One of the few works that qualifies is Paul Bradley's *True North* (1990, Fig. 5). While it

5 Paul Bradley,
True North (1990),
photograph by the author

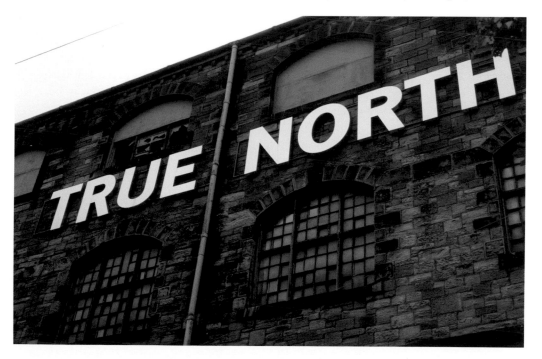

existed (like most critical works it was only temporary) this was a deceptively simple work, consisting of nothing more than the words 'True North' in big shiny steel letters, logo-style, fixed to the wall of a disused railway shed in Gateshead, on the southern side of the Tyne in such a way that they could only really be read from the northern, that is to say, the Newcastle, side of the Tyne. But that was the point, it seemed to me, for positioned like this, it seemed to suggest that the North as a region can only ever really be understood in relation to the South, the South being where in modern Britain political, economic and cultural power is concentrated and meanings are produced.

Another example of critical public art was Nathan Coley's *Show Home* in North Shields (2003, Fig. 6). This again was a temporary piece. And as with the Bradley, it depended greatly for its effect on how it was located, for it appeared at three different sites on three different days: a marina on the Tyne earmarked for leisure/entertainment development on day one, a new estate of culs-de-sac and suburban semis on day two, and a school playing field surrounded by security fences on day three. From the front it looked straightforward enough: a neat, white, two-roomed, single-storey, nineteenth-century Scottish rural cottage. From the back though it revealed itself, disconcertingly, as something else altogether: a three-sided plywood mock-up held together by wooden supports and ropes – the architectural equivalent in a way of those jaunty flags, eye-catching site-boards, glossy brochures, full-colour ads in the local press, representatives in specially printed fleeces and all the rest of it that estate agents use to advertise their wares.

6 Nathan Coley, *Show Home* (2003)

Antiquarianism

However, as I say, spiky, challenging 'critical' public art like this is relatively rare. Much more common is work that falls into Nietzsche's third category, the antiquarian: public art that invokes the past not for any ennobling or educative purpose but simply to provide amusement and interest. Needless to say, this is a way of contemplating the past that was not at all to Nietzsche's taste. Indeed in his view its only value lies in 'the simple emotions of pleasure and content' that it brings to the 'drab, rough, even painful circumstances' of modern life.[19] And not

surprisingly the kind of people to whom it appeals tend to be 'curious tourists and laborious beetle hunters'.[20]

One might wonder therefore why it should be the kind of public art that is so often commissioned these days. The answer is that it is regarded as particularly suitable as a way of enhancing a city or company's marketability. Not that that is anything new. Far from it. Take the statues of local heroes, Harry Hotspur, Sir John Marley, Roger Thornton and Thomas Bewick in Northumberland Street in Newcastle, for instance. The reason why these stand where they do in specially designed niches on the upper floors of a shop in the city's main shopping street is that they were commissioned by Boots, the Nottingham-based chemists, who at the time, 1912, had just bought Inman's Stores Ltd, a chain of northern pharmacists, and were eager to impress or ingratiate themselves with their new customers.[21] And a similar story lies behind another, much later work in Northumberland Street: Henry and Joyce Collins's relief on the side of a large new department store, *Newcastle Through the Ages* of 1974. This too was conceived as a piece of public relations. That is to say, C & A saw it as a way of deflecting any fears the local public might have as regards the new, more intrusive architectural and commercial presence in the city which they as a firm were giving themselves at the time.

Yet while antiquarian public art as a form of marketing and public relations may not be new, there is no question but that antiquarian public art as a category has undergone a profound change in recent years: a change that I believe is for the worse. For compare the Boots statues and the C & A relief with the new antiquarian public art that appeared in the 1990s in the most high-profile regeneration area in the North-East, Newcastle's East Quayside. The Boots statues and the C & A relief, it seems to me, each in their way affirm a proud Newcastle lineage. The new works on the East Quayside, on the other hand, significantly, really only make token gestures towards the city's past.

Now, admittedly, the Tyne and Wear Development Corporation, when it erected one of the latter, Raf Fulcher's *Swirle Pavilion* (Fig. 7), in 1998, was at pains to point out that the name 'Swirle' is sanctioned by history in as much as it refers to a hidden stream that, in the early nineteenth

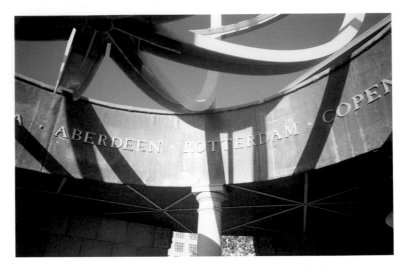

7 Raf Fulcher, *Swirle Pavilion* (1998), photograph by the author

century, flowed into the River Tyne nearby. Unfortunately, however, it does not take much research to discover that this seemingly helpful little piece of information is only half true. The eighteenth-century Newcastle historian, John Brand, talks of the Swirle Houses near the dissenters' burying ground taking their name 'from their situation near the swirl or runner which at this place empties itself into the Sidgate or Percy-Street'. But actually Sidgate or Percy Street was a considerable distance from where Fulcher's work now stands, as maps of the time make clear.[22]

As for the two other East Quayside works put up by TWDC, Andrew Burton's *Rudder* and *Column and Steps* (both 1996, Fig. 8), the way these refer to the past is not so much inaccurate as simply vague. *Rudder* is a kind of decorative, bronze, 3.8m high version of a vessel's rudder. At first sight it might seem to refer to the ships that used to throng the Tyne. However, that is about all one can say about it for sure. Certainly, there is no indication as to the nature of the vessel to which it belonged or whether this vessel had any particular connection with the Tyne. And this is true of *Column and Steps*, a decorative, abstracted representation of choppy waves lapping up against the bottom of a slightly tapering steel column, 4.5m high, with a sort of cog device on top. What exactly is this column? Is it an allusion to a marine engine? Is it some kind of abstract version of a lighthouse? Again there is no way of telling. Again there is a suggestion of past-ness and maritime-ness, but more than that we are not told.

8 Andrew Burton, *Rudder* (1996), photograph by the author

But should we expect something more? After all the function of such works, it might be claimed, is not to provide history lessons but what the French historian Pierre Nora's calls 'memory sites': some form of compensation for a perceived break with the past, in this case the recent almost complete demise of nautical activity on the Tyne.[23] I am not convinced, however. And indeed, there are two reasons why, it seems to me, such works are really quite harmful. First, they tend to distract attention away from whatever genuine relics of the past there may still be in the vicinity: in particular, the kind of unpretentious prosaic object that, as Ruskin suggested in *The Seven Lamps of Architecture*, we tend to look to when we construct for ourselves the unifying web of retrospection with which we synthesise our identity both as individuals and as a community.[24] And secondly, the vague, tokenistic way in which they refer to the past has the effect of turning history into what Guy Debord once called 'time-as-commodity': time chopped up into homogeneous, exchangeable units in such a way as to rob it of the qualitative dimension that might nurture a real engagement with the past.[25]

Fulcher's *Swirle Pavilion* is a case in point. Step inside this sculpture/building and one finds inscribed on the inside of the rim of the cornice the names of various ports: Hamburg, Genoa, Aberdeen, Rotterdam, Copenhagen, Malmo, London, Antwerp and Hull. What is to be made of these? At first glance maybe traces of something ancient that has been incorporated into the very structure of the work, like, say, those ghostly versions of domestic objects and spaces embedded in Rachel Whiteread's famous but short-lived *House* (1993–94). But, of course, that will not work. So failing that, what else instead? It's impossible to say. De-contextualised and aestheticised as they are, these names are incapable of telling us anything of any substance or value.

And this is invariably how it is with recent antiquarian public art. Take Simon Watkinson's *Head Cubes* (2000, Fig. 9), an addition to the Roman Doric column in the centre of Newcastle known as Grey's Monument (1838). This consists of a row of four glass boxes in the ground at the Monument's base, each of which contains an artificially lit, transparent, same-size cast of the massive, double-life-size head of

9 Simon Watkinson,
Head Cubes (2000),
photograph by the author

the statue of Earl Grey on top of the column. Nothing particularly offensive about that one might say. After all, whatever else might be said about them these sunken boxes cannot be called intrusive since few passers-by have probably ever even noticed them. It might even in fact be claimed that they perform a useful role in as much as they draw attention both to Grey as a historical figure (he was the Prime Minister who passed the 1832 Reform Bill) and to the rhetorical strategies that the Monument employs. Revealingly, though, this is not what the artist himself says. On the contrary, he sees them as a record of a little-known episode in the Monument's history when the twice-life-size head on the statue was struck by lightning and fell off into a nearby ladies outfitters, leaving the column surmounted by a headless figure of Grey for several years. Which is an amusing enough in its way and perhaps even worthy of commemoration. But worthy of commemoration in such a permanent and prominent form? Surely not.[26]

Or am I being unfair? After all it might be claimed Watkinson's piece is no more objectionable than, say, the inscription on the Monument on the back of the pedestal:

AFTER A CENTURY OF CIVIL PEACE, / THE PEOPLE RENEW / THEIR GRATITUDE TO THE AUTHOR / OF THE GREAT REFORM BILL / 1932

Indeed, one might see the latter pretty preposterous by comparison in that it asks us to believe that in the midst of the Depression 'the people' were actually interested in, let alone grateful to, the long-dead Grey for what he had achieved. Nevertheless, all things considered, I would see it as distinctly preferable to *Head Cubes*. Why? Because it at least

represents a genuine attempt to confront what Debord calls 'the massive realities of present-day existence'. It may not be that anyone much these days is aware of the specific reason why it was installed. In fact nowadays almost no one knows that the inscription was the idea of three members of the local landed gentry, Sir Charles Trevelyan, formerly a minister in the first Labour government, G. M. Trevelyan, the historian, and Viscount Grey, who as Sir Edward Grey had been Foreign Secretary at the outbreak of the First World War, who wanted to remind Newcastle residents of the value of British traditions of evolutionary democracy at a time when such traditions were so obviously increasingly under threat in various parts of mainland Europe. But that, it seems to me, hardly matters. What matters is that in as much as they notice it at all passers-by cannot help but see it is as making, or trying to make, a serious and useful political point.

And to show that I am not simply prejudiced against anything new, may I add that I would say the same about a piece of very recent public art in Newcastle, Ray Smith's *Shoulder to Shoulder* (2000, Fig. 10), a water feature in the form of a row of abstractly rendered concrete men encircling the base of Macklin's South African War Memorial. When this first appeared it was roundly, and perhaps deservedly, condemned as ugly and redolent of all the negative things that people in Britain normally associate with anything made of concrete. Nevertheless, by affirming, albeit in a clumsy and banal manner, the value of cooperation and communal action, it can be seen as at least attempting to make a serious contribution to Newcastle's civic life.

10 Ray Smith, *Shoulder To Shoulder* (2000), photograph by the author

I also have another criticism of *Head Cubes* and works like it. This is that they contribute to a phenomenon about which, in particular, the writer on urban history Christine Boyer has written: that, with the aim of making themselves marketable within the framework of global capitalism, more and more cities are allowing themselves to be covered over with a kind of spuriously homogeneous historico-aesthetic screen or matrix of amusing and/or pictorially vivid

11 The Viewing Box, Baltic
Centre for Contemporary
Art, photograph by the
author

details.[27] Now this may be fine in purely commercial terms. In other
ways, however, it can be very damaging. First, it helps to promote what
writers on New York City such as Sharon Zukin and Rosalyn Deutsche
call 'uneven development': that is to say, the kind of marginalisation of
the socially displaced and disadvantaged which has seen, for example,
vagrants and pigeons in recent times excluded from Trafalgar Square.[28]
And secondly, it has the effect of suppressing issues of linkage and
totality. By which I mean that, for fear of falling foul once again of
modernism's totalising impulse, we are, it seems, increasingly
discouraged from asking questions about how 'the past, the present,
and the future are related' or about what we should make of
'contemporary inversions that privatise public space and publicise
private space'. Not only that, but the very idea of community, of public
space, of a collective project to bind us together in harmony is regarded
as somehow inadmissible.

For sure, *Head Cubes* and works like it might be seen as suggestive of
a certain kind of nostalgia for a better social order that may have
existed in the past: the era of nineteenth-century civic zeal and Liberal
reform in the case of *Head Cubes*, the era of shipping and shipbuilding
on the Tyne in that of new works on the East Quayside. But if so then
that is about all. Certainly, there is no sense of social transformation
still being a real possibility. On the contrary, it is as if social
transformation must now be put on hold, for fear that the supposed

mistakes of the 1960s, the last time that anything such was attempted, might be repeated.[29]

So it is perhaps no wonder that works like the Fulcher, the Burtons and the Watkinson take their place comfortably and easily alongside a new generation of art spectacles in the North-East: for instance, the Viewing Box at the new Baltic Centre for Contemporary Art in Gateshead and Anish Kapoor's sculpture, *Taratantara*. The first of these, the Viewing Box (Fig. 11), is a room at the top of the Baltic where visitors are given a panoramic view of the city similar to that afforded by the Pompidou Centre in Paris or Tate Modern in London. Nothing new about that of course. Even in the nineteenth century, monuments such as the Eiffel Tower in Paris, the Columbus column in Barcelona or Grey's Monument in Newcastle had offered this. But what is new is that visitors to the Viewing Box find themselves able, indeed encouraged, to view the city in the same detached, disengaged, essentially pictorial manner that they would the actual exhibits inside the building.

As for Kapoor's *Taratantara*, this was a giant stretched red vinyl tube that, temporarily, during an eight-week period in the summer of 1999, filled most of the Baltic's vast empty interior while it was being converted from a grain silo into an art gallery. Like the artist's better-known *Marsyas*, which appeared in the Turbine Hall at Tate Modern three years later, it is not easy to describe for, as Margaret Althorpe-Guyton said at the time, it was not really quite like anything anyone had ever seen before. Indeed, any analogy that one might think of – muscle, hymen, membrane, sinew or synapse, a pumping device for the heart – somehow seemed entirely inadequate.[30] However, that in a way was the point. For as Althorpe-Guyton and others realised, what Kapoor produced was not so much an extraordinary, discrete structure, 45m high, 51m long and 25m wide, as an extraordinary, Alice-in-Wonderland experience that in effect turned the Baltic itself into a spectacle.

Was this to be welcomed? Some, the critic Michael Tarantino for example, certainly thought so. Art that is not fixed, that is not categorisable, Tarantino wrote,

> is endless... is a mirror of its very content, of the gaze that scans its form. It is a 'dream with a visual stimulus', in which the impossible can happen, in

which each successive view reveals another layer of possibility. *Taratantara* is about those possibilities: for the past, for the present, for the future.

For my own part, however, I felt that occupying the Baltic in the way that it did, *Taratantara* made the building seem in every sense empty. Admittedly, as its wonderfully apt title indicated, it worked brilliantly as an advertisement for the kind of spectacle that the building offered then and was about to offer later when it opened in its new guise as a gallery. But what it did not do was give any scope for any kind of critical reflection on what the significance of such a spectacle might be.

I am suggesting, in other words, that the reason why *Head Cubes*, *Swirle Pavilion*, *Rudder* and *Column and Steps* sit as comfortably as they do alongside works like the Viewing Box and *Taratantara* is that, like them, they are designed for passive, purely visual consumption. They require, in the words of the philosopher David Hume, no 'notion of causation, of that chain of causes and effects, which constitute our self or person'.[31] However, as we have seen, this is not how it always is with public art. Just occasionally work comes along that succeeds in being public in Patricia Phillips's sense of compelling us to engage with 'the cacophanous intersections of personal interests, collective values, social issues, political events and wider cultural patterns that mark out our civic life': work like Bradley's *True North* and Coley's *Show Home*, for instance. Sadly, however, the great majority of what goes up under the name of public art is not like this; it merely gestures towards the past. And what is particularly worrying is that, as I have tried to show, such work is more and more the norm. Even a generation ago, there was still a feeling that commemorative public art could and should make a serious attempt to enrich our understanding of the past. But not nowadays. Nowadays what we are increasingly getting is a kind of public art that encourages viewers to see themselves not as citizens with a stake in where they live but simply as tourists.

Notes

1 Saul Bellow, *Mr Sammler's Planet* (New York: Viking, 1970), 190, quoted in David Lowenthal, *The Past is a Foreign Country* (Cambridge: Cambridge University Press, 1985), 198.

2 Patricia Phillips, 'Out of Order: The Public Art Machine', *Artforum* (Dec. 1988), 92–96.

3 Ibid, 93.

4 Ibid, 93.

5 Paul Usherwood, Jeremy Beach and Catherine Morris, *Public Sculpture of North-East England* (Liverpool: Liverpool University Press, 2000), xx.

6 See Paul Usherwood, 'The Media Success of Antony Gormley's Angel of the North' , *Visual Culture in Britain*, Vol. 2, No. 1 (2001), 35–46.

7 There are echoes here of Guy Debord's claim that culture would be the driving force of the American economy in the second half of the twentieth century: see Guy Debord, *The Society of the Spectacle* (Thesis 193) (New York: Zone Books, 1995), 137. Whether public art has had this effect is, however, debatable: see Sara Selwood, *The Benefits of Public Art* (London: PSI, 1995).

8 Rosalind Krauss, 'Sculpture in the Expanded Field', in H. Foster (ed.) *Postmodern Culture* (London and Sydney: Pluto, 1985), 31–42.

9 Ibid, 35.

10 Friedrich Nietzsche, 'The Use and Abuse of History', in *Thoughts out of season. Part II* (trans. A. Collins, London, 1909–24).

11 Ibid, 19.

12 Quoted in Usherwood, Beach and Morris, *Public Sculpture of North-East England*, 131.

13 See Charles L. Griswold, 'The Vietnam Veterans Memorial in Washington Mall: Philosophical Thoughts on Political Iconography', in W. J. T. Mitchell (ed.), *Art and the Public Sphere* (Chicago and London: Chicago University Press, year?), 79–112.

14 Usherwood, Beach and Morris, *Public Sculpture of North-East England*, 57–59.

15 Antony Gormley, *Making an Angel* (London: Booth-Clibborn Editions, 1998), 15.

16 Nietzsche, 'The Use and Abuse of History', 16.

17 Ibid, 17.

18 Ibid, 28.

19 Ibid, 25.

20 Ibid, 17.

21 Interestingly, only a little later Boots employed the same tactic to woo a local public when they rebuilt the Inman's store that they had just acquired in Princes Street, Edinburgh, in the 'Scotch Baronial style': Stanley Chapman, *Jesse Boot of Boots the Chemists* (London: Hodder and Stoughton, 1974), 88–89.

22 J. Brand, *History and Antiquities of the Town and County of Newcastle upon Tyne* (London, 1789), Vol. 1, 423, note w.

23 Pierre Nora, *Les Lieux de Mémoire* (Paris: Gallimard, 1984–93).

24 John Ruskin, *The Seven Lamps of Architecture*, in E. T. Cook and Alexander Wedderburn (eds), *The Collected Works of John Ruskin*, Vol. VIII (London: Geo Allen, London, 1903), 224.

25 See Debord, *The Society of the Spectacle*, Thesis 149, 110.

26 Ironically, given my feelings on the subject, the artist told me he came across this story in Usherwood, Beach and Morris, *Public Sculpture of North-East England*, 96–98.

27 M. Christine Boyer, *The City of Collective Memory: As Historical Imagery and Architecture* (Cambridge, MA, and London: MIT Press, 1994), 3.

28 See for instance Sharon Zukin, *The Cultures of Cities* (Oxford: Blackwell, 1995) and Rosalyn Deutsche, 'Uneven development: Public Art in New York City', *October*, 47 (1988), 3–52. I am referring to Mayor Livingstone's improvements, part of his 'World Squares for All' scheme, unveiled in 2003.

29 In Newcastle it should be pointed out such a view has particular currency because the attempt to realise a coherent, modernist urban vision in the 1960s is linked in people's minds with the administration of the charismatic leader of the city council, T. Dan Smith, who ended up in gaol for corruption.

30 See Marjorie Althorpe-Guyton et al., *Anish Kapoor: Taratantara* (Gateshead: Baltic, 2000).

31 See J. I. Biro, 'Hume on self-identity and memory', *Review of Metaphysics*, 30 (1976–77), 29.

6

Managing Disappointment
Arts Policy, Funding, and the Social Inclusion Agenda

RORY FRANCIS

One of the distinctive characteristics of the 'New' Labour government elected in 1997 was its commitment to an 'inclusive society'. Within months of its election the Social Exclusion Unit was established. A series of Policy Action Teams were set up to forward proposals to the unit with ways to realise this initiative. Policy Action Team 10, responsible for the arts and sport, was enthusiastic in its report[1] delivered in 1999, via the Department of Culture Media and Sport, about the positive contribution the arts can make to the goal of social inclusion. The Arts Council of England, a client of the department, endorsed the policy through a range of initiatives as a criterion for funding, conducting research and employing dedicated staff.

The purpose of this essay is to explore the changing relationship of central government with the subsidised arts sector. The aims are twofold: first, to understand why the Arts Council was responsive to what, at one time, would have been seen as direct government interference; and secondly, to understand the meaning of social inclusion.

The tradition of a degree of autonomy afforded to the subsidised arts sector was secured in the foundation of the Arts Council in 1946. Indeed, for the Arts Council to become engaged in furthering government policy through its adoption of the need to address social

exclusion in its activities was a fundamental shift. This decision has implications not only for understanding cultural policy in relation to organisations and institutions but also for understanding the future activity of individual artists.

Although the idea of social inclusion has a currency through its use, as a term it remains fundamentally problematic. There are a range of possible interpretations and meanings which relate to the condition of the society, and the ways in which exclusion is produced, and hence inclusion possibly secured. Unless there is a clear understanding of what is meant by social inclusion, then research into the impact of arts activity will be flawed, however robust its methodology. This is particularly the case for the Arts Council whose research into social inclusion reiterates government terms: a litany of social ills unrelated to critical analysis.

This essay will examine the transformation of the Arts Council into its current state as a single, unified body. I shall consider the meanings and implications involved in the abolition of the Regional Arts Boards, which are now incorporated into the Arts Council, as well as explore the meanings, ideals and hopes that were invested in the fledgling, post-war organisation. *The Glory of the Garden*[2] report in 1984 shall be taken as the marker between the then paternal, and the now increasingly instrumental, model of state support for the subsidised arts. The action taken by the arts community itself to justify the arts in economic terms in the 1980s, and in social terms in the 1990s, shall be presented in its context as both necessary, and as ultimately contributory, to the loss of autonomy.

The concept of social inclusion is intractably bound up in the transformation of 'Old' Labour into 'New' Labour and the articulation of the so-called 'third way'; the political ideology that carries the memory of socialism while trying not to be capitalism. Three approaches for understanding the term social inclusion are presented. The first is based on a class model of society. Here the issue is one of poverty and is linked to an analysis of 'Old' Labour's chances of electoral success in a society with a diminishing traditional working class. The second presents the alternative model proposed by Will Hutton[3] where the

defining feature is the experience of risk and insecurity in society. The third approach presents the three distinct, yet interlinked, discourses embedded in the term social exclusion identified by Ruth Levitas.[4]

I propose that traces of each approach may be found wherever the term social inclusion is used. Although all share a common, at times benevolent, concern for society, unless clarity of meaning is introduced into the discourse, and an appreciation of the distinctive, and contradictory, aspects acknowledged, then conflicting expectations, and hence outcomes, will arise. This concern for clarity does not valorise the intrinsic over the instrumental in cultural policy, although the implications are obvious; rather it requires that a clear and acknowledged meaning to the term social inclusion is presented when the arts are involved instrumentally in securing social objectives. The alternative otherwise is managing disappointment.

The range of issues broached so far have implications beyond the concern of this essay. The focus for this analysis draws upon the current situation of the subsidised arts in England. This may appear parochial. The limitations this focus imposes may also lead to a biased and inappropriate reading when examined from a broader perspective. This applies as much to the political and historical context as it does to the narrowing of attention to the situation of the visual arts. However, I hope that what is explored will have a wider appeal.

Reducing youth crime – an instrumental use for the arts?

An announcement was placed on the inside pages of the March 2002 edition of *Community Renewal News* with the headline that 'the arts and sport can reduce youth crime'. The article covered the speech given by the then Culture Secretary Tessa Jowell at a conference held by the Youth Justice Board and the Arts Council for England. It recorded what was understood as the claim made by Tessa Jowell that the arts and sport 'can be used to break the cycle of crime for young people'. The story didn't break in this magazine. A number of press releases from the Department of Culture, Media and Sport had appeared around the same time.[5]

For those arts practitioners whose work could be described as 'socially engaged', or gathered under the title of community arts, these claims would have been both understood, and alarming. As a form of arts practice politically and ideologically motivated, it has been axiomatic that arts interventions in the social sphere secure social engagement and change: the rhetoric has been as much dissenting, campaigning, oppositional as transformative, pedagogical and democratic. What would have been alarming was that what was once a marginal, radical and frequently discredited form of arts practice had the apparent support and affirmation of central government at ministerial level.

Equally significant is the reference in the article to the 'growing evidence in support of arts-based initiatives'. The use of the word 'evidence' has a significance and authority beyond the mere acquisition of data. It suggests a judicial metaphor which promises a positive outcome with a level of assurance previously unfamiliar in the arts world. This raises issues of credulity as much as of credibility. It was at one time sufficient to state the nature of arts activity through anecdote, explanation and audience size, and so justify the mores of accountability and financial transparency. Now the argument is supported through data collection, rigorous research methodologies, impact studies and the appeal to evidence.[6] Both approaches, it should be noted, would claim allegiance to an artistic tradition, but tread more cautiously over the hostile and contentious issues of quality and innovation.

There follows an assumption, or an aspiration at the very least, that once a consensual approach to the gathering of evidence is secure, the methodologies agreed and of a sufficiently robust nature, then the findings of impact studies will reveal the causality between arts practice and social change. The impact research literature concerning the arts focuses on the adequacy or otherwise of the evidence, the methods, the value and indices.[7] This is as much from those whose work is broadly ideologically sympathetic to the endeavour as those who critique its measures and efficacy. Two observations arise from this: first, that there is limited concomitant critical discourse placing the increased political

agenda in cultural activity under scrutiny; and secondly, that there is need to speculate on the conditions of the cultural field in which the case for social impact is proven.

There is the reductive tendency in research and discourse into the social imperatives attached to the arts to focus on the singular issue of meeting, or at least addressing, this agenda, rather than undertaking a full assessment and critique of arts activity of which the social is one aspect. The impression that this results in, and hence the distorted claims, for some, that this encourages, is that the arts are reduced to being seen as an instrument in securing social policy: Jowell herself refers to the 'use' of the arts, a descriptor that some within the arts find particularly problematic. The ambiguity that is then to be resolved is who has the ownership of this process.

The policy has its genesis in government agendas, which through economic and fiscal measures can dictate its taking place, and decide *who* has the authority and legitimacy to act. This places the artist, as the instrument, in the position of securing funding under the condition of agent rather than initiator, and the community as the 'problem'. The potential danger, and cynicism, latent in this model is that the arts activity is honed in an acceptable manner to secure financial support, dependent upon the current wave of political fashion. There is nothing apparently new in this. The debate concerning integrity and compromise is part of the ethical dimension for all those whose funding is secured through subvention and sponsorship, a position in itself not peculiar to the arts. What *is* of concern in this situation is the political interest in the transformative imperative.

The perceived autonomous, or semi-autonomous, role of the artist in the cultural arena has faded. Certainly, the discourse of arts practice has undergone fundamental change within the articulation of practice by artists themselves, along with a reconsideration of critical discourse and theory. In addition, the role of the state in relation to the cultural arena is being explored and reconfigured through greater attention to financial accountability and a range of policy imperatives, of which social inclusion is currently having the most impact. How this has taken

place, and why the arts constituency has responded in the way it has, needs examining.

The Arts Council of England

On 1 April 2002, the Regional Arts Boards in England ceased to exist. This apparent act of self-immolation took place with a rapidity, and lack of ceremony, that took even those who had some connection with the arts infrastructure in England by surprise. What had previously been an affiliated network of independent regional organisations, charged jointly with the responsibility for the development of the arts in England, was replaced by a single organisation based in London with regional offices. Under a central government that had set up limited powers of political independence for Scotland and Wales, in addition to those already being explored in Northern Ireland, and that continues to develop the possibilities of regional government in England, this centralisation of the Arts Council's operation appeared doubly paradoxical.

Although the Arts Council of England's progenitor, the Arts Council of Great Britain, had been established by Royal Charter in 1946 as a national body, the Regional Arts Boards had their origins in regional initiatives. Reform, and the development of the arts infrastructure in the pre-2002 period, had taken place slowly over the years through a protracted process of consultation, negotiation and compromise. Fundamental to each stage of development had been the focus of attention on the issue and danger of centralisation, articulated through various agendas from the concern for artistic quality through to the justification of local needs through local accountability.

A significant feature of the need for change presented in the paperwork leading up to the decision to abandon the Regional Arts Board network was the focus on the need for economies; a streamlined organisational structure would offer up savings that could be ploughed back into the arts. It is perhaps too early as yet to assess the integrity of this argument, or other potential gains. Neither is it my aim here to challenge the veracity of charges of centralisation in relation to the meeting of needs on a regional basis, although this has ramifications on

state intervention/investment in the arts and the rights of access to the arts per se. Rather, my focus is on the implications for the arts world within an overtly politicised cultural agenda, and ultimately on the subsidised arts economy, as the potential for the delivery of social objectives is pioneered by central government through the Department of Culture Media and Sport.

Who is responsible for spending 'our' money?

At the time of writing, in the summer of 2003, Tate Modern in London is showing Carl Andre's *Equivalent VIII*. The work is displayed, roped off from the public, with a timeline recording the history of the work since its conception. It tells a story of controversy, vilification and the questions posed by the challenges of modern art. It is the biography of the 'Tate Bricks'. For those who have a knowledge of the work, it serves to remind them of a familiar, yet increasingly distant tale of a battle which spilt from the confines of the gallery, and the closed world of the arts, into the hands of an incensed and hostile press. The 'Tate Bricks' was shorthand for the misguided project of modernism and drew attention for the first time, on such a scale, to the use 'they' were making of 'our' money.[8]

Perhaps now, for an increased number of people, the showing of *Equivalent VIII* and the accompanying timeline serves as an introduction: a lesson in the story of art from a time when issues of accountability and public scrutiny, access and the place of socio-economic impact studies, were alien. The world the arts now occupies is vastly more complex, with more players and partners than before, and with a vocabulary that reflects the legacy of changes and the aspirations for development. There is no longer one Tate Gallery,[9] there are four; the aggregate of local government financial support for the arts is reported to be greater than the entire devolved budget of central government funds through the Arts Council of England;[10] the National Lottery was introduced in Britain in 1994; the phenomenon of 'Brit Art' elevated some artists to the status of celebrity; the government established a Department of Culture, Media and Sport. The place of the arts within the cultural life of the nation had shifted to a more central

position, and it was not sustainable, nor was it expedient, to permit the operation of semi-autonomous organisations outside Arts Council, and central government, control. (This issue became politically pertinent with the introduction of the National Lottery, and the injection of additional funding for the arts, which I will explore next in greater detail.) In the well-rehearsed defence of structural change the political imperative was economically articulated: the Regional Arts Boards had to be subsumed into the central body of the Arts Council.

Alongside this shift has been a radical modification, if not the complete abandonment, of one significant principle with which the earlier years of the Arts Council were characterised: the idea of 'arm's-length' control. The accepted wisdom for managing the funding of the arts had been based on a clear and irrefutable distinction between the realm of the political and the world of the arts. As 'the civilising arts of life',[11] it was understood that the state had a duty to support the arts, though only so far as to encourage rather than dictate terms and conditions. Political interference was seen as not only undesirable but also incomprehensible: the arts were other-worldly, if not ultimately transcendent.

The opportunity offered through this 'arm's-length' principle was responsibility for the success of the pride of British cultural achievement without the responsibility for the detailed allocation of limited resources. It permitted a degree of autonomy for the conduit of funds, the Arts Council, from its source, the state. The extent to which this principle was ever truly operational depends on an understanding of what was permissible: as a protocol it could be seen as merely the absence of 'directly *traceable* control'.[12] Certainly the low level funds available to the arts through the Arts Council, relative to the overall remit of the Exchequer, meant that the liability attached to conducting such a system was sustainable in principle, even if the reality was different.

The National Lottery

The scale of funding managed by the Arts Council, and particularly the consequent political liability, increased to a critical level with the introduction of the National Lottery in 1994. The scheme in Britain was both an act of expedience and of necessity. As a European country without a national lottery, it was open to the potential threat of another country operating a rival project, and it offered an additional stream of central funding. The system that was set up was managed by the business consortium Camelot and regulated by the government department of National Heritage, the forerunner to the department of Culture, Media and Sport. The beneficiaries of the Lottery, known as the five 'good causes', were to be sport, the arts, heritage, charities and the millennium project. Between them they were to receive a one fifth portion of the 28 per cent of funds raised: the majority of the funds going to the operating company Camelot and the Treasury.[13] The principle of 'additionality', by which the allocation of Lottery funds were adjudicated, linked to the idea of 'good causes', the five intended beneficiaries of the money raised, served to present a humanitarian project without the charge that it constituted an alternative form of taxation.

Yet the fact that not only the operating company, Camelot, but the Treasury, were the substantial 'hidden' beneficiaries – while the Arts Council of England received relatively small sums – eventually led to the Lottery subvention attracting considerable negative comment. The Arts Council failed to act as the necessary buffer between the government and those responsible directly for funding cultural activity. The opprobrium in the press and the general feeling of betrayal was targeted at what was seen as the inappropriate and selective allocation of grants: the Royal Opera House in London, and via a second 'good cause', the Millennium Dome,[14] doing for the Lottery what the 'Tate Bricks' had done for the arts twenty years earlier. Not only had the Arts Council been seen to fail in its duty to manage its affairs in an equitable and prudent manner, but its continued existence was drawn into question. The outcome, and increasingly the solution, was to be found in the intervening role of government, and the Secretary of State, in the

decisions and direction of the arts, and much later, the eventual consolidation of the Arts Council and the regional boards into one manageable body.

However, to realise the extent of the change that this whole process signified, it is necessary to return to the duties charged to the Arts Council of Great Britain at its foundation. The report produced in 1984, *The Glory of the Garden*, acts as a focal point between the values of the 'old' council, and the conditions of the 'new'. Its importance here lies in the ideas, meanings and aspirations that it presents rather than its strategic significance as a potential tool of financial leverage with local authorities. It is for this reason that I offer now an examination of this period.

The Glory of the Garden 1984 – from the paternal to the instrumental

The proposed strategy, *The Glory of the Garden*, was the outcome of a protracted period of consultation between the Council and its clients, and was written in a style and manner that reflected the paternal urgency for reform in a time of increasing financial constraint. The then Conservative government had introduced the 'Financial Management Initiative' in 1982, which sought to secure a level of accountability and strategic management previously unfamiliar in arts management. This reflected a government which, under the leadership of Margaret Thatcher, aspired (at least rhetorically) to reduce the perceived role of the state, and secure value for money from public services through greater efficiency and effectiveness. It was also a time when funding for the arts no longer grew at the rate sustained through the 1960s and 1970s, but was only maintained year-on-year, so producing what was experienced as an effective cut in support. *The Glory of the Garden* was principally concerned with addressing the underfunding of regional provision in relation to what was perceived as the 'success' of London. The proposed strategy also marks the demise of a style of state patronage and beginning of the abandonment of many of the features deemed sacrosanct by those who had authored and secured the fledgling Arts Council in the 1940s.

The history of government support for the arts demonstrates a distrust of political interference from the arts community *as well as* politicians, and a desire for independence from the main political structures of the state. Culture, and the arts in particular, was seen to be outside the function of government responsibility, at least in principle. The Arts Council was established as an independent body operating within the constraints of its Charter and accountable to its purpose to 'support', rather than 'direct', culture. What this meant was that the funding was acceptable to arts organisations, but not the specific details on what and how it should be spent. However, given that the control of resources is one of the central concerns of government, and that those resources and funds are provided by the state, it would be naive to assume that the principle of 'arm's-length' involvement would be honoured so completely.

In a BBC radio talk delivered in 1945 Maynard Keynes outlined the purpose and priorities of the proposed Arts Council: he was subsequently, and briefly, to be its first chairman, having also been chairman of its predecessor body, the Council for the Encouragement of Music and the Arts. The two main priorities of the Arts Council, he stated, were to establish London as a 'great artistic metropolis', and to 'decentralise and disperse the dramatic and musical and artistic life of this country'.[15] London was at the time 'half in ruin' and the work that lay ahead was visionary, optimistic and part of the post-war project for the reconstruction of Britain, and the realisation of a more equitable society. The same sentiments were reiterated and endorsed forty years later by William Rees-Mogg, by then chairman, in the preface to *The Glory of the Garden*. The vision, he claimed, had been in large measure realised, and the ideals set out forty years earlier still had a currency and validity: London had excelled in its aim to achieve greatness. However, the ambition to disperse and decentralise the arts was found to be wanting: 'we live in two artistic nations', he stated 'London and everyone else'.[16] *The Glory of the Garden* was intended to address this problem, setting out a strategy for implementation through institutional, administrative and financial measures: maintaining the position of London, yet strengthening the regions. It was perceived, and

couched, as a radical programme of devolution of funding and administration, counteracting the tendency to centralise bureaucracy.

What has received less attention is debate about exactly *what kind of* art should be promoted, and *which* artists and organisations 'supported'. Certainly, only limited attention was ever given to *where* that art was presented: the discussion, as we have seen from the formation of the Arts Council in 1946 up to, and endorsed in, *The Glory of the Garden* strategy in 1984, was locational. The concern was one of distribution. Also, the assumption underlying this distinction had been that an art worthy of promotion had in some way been linked to a past tradition, or consensus of work of universal and historical interest: and it should be the practice of contemporary, living artists, whose allegiance was to that tradition, that would be encouraged.

The asking of these questions positions *The Glory of the Garden* as a proposed strategy at the threshold between a paternal model of state patronage and the putative current model of social instrumentality. To what extent is it still possible to speak of a 'national culture', or a tradition or traditions of national importance, within a potentially fragmenting, certainly pluralistic, society? What role do the arts play in the critique or affirmation of, and participation in, that society? And significantly, and in line with the focus of this essay, to what extent are artists and institutions now required to renegotiate their relationship with that model of society in accordance with government policy, and in particular that of 'social inclusion'?

The crisis of the fine arts

In reviewing the literature recording and examining the history of the Arts Council of Great Britain considerable attention has been paid to the wording of the Charter of Incorporation.[17] This places exclusive emphasis on the development of the 'knowledge, understanding and practice' of 'the fine arts' as the primary purpose of the organisation. It is no longer possible to speak of the 'fine' arts without suggesting the irony intended by placing the term in parentheses. Yet, to communicate the ironical intention appropriately requires both a knowledge of its reference, and a self-conscious, and political, awareness of distance from

its original usage. The 'fine arts' speak of the axiomatic canon of cultural tradition: the selective and selected body of work refined over time, upon which, and through which, the culture and identity of a nation, and people, are defined. It can also be seen to refer to the defence and maintenance of that tradition through training, education and induction: a process of connoisseurship leading to participation in the civilised world. In effect, a political process working through the cultural, reinforcing the place and position of the dominant group in society by the use of cultural instruments: securing the status quo through certain practices and by the exclusion of others.

When the new Charter was issued in 1967, the phrase 'the fine arts exclusively' was replaced by 'the arts'. The use of the expression 'fine arts' was initially intended by Maynard Keynes as a way of avoiding the paying of taxes by the Arts Council through a use of words that would secure exemption under the Scientific Societies Act. It was also seen as a broad definition that was open to interpretation, and yet distinct from possible confusion with the 'technical' arts. However, it was neither broad, nor did it gain exemption from taxation.[18] No definition of what either the 'fine arts' or the 'arts' was intended to cover was ever given in either the original Charter, nor in its amended version. As such, it is impossible to be clear exactly what principles would govern the development that the Arts Council was charged to undertake. In the absence of any detailed policy, and the lack of a strategy for implementing its purpose, the way forward was through debate and interpretation through a complex system of committees.

Although this approach may have been intended to avoid the pitfalls of *L'Art Officiel*,[19] and with it the totalitarian overtones implicit in promoting a national orthodoxy that such a system implies, there was a convergence of opinion about what received Arts Council support which was an orthodoxy in everything except name. This can in part be understood as a result of the homogeneous composition of the advisory panels, which did not reflect the complex and conflicting characteristics of class, gender, ethnicity and social and political beliefs at large in society. It can also be seen in the resistance to emergent and marginalised arts practices and the attention to a narrow interpretation

of the arts where the term 'fine arts' is descriptive, and selective, rather than ironic. A poignant example is that of photography which had been dismissed as a marginalised practice when placed beside the 'proper' activity of painting and sculpture.

The argument then, as now, revolves around the interpretation of what culture is being promoted and developed given the constraints imposed by a limited budget, the implication being that, were the funds without limit, then all forms of cultural practice would receive support. This is not the case. It would be disingenuous to presume that the subvention of art practices through the allocation of funds does *not* disguise the interpretation of the cultural through a process of inclusion/exclusion. The contention here is that the increased political attention to the cultural agenda, and the measures introduced, becomes an end in itself rather than a means to an end. At what point does the concern for the economic, the agenda of the 1980s, and the concern for the social, the agenda of the 1990s, shift from being an attribute, condition or requirement *additional* to the criterion for funding, to being the principal criterion? Does an understanding of 'the cultural' accommodate the conflicting issues of inclusion and of exclusion presented by a plurality of traditions, or is the political imperative for inclusion based on a singular model of society?

Although state patronage of the arts was not central to the reform programme that brought into existence the National Health Service and other public services associated with the establishment of the Welfare State in post-war Britain, it had been seen by the Labour party that culture would have been part of the project.[20] The National Executive Committee of the Labour party outlined in 1942 its mission to achieve the provision of cultural and recreational amenities for all citizens secure from the vagaries of private patronage. The architecture of the Welfare State was based on the ideas presented in the 1942 *Report on Social Insurance and Allied Services* by William Beveridge. Following their landslide victory in the post-war General Election in 1945 the Labour party put into place the foundations of the Welfare State, based on Beveridge's ideas and ideals: a model of social welfare which was to remain in existence largely intact for the next thirty-five years.

The establishment of the Arts Council took place at the same time as this programme of reconstruction, which included the reforms introduced in the 1944 Education Act, the foundation of the National Health Service, the nationalisation of major industries, the introduction of unemployment benefit and the state pension scheme. The list is significant. It outlines the series of crises in recent years as challenges to the Welfare State came from economic, political and ideological quarters, the most recent being in pensions. The Arts Council, as a parallel project in post-war reform, has also had to face challenges to its legitimacy, accountability and ultimately its very existence. The National Health Service remains in crisis, even in danger of being disbanded, as much for its limited resources, as it is threatened by a fundamental change in the concept of what health and sickness mean: the two issues are linked. Similarly, the Arts Council not only has had to contend with the challenge of administering finite resources, but also to consider what art is, and what it is for, in contemporary society.

The artist as engineer of social change

The idea that scientists and artists are brilliant, inspired and mad (and in the case of artists, within an English context, also preferably white, male and French) is as much part of popular mythology as it is that small, furry animals can talk. What is surprising is that the myth of the artist is so universal and persistent, and appeared in policy documents produced by the Arts Council. The role of the artist in society is a constantly changing function that both reflects upon that society, and is reflected in that society. Whether the perceived characteristics of the artist are those of the intellectual, and occasionally moralising, critic, or the inspired shaman, the received notion of the person who stands apart is a fundamental tenet of the avant-garde in the modernist tradition.

Whether such a position is secure in the complex relationships of current theoretical analysis, and the raft of critical activity launched through the 'new', increasingly mainstream, art historical tradition, is less certain. What is clear is that the notion of the artist as nominally individual, male and 'free' was advanced by Keynes as part of his

address in 1945, and reiterated verbatim in the preface to *The Glory of the Garden* by Rees-Mogg in 1984: 'the work of the artist in all its aspects is, of its nature, individual and free, undisciplined, unregimented, uncontrolled. The artist walks where the breath of the spirit blows him...'[21] The view of the artist expressed here is within the legacy of the Romantic movement, with strong overtures to a quasi-religious, Hegelian tradition. Is it possible that the same person, or persons, is able to effect a reduction in youth crime? Is it more the case that such feckless (avant-garde) behaviour would lead to an increase in youth crime; if not, then at least that such behaviour is responsible for attitudes that challenge the social order, rather than conform to it?

The contention here is that there needs to be a theory of the artist, as much as a critique of putative instrumental cultural policies, which explores the relationship of the artist as individual with the audience as society. This should acknowledge the complex interrelationship, pressures and brokering of power, of participatory arts practice, the current focus for furthering the social inclusion project, and the place of the gallery/museum as the site of competing cultural identities, traditions and histories. The proposition requires examination beyond the reductionist tendencies of instrumentality and the positioning of the artist as social engineer. This examination is possible, though will not be necessarily conclusive, within an exploration of the social inclusion agenda advanced by the current Labour government in England, and a critique of the political context of cultural entitlement.

Before continuing with the examination of the Labour party there is a fundamental paradox drawing these last two lines of thought together that needs elaboration. The place of art, or the cultural artefact, if the gallery and the museum may be amalgamated for the purposes of this example, has been the site and the catalyst for controversy. Both the practice of artists, and the theoretical and critical attention of arts activity, has situated itself within a discourse that has placed the gallery/museum as problematic. The position is further complicated through the tendency to collapse the range of institutions, collections, practices and histories that comprise the collective gallery/museum into the singular. The Bowes Museum in Barnard Castle and the Baltic in

Gateshead, both of which should share the claim to be organisations of national cultural significance without the burden of obligation or critical attention that may attract, negotiate a responsibility to the social imperative as different from each other as they differ in relation to the cultural agenda. However, both find themselves sharing, because of funding imperatives, the duty to interpret the social inclusion agenda within the competing claims of financial economy, efficiency and effectiveness, and the charge to configure themselves in the role of centres of social change.[22] This raises not only the organisational conflict in juggling the fiscal with the social, but also questions the political issue of what is *meant* by social change.

The predominance of the government's economic agenda of the 1980s saw the cultural sector required to justify itself in economic terms as a response to the pressure of accountability and public scrutiny. The legacy of this demand is in the language still employed which refers to funds and subvention as 'investment' with the corollary of the expected 'returns', and the justification of arts activity within the generalised arena of banking on 'cultural capital'. Significant credibility was given to this agenda through the attention to studies of economic impact of which John Myerscough's research report *The Economic Importance of the Arts in Britain*, published in 1988, was seminal. Although the subsequent critique of this work has challenged the methodology and findings, and the economic reductionism reflective of the Thatcher years and dismissal of intrinsic and educational values has been found wanting, the force of the argument that 'culture is good for business' has not lost its potency.

The social agenda of the 1990s has seen the rise of a similar project within the cultural sector to justify the arts in terms of their social impact. Again this can be placed in contradistinction to the idea of intrinsic value, and seen as reflective of the reductive tendency of the New Labour period to secure the project of social inclusivity. The efficacy, value and purpose of this project to articulate the social worth of the arts, whether contingent or complementary to broader issues of entitlement and justification, require an expanded discussion of social inclusion and, as referred to earlier, a clearer focus on the meanings and

expectations of social change. Therefore, it is necessary to place the political project of social inclusion in the historical context of the project of New Labour to re-articulate the socialist/social democratic agenda.

The transformation of 'Old' Labour

The landslide election victory won by New Labour in 1997 brought to an end the longest period in government by a single party in the history of British democracy.[23] Eighteen years previously the Conservative party under the leadership of Margaret Thatcher came to power with a radical agenda for the transformation of British society. Her intention was to address the failure of preceding governments from both the left and the right to arrest the perceived decline in Britain. She blamed the trade unions, punitive taxation and excessive state intervention, and reversed the post-war consensus in Keynesian economics in favour of monetarist theory. As pointed out earlier, she set about dismantling the Welfare State, placing the onus of responsibility back on the individual citizen and so returning the 'right of choice', and of 'dignity', necessary for individual social and economic well-being. The theme of 'choice' was central to the rhetoric of her reforms and was, in her own view, raised to the level of a philosophy. 'In education, housing and health the common themes of my policies were the extension of choice... This was the application of a philosophy not just an administrative programme'.[24] The impact of this radical, rightwing political agenda informed directly the path taken by the Labour party as it sought to reconfigure itself in a manner appropriate for an opposition party and government-in-waiting.

The first experiment was policy-based. Analysis of their defeat in the 1979 election led the Labour party in the early 1980s to an equally radical leftwing solution. The problem was seen to be the responsibility of the moderate centre of the party which under the leadership of Jim Callaghan in the 1970s witnessed a series of humiliations, culminating in the 'winter of discontent' of 1978/9. The challenge to his political acuity was founded in his failure to recognise, let alone anticipate, the impending crisis. The response was a further shift to the left and the adoption of a tranche of radical socialist economic policies, withdrawal

from Europe and the pursuit of a policy of unilateral nuclear disarmament under the party leadership of Michael Foot. It failed as an electoral strategy. The party itself split with the formation of the short-lived, breakaway Social Democratic Party and between 1979 and 1983 the party lost a quarter of its vote, polling less in the 1983 election than the failed Callaghan government had done four years earlier.

The second experiment was the long, slow and painful process of so-called 'modernisation'. This was based as much on the perceived need for change following the disastrous 1983 election as it was on a recognition of the social change in British society, in part engineered by the 'success' of the Thatcher reforms. It is through an awareness of this process of transformation of the Labour party into 'New Labour', and the search for alternatives both within the history of socialism and elsewhere, not least within the legacy of Thatcherism itself, that the confusion of meaning with, and aspirations for, an inclusive society can be understood. The New Labour project is not a coherent ideology. As the so-called 'third way' it carries within itself the conflicts, contradictions and opportunism inherent in a political party in opposition seeking power. It also carries the responsibility for the history and legacy of the labour movement at a political level. As a political philosophy it is the amalgamation of a range of possibilities found in the space between capitalism and socialism. It is a British solution to the crisis of the left. It is philosophically Anglo-Saxon and pragmatic in its realisation.

It is within this political context, and as a response to the directives authored by this project, that the cultural agenda is currently being negotiated. Any understanding of the social impact of the cultural, however efficacious its methods, comprehensive its data or robust its findings, is partial and flawed without an articulated theory of what 'social' means. The arts may reduce youth crime because of some ameliorating quality intrinsic to the arts; or they may delay the crime waiting to be committed; or they may engage in the critique of a society in which disenfranchised youth resort to crime. How the arts interact in the social is the cultural, and necessarily political, discourse at the heart of the inclusive agenda, and that requires an understanding of the

society into which, and from which, one can be included or excluded. It not only asks the question 'whose society?' but also 'what sort of society or societies?', and more pertinently 'what is the nature of the contract/relationship with the society/societies?'

New Labour – participation and the 'third way'

In 1994 Tony Blair became leader of the Labour party. Three years later he was elected Prime Minister. The intervening years saw the transformation of Labour into New Labour and the adoption of the 'third way'. This active step to articulate a path between the new right and the 'old left' necessitated shedding the main tenets that defined the Labour party. This was most significantly symbolised through the ratification of the new Clause IV in 1995. Previously the party had been committed to a policy statement of its belief in the common ownership of the means of production, distribution and exchange through the articles of its constitution.

As a matter of political expediency, should they be elected, Blair committed the party to the then Conservative government's plans for taxation and spending for the first two years in office. As an election promise it was not merely expedient but also reflected the legacy of Thatcherism accepted by New Labour: the apparent success of the Conservatives' commitment to low inflation, trade union reform and the 'free market' was embraced as a marked contrast to the obsolete economic policies of 'statist socialism' and interventionism.

New Labour also spoke in a new language that lent itself to phrases and slogans that captivated the electorate for the promise they expressed rather than the meanings, principles or policies they communicated. 'New Labour, New Britain', the party manifesto, had the same optimistic and resolute ring as does an 'inclusive society'. This does not suggest that there is a sinister element at work here, a Trojan Horse for the ultimate project or the workings of an inner cabal, although the tendency to 'spin' lends itself to the conclusion that there is an ideological vacuity. Rather, there is the working out of ideas and principles which draws upon experiments in 'stakeholding' and communitarianism. These operate within a different model of society

and analysis of its failings. The shift moves the discourse away from the issues of poverty and the structural inequalities *constituting* society, to participation *in* society.

One of the key imperatives that motivated Labour's modernisation was a recognition of demographic changes in society.[25] The traditional heartland of Labour party support came from the working class. This was both reducing in size and changing in character, and unless the party broadened its appeal to the significant mass in the middle, it would remain unelectable. The analysis was based on a class interpretation of society divided into the '10:70:20' model of which the bottom 20 per cent were the working class. Labour could not afford to be seen as a narrow class-based party. In line with an expansion of its identity and rejection of its 'class bias' and contingent policy portfolio, Labour also needed to explore a model of society which was not 'class-based'. This was offered by Will Hutton in his hugely successful book *The State We're In*, published in 1995. This advanced the stakeholder society, an alternative divisional model of social groups, and spawned the stakeholder epithet.

Social inclusion – risk and the stakeholder society

The proposition forwarded by Hutton was based on a different reading of the social trends that had taken place as a result of Thatcher's politics and the waning of socialism as a credible political ideology. Concurrent with the radical right agenda being developed in Britain under Margaret Thatcher, and in the USA under Ronald Reagan, a project of reform and openness was being explored in the former Soviet Union under Mikhail Gorbachev.

On 9 November 1989 the Berlin Wall came down. This was not simply an isolated symbolic event embodied in the physical dismantling of the frontier dividing East and West Berlin as a city. It represented the complete reordering of the political structures, ideological affinities and cultural allegiances that had defined Europe as a continent during the post-war period. It also marked the crisis of authoritarian state socialism as a legitimate and authoritative alternative to capitalism. The 'third way' was not an option. It was the necessary route between the

Scylla of insecurity, marginalisation and disadvantage caused by capitalism and the Charybdis of the discredited ideology of authoritarian state socialism.

Hutton identified a malaise and increased sense of risk and insecurity brought about during the previous years of rightwing reform in Britain. Together with an increase in affluence and personal aspiration, the years of Conservative rule were also marked by an increased threat to security, particularly in jobs: short-term contracts, part-time and unpaid work, training and the portfolio career became part of the vocabulary of employment. Significantly, this threat was experienced by all sectors of society. This led Hutton to posit a model of the divisions in society based on the experience of employment and security rather than that of class.

As such Hutton's 30/30/40 society is defined by economic viability and engagement. The bottom 30 per cent broadly refers to the excluded poor of the conventional categorisation of underclass. The second group is the 30 per cent who are marginalised and in insecure employment, marked by increased risk and low pay. The top 40 per cent are the privileged. This is defined by their secure and full-time employment. However, the central concern that Hutton introduces to this analysis is that this top group is shrinking: although privileged they are not immune to risk and face an increasing threat to full-time employment.[26]

The central proposition of a stakeholder society operates within a modified form of capitalism: and it is the possibility of a socially cohesive and regulated form of capitalism that gives the mechanics of inclusion its definition. In an economically modelled society the terms of inclusion are primarily economic. In an insecure society the terms are articulated through the management of risk. It is the legacy of this modification of the terms of inclusion that bedevils the operation of a coherent strategy as much as it is that the term social inclusion is problematic and carries within itself a range of discourses.

Social exclusion – RED, MUD and SID

Implicit in the division between inclusion and exclusion is the boundary. There is no place for consideration or negotiation. It is the either/or of belonging, participation and fulfilment, or not. Moreover, it focuses attention on the periphery without considering the inequalities that feature at the centre of society. It places the problem on 'them' rather than on 'us': the issue is to secure their transition rather than address our bigotry. It is this range of problems that Ruth Levitas[27] unpacks in her analysis of the discourses that are embedded in the term social exclusion. She identifies three ways of understanding and interpreting the ideas that are implied in its current usage. For these she applies the acronyms RED, MUD and SID for the 'redistributionist' discourse, the 'moral underclass' discourse and the 'social integrationist' discourse respectively.

The REdistributionist Discourse is concerned with poverty. In its initial analysis the issue of poverty was understood as the prime cause of social exclusion with the reduction of inequality as the solution. This was extended into an examination of the processes and causes of inequality. Here the concern was with not only the material, but also the social, political and cultural inequality at large in society, and hence the consequent imperative for the redistribution of resources and power.

The Moral Underclass Discourse is concerned with social order, the moral integration of the underclass and the culture of dependency. Here the focus is on the excluded themselves who, as a product of the Welfare State and the instruments of support in place, have become both the problem of the system, and the critique of its efficacy and condition. As a gendered discourse, and with Jowell's claim for crime reduction in mind, it targets criminally inclined young men and 'feckless' single mothers. The issue of exclusion becomes 'their' problem and 'our' concern. The *behaviour* of the poor rather than their poverty fuels the debate, which conceals the need to address the inequalities in society at large, but does seek to reduce the welfare budget.

The Social Integrationist Discourse is concerned with paid employment. Social participation is primarily, though not exclusively, secured through work which is paid, and brings with it the consequent

social, cultural and political benefits that 'insertion'/integration in society accords. It is this strand of exclusion that draws on French social policy and the increasing significance of European Union law: subvention via the main Structural Funds is directly related to promoting social participation through job creation and engagement in the labour market. Although it seeks to extend its concern into issues of education, housing and health, it is, in Levitas's analysis, fundamentally Durkheimian in its focus on social integration in work.[28] As such it obscures inequalities in the workplace, particularly those of gender, pay levels, status and position of unpaid work.

The importance of Levitas's work for the arts lies in her ability to distinguish the distinctive threads of meaning with the clarity necessary for assessing their implications and ultimately their impact. The enthusiasm with which the arts community has adopted the social inclusion agenda collapses, and disguises, the fundamentally problematic nature of the term. It is this issue that Levitas addresses. Unless a degree of clarity is introduced into the debate within the arts community itself then all attempts to realise and meet the imperative for social inclusivity is doomed to the management of disappointment and confusion: the opportunity and condition of the current situation allows contradictory and conflicting outcomes to co-exist as positive and beneficial. The reduction in youth crime as a result of an arts initiative will be seen as successful, whatever the rigour of its empirical findings, as long as 'they', the excluded, *attend*. Ultimately, mere attendance is wanting, not least financially. The arts world need to know what they *do* do, not what they, or others, would like them to be *seen* to be doing.

As Levitas draws her initial summary of the three discourses to a conclusion, she acknowledges the overlap and sharing of common elements: the place of paid work and moral content. She also recognises the oversimplification, but value, in highlighting the distinctive feature that each discourse puts forward as being lacking in the excluded: 'in RED they have no money, in SID they have no work, in MUD they have no morals'.[29] It is a short step to recognise an oversimplification of the artist as individual, and as myth, in this summary. In a similar vein to

the condition of the individual artist at 'risk' in the model of society proposed by Hutton referred to earlier, it is through a reading of Levitas's work, and in light of the social inclusion imperative adopted by the Department of Culture, Media and Sport, that a radical reconfiguring of the role of the artist in society is being articulated. The 'free, undisciplined, unregimented, uncontrolled' individual of twenty years ago in Rees-Mogg's art world is also the moral delinquent of today, their response to the vagaries of the 'spirit' is now our liability, and they need to work.

The social inclusion agenda has the potential for delivering not only a level of social responsibility in the institutions and organisations of the arts world, but also to bring 'respectability', through social responsibility, to the individual arts practitioner. Whatever the explicit intentions of impact research, whether economic, social or regenerational, the corollary evaluation of the arts as responsible to the cultural agenda, or for the social order, is being made. Whether this is either desirable or constructive for the institutions, organisations and individuals who constitute that world, it is the responsibility of the arts world to negotiate their identities and values for themselves. Although the meanings and intentions are confused, the terms and conditions are absolutely clear.

Conclusion

The headline announcing the reduction of youth crime secured by the arts and sport made by Tessa Jowell in *Community Renewal News* placed the phrase 'can reduce youth crime' in quotation marks. This suggests either a respect for the actual words spoken, or an attempt to question the value of the announcement: the report also treated it as a claim. In support of this announcement, which prefaced the launch of the Creative Partnership scheme, Jowell reported the 'growing evidence in support of arts-based initiatives in the criminal justice system'. What is at stake is the £40 million invested in a two-year 'arts' project where the expected outcomes reported are 'lower truancy rates and youth offending'. There are three issues of interest here: the first relates to the

validity of evidence, the second concerns the instrumental use of the arts, and the third issue is the broader discourse of social inclusion.

Considerable attention has been paid to the study of impact in economic and social terms. Increasingly, this research has been critiqued both for its methodology and the validity of the data presented. However, given the current political emphasis on the need for evidence-based policy there seems little support for abandoning the project. This is particularly the case in a European context where the cultural agenda is being driven by a discourse of social inclusion framed around employment. Rather, the research will continue through refinement of the instruments of analysis and the quality, and relevance, of data assembled. Moreover, there is a validity in the exploration of impact studies *conditionally*. The context, both historical as well as political and economic, is essential for any accurate reading of the search for evidence of the cultural. As such, the project is not essentially flawed. It is flawed in relation to the standards and conditions of its critique. This is not to lapse into the free-fall of absolute relativism. The quest for economic indicators and the justification for arts subvention in the 1980s, and the social apologetic of the 1990s, though wanting methodologically, has a relevance to the time in which they were being explored. Indeed, they have opened up areas for debate previously unrelated to the arts, and have extended the agenda of cultural discourse through an empirical route which has challenged the autonomy of arts practice at a theoretical level. This opens up the possibility of a theory of the cultural which posits the arts as non-autonomous and socially valued. If the cultural value intrinsic to arts activity is allocated space in this process, then the framework is in place to generate a comprehensive, robust and relevant cultural policy.

The threat of the instrumental use of the arts is the redundancy of the arts per se as the vehicle for social change. This is the logical extension of the singular application of the arts in securing social objectives. Funding, which is conditional on social outcomes, faces the challenge from alternative interventions in economic terms: the arts become the luxury option in the face of efficiency. However, given the low pay of the arts worker who would be responsible for actual delivery

vis-à-vis other professionals, this would seem unlikely. Nevertheless, granted that the subsidised arts receive public funds, and reciprocity is expected, then the terms should be primarily cultural. This does not exclude the instrumental. Rather, it places emphasis on the cultural value intrinsic to arts activity and reserves the instrumental as corollary. It challenges the tendency to collapse the value of arts activity into an assessment of either social, economic or regenerational impact through offering a model of arts activity which is complex, multi-faceted and multi-referential. It also returns the argument to the discourse of social inclusion. The youth offender and the truant have a right of entitlement to, and a right to contribute to, the culture/s from which they are 'excluded' however 'morally delinquent' their behaviour.

Ruth Levitas was guardedly optimistic that, whatever her reservations, the idea of an inclusive society might inform her own quest for a just and sustainable society. It is a mercurial concept which feeds on a lack of clarity: its appeal lies in its flexibility at both an individual and political level. As a motivator for participation it plays on the fear of exclusion, yet at the same time stigmatises difference and fosters social control. As a political instrument it serves as a moderator of conflicting intentions: varying aspirations can be disguised through the flow between the different discourses. Moreover, it is through the articulation of these discourses that the desires of government may find common cause with the endeavours of arts practitioners *and* cultural institutions. It also provides the framework for the cultural to negotiate, and participate, with non-cultural agencies and agendas. This is its strength. However, its meanings are various and it is neither desirable, nor sustainable, for the arts to disguise the latent differences for the temporary attention, and funding, it offers.

I would like to thank students and colleagues in the Department of Contemporary Arts at Manchester Metropolitan University for their unwitting contribution to the ideas in this article. I would also like to thank Tom Cockburn, Victoria Pallin and Virginia Tandy for their advice, knowledge and support.

Notes

1 Department of Culture, Media and Sport, 'Policy Action Team 10: Report on Social Exclusion', at http://www.culture.gov.uk/global/publications/archive_1999/pat10_social_exclusion.htm (accessed July, 2003).

2 The Arts Council of Great Britain, *The Glory of the Garden: The development of the arts in England* (London: Arts Council of England, 1984).

3 W. Hutton, *The State We're In* (London: Cape, 1995).

4 R. Levitas, *The Inclusive Society* (London: Palgrave, 1998).

5 See Department of Culture, Media and Sport, Press Notices Archive, at http://www.culture.gov.uk (accessed July 2003); for example, '£12 Million cash splash to turn youngsters away from crime' (9 May 2002); '"Arts And Sport Can Help Tackle Crime" Says Tessa Jowell' (21 March 2002).

6 See M. Reeves, *Measuring the Economic and Social Impact of the Arts: A Review* (London: Arts Council of England, 2001); C. Wavell, G. Baxter, I. Johnson and D. Williams, *Impact Evaluation of Museums, Archives and Libraries: Available Evidence Project* (Resource and Robert Gordon University, 2002).

7 See P. Merli, 'Evaluating the social impact of participation in arts activities', *International Journal of Cultural Policy*, 8.1 (2002), 107–18; S. Selwood, 'Measuring Culture', at http://www.spiked-online.com (accessed July 2003); T. Hanson, 'Measuring the Value of Culture', *International Journal of Cultural Policy*, 1.2 (1995), 309–22.

8 See M. Wallinger and M. Warnock (eds), *Art For All: Their Policies and Our Culture* (London: Peer, 2000), for an illuminating anthology of texts examining the relationship between cultural practitioners and policy makers'.

9 Tate Britain, opened 1897; Tate Liverpool, opened 1988; Tate St Ives, opened 1993; Tate Modern, opened 2000. For a timeline history of the development of the Tate Galleries see http://www.tate.org.uk/archivejourneys/historyhtml/timeline.htm (accessed July 2003).

10 See Stuart Davies, 'Local Authorities: New Opportunities and Reduced Capacity', in S. Selwood (ed.), *The UK Cultural Sector: Profile and Policy Issues* (London: Policy Studies Institute, 2001), 104–17.

11 The Arts Council of Great Britain, *The Glory of the Garden*, iii.

12 R. Hutchison, *The Politics of the Arts Council* (London: Sinclair Brown, 1982), 17.

13 R. Witts, *Artist Unknown: An alternative history of the Arts Council* (London: Little, Brown & Company, 1998), 508–09.

14 See http://millennium-dome.com/dome/ (accessed July 2003): 'The new millennium officially started in Greenwich, England on 1st January 2001; the World's biggest dome was built on the Meridian Line (The Prime Meridian of the World) in Greenwich to celebrate this historic event'. The project of cultural exhibitions and events held in the Dome during the preceeding year of 2000 was marred by political controversy.

15 Arts Council of Great Britain, *The Glory of the Garden*, iii.

16 Arts Council of Great Britain, *The Glory of the Garden*, v.

17 See Witts, *Artist Unknown*; N. Pearson, *The State and the Visual Arts* (Milton Keynes: Open University Press, 1982); Hutchison, *The Politics of the Arts Council*; J. Harris, 'Cultured into Crisis: The Arts Council of Great Britain', in M. Pointon (ed.), *Art Apart: Art, Institutions and Ideology across England and North America* (Manchester: Manchester University Press, 1994).

18 Hutchison, *The Politics of the Arts Council*, 82.

19 Pearson, *The State and the Visual Arts*, 59.

20 O. Bennett, 'Cultural Policy in the United Kingdom: collapsing rationales and the end of a tradition', *International Journal of Cultural Policy*, 1.2 (1995), 212.

21 Arts Council of Great Britain, *The Glory of the Garden*, iii.

22 See Department of Culture, Media and Sport, *Centres for Social Change: Museums, Galleries and Archives for All* (London: Department of Culture Media and Sport, 2000); J. Dodd and R. Sandell (eds), *Including Museums: perspectives on museums, galleries and social inclusion* (Leicester: Research Centre for Museums and Galleries, University of Leicester, 2001).

23 A. Heath, R. Jowell and J. Curtice, *The Rise of New Labour: Party Policies and Voter Choices* (Oxford: Oxford University Press, 2001), 1.

24 Heath, Jowell and Curtice, *The Rise of New Labour*, 5.

25 Heath, Jowell and Curtice, *The Rise of New Labour*, 10.

26 Levitas, *The Inclusive Society*, 54.

27 See Levitas, *The Inclusive Society*.

28 Levitas, *The Inclusive Society*, 178–89.

29 Levitas, *The Inclusive Society*, 27.

7

A Changed Experience of Space

**WOLFGANG WINTER AND BERTHOLD HÖRBELT
INTERVIEWED BY DANIEL BIRNBAUM***
INTRODUCTION AND NOTES BY LAURA BRITTON

Wolfgang Winter and Berthold Hörbelt form an artistic partnership whose signature pieces are 'crate-houses', architectural structures made out of used bottle crates. From lighthouses, cinemas and tea houses to lookout towers and bus-stops, their multi-functional work has been shown and used in major exhibitions around the world from the Venice Biennale to the Skulptur.Projekt Münster. These colourful fabrications might look ephemeral, transient and temporal, mirroring their functional building blocks; however, the meticulous attention that the artists pay to details such as lighting and creative design renders these houses slick and glossy products. The utilitarian simplicity of the buildings references modernist architecture, the purity of which is subverted, however, by the fact the work is site-specific and both socially and politically engaged. Through the gaps in the crates the outside world is visible, and while on one level the towers of crates they build seem impenetrable, on another they break down the boundaries between outside and inside space: location and function is central.

For the Liverpool Biennial Winter and Hörbelt chose a run-down 'balcony' area above a row of shops that masks the façade of the city's main railway station, Lime Street. Intersecting an architectural face-off between the dreary concrete exterior of St John's shopping precinct, a multi-storey car park and the Corinthian arcaded frontage of one of

Liverpool's most important municipal buildings, St George's Hall, *Crossing* articulated the contradictions inherent in the fabric of a city with a chequered history of power, wealth and poverty. As Lewis Biggs, Director of the Biennial, stated: '*Crossing* is intended to contribute to a material dialogue between citizens and city, helping to create a debate around the planning of Liverpool's city centre developments'. The circumference of a stagnant puddle on the site became the ground plan of the structure and its thin metal lattice walls ensured it blended into its urban setting; the work was a place to look out from rather than an object to look at.

'In our work, the crucial focus is on a changed experience of space, of the actual surroundings...'

DB During recent years, your sculptures made of used drinks crates have caught the international eye. Your crate-houses were on show at major exhibitions such as 'Sculpture Projects in Münster 1997' and at Harald Szeemann's *Apertutto* exhibition at the Venice Biennale in 1999. Alongside the crate-houses you have also pursued a few other interesting ideas, among other things the groups of works using games equipment. What do you find interesting there?

WW Well, these devices are simple objects, usually made of tubular steel. In terms of formal idiom, they are pretty minimalist,[1] and they are colourful. They can be found everywhere the globe over, but in the USA, for instance, they look somewhat different from those in Sweden. We repaired the games equipment people gave us as they no longer used them, and added a new coat of paint. And other items we simply invented, i.e., we made them according to our own specifications and then exhibited them in public spaces.

DB They're typical modernist sculptures, aren't they?[2]

1 *Crossing, Basket #3
(Requiem for a Balcony)*
(September–November
2002), light screen
(gridded slats), 8
galvanised steel doors,
various materials, 330 x
1175 x 480cm, Lime Street
Station, Liverpool, © the
artists

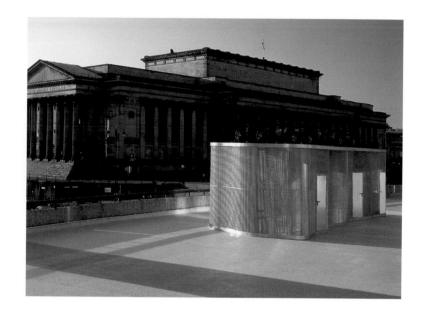

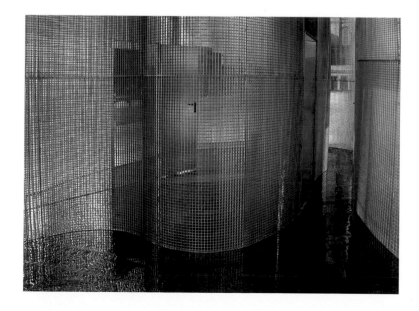

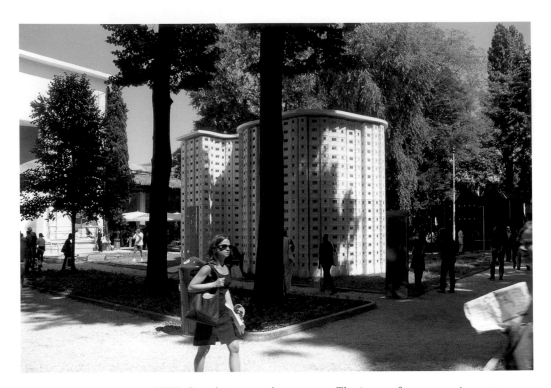

2 *Kastenhaus 1840.17,*
Casa bianca per una
Nazione sconosciuta
(1999), white Italian bottle
crates 'Lissa', various
materials, Giardini, Venice
Biennale, © the artists

WW One thing says they are not. The items of games equipment are conceived of as objects to be used and that flies in the face of the modern sculptural tradition. They are items for gymnastics, apparatus that contains references to their possible uses. They get by without words. You are always reminded of something or other. They can be seen formally as sculptures or at the same time used as gymnastics apparatus.

DB Is that applied art, as it were?

WW They leave the division between applied and autonomous art well behind them. They are both: sculptures that can be used as apparatus.

DB Do you feel there are real references here to art history?

WW The group arose from a focus on questions of art in public spaces. And of course I immediately think of the work of Marcel Duchamp. His readymades such as *Porte-Bouteilles* (1914) or the *Roue de bicyclette* (1913) on its plinth are not only anti-art,[3] they also show that the

context in which an object is placed is of decisive importance as regards how it is perceived. One could add, paraphrasing Sol LeWitt: An object of art is in itself insignificant; what is important is the idea it transports.

DB Do you think that anyone familiar with your games equipment will then look at playgrounds in a different way? Sometimes art involves such a circle. If, for example, I am having to wait at the airport and am looking outside, then I repeatedly discover pictures by Andreas Gursky. And I would assume, now that you have drawn our attention to the recurrent aesthetics of playgrounds, that we will now probably see them in a new light.

WW It is not just the aesthetics of such a location that is suddenly in focus. Playgrounds are also places where bodies are exercised and trained, and the entire body and fitness cult perhaps somehow starts there. Later in life, people go to health clubs to work out. Incidentally, I was a child who almost never went to playgrounds; we had meadows, woods and best of all a really interesting and adventure-ridden scrapheap near-by.

DB Your crate-houses have also led to people relating crates for mineral water bottles to your work and seeing them from a new angle. Each time people see a few crates stacked up, for example, at the local drinks store or even at home, they find themselves seeing works by Winter and Hörbelt.

BH At the beginning, there wasn't any specific strategy to it, or any fixed concept, and to tell the truth we are sometimes surprised ourselves at the way things are going. We wanted to build large-scale sculptures that people could walk through and the crates seemed just the right kind of material. Working with the crates we discovered aspects of the material that are worth developing further. For the exhibition Demeter in Obihiro, Hokkaido, in Japan, we plan to change the method of construction we have used completely.

DB Which begs the question: when does art start to become effective? Now, when people see crate buildings, they think of you. Unpleasant bureaucratic situations remind them of Franz Kafka. This is very interesting. When an artist takes something from the real world and amplifies it, then, when we then see it again in what we call the real world, we think about that artwork. With Pop Art, art clearly demonstrated for the first time what it can do with items taken from the commercial world. Nowadays, things can go in the opposite direction, too; everything is becoming much more complicated, and there is a constant exchange between the different worlds. In the commercial world, for instance, quotations by artists are always cropping up – by Pipilotti Rist or Matthew Barney to name but two.[4] In this application created through advertising they lose their meaning, become strident. Your work, the crate-houses at least, are – on a superficial level – a kind of logo. But upon more careful consideration, additional aspects become apparent, even looking at the work produced alongside these crate-houses. Alongside your work on the crate-house project, there are other projects, which appear to be of secondary importance. As a student, and then as a university professor in Sweden I wrote about art in my free time and suddenly what had seemed to be incidental took on an increasingly central role. Is the same true of your project in São Paulo? Just what have you got planned for it?

BH Artecidade is a Brazilian initiative which organises projects and discussion forums on the subjects of urban development and mega-cities. Brasmitte, a project to which we were invited in 1999, dealt with the Bras district and originally a dialogue with Berlin Mitte was planned. Hence the name.[5] Because the city has spread rapidly from the centre outwards, Bras has been pushed into the eastern zone of São Paulo and is currently serving as no more than a giant warehouse for food and raw materials. One of Artecidade's objectives is to investigate how the district can regain some of its urban flair. Artists, architects and sociologists have been invited to come up with architectural/artistic designs. Suggestions have, for instance, been received from Vito Acconci and Rem Koolhaas.[6] Interventions are planned at various

3 *Cola View Point* (1999),
various materials, model
110 x 35 x 35cm,
Artecidade, São Paulo, ©
the artists

locations within the district, along with a central exhibition at a cultural centre in the SECS Belenzinho district. This is where we intend to erect what we call our Crate-House View Point for São Paulo, which has already been developed and presented locally. This belvedere offers a good view of the eastern zone of São Paulo.

DB When is this project due to start?

BH It actually started several years ago. The project concept can be viewed on the Internet. The project is about to be implemented.

DB How does an artist cope with the fact of implementing a work of art in such a vast, chaotic city?

WW The example of São Paulo demonstrates a particular kind of dynamism, but also the brutal toughness of the mega-cities. In some part of the city there is a kind of poverty that highlights the limits of the artist's desire to design the world artistically or even renders such efforts obsolete. On the one hand, there are closely guarded villa

districts surrounded by barbed wire fences and on the other, families living on the streets. Every week, a few thousand people swell the ranks of São Paulo's at least 15 million inhabitants, all hoping for some kind of social betterment, however small. There are people living on the central reservation of the highway. Many people end up in the favelas, giant housing projects, containers for thousands of people. At this point it would take too long to describe life there. But coming to terms with a mega-city of such dimensions provokes one to rethink a number of things and to re-evaluate one's attitude to art.

DB What are the projects you are currently working on?

BH At the moment we are developing an item for an exhibition in Obihiro in northern Japan. Obihiro is a town on the island of Hokkaido, about three hours' train ride from Sapporo. In the town there is a place where several horse-races that are completely foreign to us Europeans take place every year. Fat, cold-blooded horses are made to drag concrete blocks across hills, up and back down again, always over sandy terrain. In the winter, up to 500 horses live on the grounds. They are very large grounds with flat buildings where, depending on season, the horses can be housed, together with the families of the people who look after them, and there is a giant hall where people can play a kind of horse lottery. All in all, for us it is an unusual location; it even seems almost unreal. And it is here that we will be realising a large-scale project, a gangway

DB People are already familiar with the way your works in public spaces function in Europe. What is different in Asia, where you have already realised several projects?

WW Two and a half years ago we built the Hanoi City Tea House in Hanoi, Vietnam. We had been invited to work as university professors at the University of Fine Arts. The way the students work there is very classical and very academic. After initial difficulties in making contact, we decided to show them how we work. We bought 500 red plastic

trays, some wood and some PVC and erected the Hanoi City Tea House together with the students. We built a pavilion using cheap plastic trays and hand-sawn roof laths. In Vietnam, people normally build things out of bamboo. The Hanoi City Tea House had two narrow entrances, it was rectangular and its interior was about 12 square metres in size. It seems absurd for us Europeans to be building a tea house in Vietnam, a country where tea is actually grown. But we intended it as a place where people could meet without constraints. The installation stood in contrast to the sculptures in the Vietnamese socialist realism style that were all over the campus. It really looked like the former German Democratic Republic or the Soviet Union. To celebrate our opening, there was beer out of converted gas canisters and simple Vietnamese food. It really was very pleasant. At the time, the experience was rather unusual for the Vietnamese students. For them and also for us.

DB What was it that was so unusual, the way you used the new material or the way it was exhibited?

4 *Hanoi City Tea House* (1999), red plastic trays, roofing slats, various materials, 290 x 390 x 270cm, University of Fine Arts Hanoi Campus, Hanoi, © the artists

BH The material was new and the framework was completely different. At the time, the strict exhibition conditions in Vietnam caused us to remain on the campus. And even that created enough of a stir. Vietnamese artists probably wouldn't even have received permission for that kind of activity. When we visited Hanoi this year we held long discussions with university professors and students. For them it was something new to be able to build something publicly. A number of people criticised the pavilion's cheap appearance. When we showed slides of our other work we were often asked who had given us permission for the buildings. If they were to do something similar, they would probably have to take down the installations as a gross misdemeanour or for political reasons the day after they had been put up.

DB Was your work positively received or were some people annoyed, too?

WW Actually, the reception was often a sympathetic one, everybody was quite curious. What I found very interesting was that the colour red does not have positive connotations for the Vietnamese. We had assumed that red was of great significance, since there are red flags and banners everywhere in the city. In Vietnam, the so-called public domain is in the service of politics. Political messages drone out at people from loudspeakers installed all over the streets every day, both in the mornings and in the evenings.

DB Was your work perceived as a kind of disruption?

BH At first, the Vietnamese didn't know what to think. They couldn't see the point of a sculpture they could walk into. Naturally, both professors and students at the academy knew about Western art, but we were seemingly the first Western artists to build a work of art designed as a meeting-place. Of course the point should not be to produce something that would serve as an example for future artistic work.

DB What was, in fact, the starting point for your collaboration? You wanted to redefine the traditional concept of sculpture, and you did not want to work within a normal art context. Which means that on the one hand you wanted to work as part of a team, but on the other, to exhibit not only in galleries and museums, but in other locations, too. This is how it started, isn't it?

WW We studied at an academy where the commercial aspect of the whole art business was not really stressed. Accordingly, we were not initially looking too far ahead when we decided to work together. We knew each other very well and had already rented a number of studios together. We offered each other criticism and it consequently became a matter of course for us to design and produce work together, too.

DB Collaboration is interesting. Of course, people do still formulate their own subjective ideas, but at the same time, the two partners more

5 *Lighthouse* (2000), green German mineral water crates, various materials, illumination 380 x 400cm, North Sea, outside the Nordisk Akvarellmuseet, Skärhamn, Sweden, © the artists

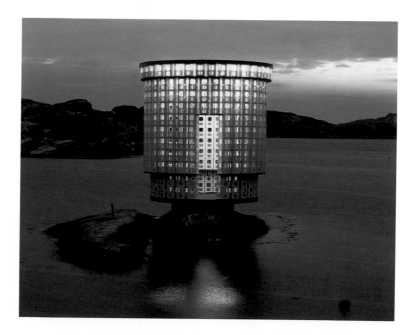

clearly push each other in the kind of directions that they might not have considered alone. The question is: does one moderate one's own tastes or do the two partners head in a new direction together? How do things work between you two?

BH We attempt jointly to achieve an optimum situation with regard to our artistic endeavours. And, to a certain extent, we need the ability to work as a team. In every project we collaborate with people from other specialist fields and with our own staff.

DB You mention Richard Serra's work as an early source of inspiration during your studies.[7] How do you see this today?

WW Actually, there were a whole series of North American artists that initially impressed us a great deal. We both found Walter de Maria pretty good, and the exponents of Land Art, artists such as Michael Heizer and Robert Smithson were of great significance for us, even if we do work in a completely different way.[8] And talking about Richard Serra: the monumental quality of his sculptures was very attractive to fledgling sculptors. *Tilted Arc*, for example, was a great sculpture and a truly radical project for the public sphere in New York. European sculptors of that generation such as Ulrich Rückriem also influenced us.[9] Rückriem's sculptures possess a great clarity and a real down-to-earth quality. Of course, our generation has other preoccupations and other questions to ask. Issues that we need to address. But the question of whether Ad Reinhardt's 'Art is art and everything else is everything else' is still relevant remains unanswered.

DB How do you get involved? What role does the size of an intervention in the public sphere play?[10] Sometimes your projects are very helpful to their locations, they aim at complementing something, at improving a situation. How did you change the public sphere in Münster, during the 'Sculpture.Projects in Münster'?

BH We erected our pavilions at four different points in the city. At the time, these pavilions were designed as information stands for an exhibition, with no ulterior motive. At the same time, we were reacting to certain urbanic features, something exemplified by the Bauzaun, a box-like construction in front of the Karstadt department store in downtown Münster. In this area one is confronted by a large number of architectural decisions and consequently with stylistic models. On the occasion of the 'Sculpture Projects in Münster' in 1987 Scott Burton suggested converting the square into a potato field. Later a stainless steel sculpture with a sheet metal flag was put up here, a gift from one of the city's patrons. The ground was paved with cobblestones to give it a historical air and typical urban furniture was grouped around the local trees. We initially wanted to integrate the stainless steel sculpture into a box-like construction, but we later decided to build the box-like construction in Salzstraße around the already existing sculpture. The Bauzaun can be walked through, thus making it into a vehicle that allowed people to cross the square without perceiving the environment in the usual way.

DB Nevertheless, this work is a bit different from the others. It is an arcade, whereas your work is otherwise fundamentally concerned with the relationship between the inside and the outside. Here, the inside is more important than the outside. It is almost a meditative cell, one that demands a kind of concentration. Here there was something different, here there was a transition. Here, people were helped through.

WW Our aim is to redefine the terms 'location' and 'path'. This work deals with a changed perception of space, of a concrete urban environment.

DB I have just been reading what Benjamin Buchloh has to say about Thomas Struth. For the past twenty-five or thirty years, Struth has kept taking all those photos of various cities and Buchloh interprets the activity as a way of bearing witness to a vanished world. He notes that there is no longer such a thing as public space. Everything has become

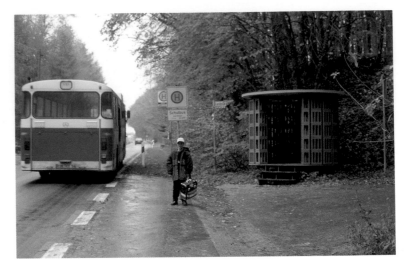

6 *Kastenhaus 90.5, Bus
Stop* (1998), brown bottle
crates, various materials,
260 x 260 x 200cm,
Havixbeck, Baumberg,
Germany, © the artists

an issue and as for art, it is expected to do something new. Which
means that even public space has become an art complex.

WW And it also depends on how you define it. But is there still such a
thing as public space?

DB While I was writing about Thomas Struth's street photos I had the
impression that the world they were portraying had long disappeared.
Of course, you still find those kind of streets in Düsseldorf or in other
European cities, but the era visible in his photographs is not the present
one. As Benjamin Buchloh suggested, these images can be seen as
archives of a global disappearance of the real: in this case of the reality
of a social sphere and its architectural structure. Our age of electronic
communication and media technology challenges our old notions of
public space. These images of architecture photographed in the old way
appear as reproductions of a past charactcrised, as Buchloh shows, by
utopian expectations of the public experience, social interaction and a
sense of a spatially and temporally limited reality. Since our notion of
public space has changed, it may be appropriate to redefine our notion
of art in public spaces. It is possible that a number of your works have
already taken these changes into account.

WW Let us assume that public artistic activities are always site-
specific.[11] So, our aim is to offer functional alternatives. Depending on

the circumstances, a work of art can then offer new ways of using a location, while simultaneously highlighting its autonomy and freedom.

DB There are different ways of using your work. On the one hand, you create a place for concentration, for perception; on the other, perhaps this same place will also be used by young people, for their parties.

WW Nobody is ever refused entry to our crate-houses, they are open to everybody. Some people spend the night in them, too. In Münster, a local tramp used the pavilion in front of the castle as his sleeping quarters. Then, of course, it temporarily became his house.

DB On the subject of the different ways of using a space: sometimes art is only concerned with seeing and enjoying something. But in your case there is always this ambiguity. On the one hand, what you produce looks good and interesting, on the other, it has a kind of function, even if this is only to create space for the people passing by. I am thinking of two of your works: the cinema in Berlin and then the bus stop. These are two examples. Perhaps you can say a few words about them.

7 *Lichtspielhaus 2640.15* (1998), brown bottle crates, various materials, canvas, projector, 100 folding chairs, 550 x 900 x 2150cm, *The Cinema Project (Tarantino Syndrome)*, Künstlerhaus Bethanien, Berlin, © the artists

BH In the case of the cinema for the Cinema Projects exhibition at Künstlerhaus Bethanien we knew that we needed to address the kind of questions that we are usually not too interested in. How are the acoustics? Where do people sit? But right from the outset we were interested to

know how the crate-house would change when it showed its first film, how the film projector's flickering lamp would light it up.

DB People often maintain that today art is, and has already been for some time, engaged in discussions with other applied fields, be they design or architecture. The above was an example of an instance where this dialogue really has been implemented.

BH In the case of the cinema, our main preoccupation was still with questions relevant to sculpture. In the final analysis, it must look as if we simply come along, pile up a few crates, put on a roof and that's that. These are not monuments or memorials to any clearly defined person or occasion. In the final analysis, these works, in all their emptiness, stand for themselves, too, even when a real function is a possibility, for instance that of a bus stop.

DB Sometimes, you have linked your projects to other functions – we have already mentioned the cinema. And then there are your projects in Billerbeck. Here, for an art form, things become more complicated. Perhaps you should explain what the assignment was.

BH There is a chapel in the Westphalian town of Billerbeck designated a war memorial to the soldiers who fell in the First World War. A local citizens' initiative wanted to rename the chapel. To this end, a procurement process was initiated, a competition which was organised to convert the chapel into a monument to the victims of all kinds of violence.

DB A monument? What did you do?

BH To begin with, we renamed the war memorial 'Chapel of Peaceableness'. We attempted to invent a permanently recurring ritual, a kind of long-lasting performance – admittedly on a temporary basis – but to last for as long as thirteen years. Every Sunday at the same time a musician plays a piece of music in front of the chapel. Not only is the

musician interpreting the piece of music, he is also standing there as a person. The people of the town – and visitors come from outside, too – see this as a symbol. There is one person standing there with a musical instrument, or he sings, it takes four minutes, sometimes it snows, sometimes it rains, sometimes the sun shines, but punctually at 11.30 a.m. he is standing there performing his piece. It is a composition by Friedrich Jaecker from Cologne.

DB How did you come upon the piece?

WW Friedrich Jaecker was recommended to us and in a very short space of time we were sure that he would write us the right composition. The piece written for Billerbeck plays with omissions. The long pauses between the individual fragments of tune are, if I may say so, very sculptural. They incorporate the surrounding noises. The music opens up a space, much more so, in this instance, than would be possible with a tangible sculpture. The only material sculptural element by us is an unspectacular platform made of artificial red stone, on which the musician stands to perform the music.

DB How important to you is the political aspect of this kind of performance in this kind of location?

WW Such locations are often to be found in Germany. And yet the subject is highly explosive. We spent a long time discussing whether we should intervene there, and if so, how. The risk of being misunderstood on such occasions is very great. But on the other hand, this is part of our work. It is often the case with these monuments, that are erected all over the place, that in the final analysis large memorial stones do not elicit sympathy. They are often laden with false pathos. Of course, we have had thoughts about the monument in Berlin and followed the discussions surrounding Peter Eisenmann and Richard Serra's design for Berlin's memorial to the victims of National Socialism. It remains to be seen how this kind of monumentality will be received in years to come.

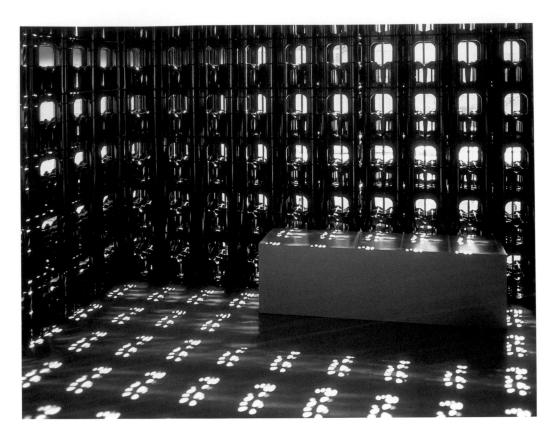

8 *Kastenhaus 1100.10, 'Is there anything between black and white?'* (September–December 2002), white and black bottle crates, various materials, electric light, 358 x 930 x 415cm, Fribourg, Switzerland, © the artists

DB In all your work it strikes me that you always include the people who navigate your sculptures. Inside and outside space relate to each other like the private and the public sphere. And one also senses a kind of unprejudiced hospitality and a permanent surprise: people enter a space and find something quite different from what they had expected.

*Interview recorded April 2002.

Notes

1 Rejecting the painterly excesses of Abstract Expressionism, Minimalism was a move in the 1960s towards an art based on an economy of means. Materials from commercial manufacture were employed, such as bricks, glass, acrylic and metal, which removed the sensual appeal of the artist's touch. Pioneers of High Modernism Michael Fried and Clement Greenberg saw Minimalism as a betrayal of the cause. In his essay 'Art and Objecthood' Fried argued that Minimalism borrowed techniques of the theatre and was, in essence, 'literalism', it therefore crossed two distinct art forms blurring the purity of the medium that Modernism insisted upon. Indeed, this criticism is not unfounded in the sense that minimalist sculpture, with its simple, clean symmetry often bears a closer resemblance to architectural forms than to traditional art forms.

2 Privileging form over content and structure over meaning, modernist sculpture strove for formalistic and ideological autonomy. To differing degrees and driven by diverse motivations, theorists from Maurice Denis, Roger Fry and Clive Bell to Clement Greenberg pioneered a reassertion of the formal qualities of art, its shape, its colour, its composition, its use of line and its order. In inverse proportion the value of literary associations, subject matter, symbols and metaphors, was questioned. Intrinsically connected to this was the problematic relationship between the art product and the context of production: art and life. In a pluralistic age where personal identity is political, the idea of a purely formalistic approach to art is archaic. The notion of art as autonomous – an ahistoric object existing in a socio-political vacuum – is the provenance of the utopian dream of a bygone era. As Daniel Birnbaum's comment suggests, the irony is, however, that while the theoretical bubble has been popped, Winter and Hörbelt's works *look* like 'typical modernist sculptures' when in fact, they reject the central premise of Modernism. These objects are not autonomous, they have a function, they relate to their context.

3 The smooth efficiency with which Duchamp critiqued the authenticity of the artwork and its hieratic status has become a paradigm for artistic production in the 20th and 21st century. His readymades question what art is and how it is valued. Taking this to an extreme level the art object itself becomes irrelevant as it is the context in which it is placed that gives it meaning. Perhaps the strongest assault on the notion of Art (with an 'A') was mounted by artists associated with conceptual art who destabilised the art object through what Lucy Lippard described as a process of 'dematerialisation' where ideas and creative processes take precedent over making a final precious object. In his article, 'Sentences on Conceptual Art', Sol LeWitt argued that: 'Ideas alone can be works of art; they are in a chain of development that may eventually find some form. All ideas need not be made physical.' In this way, artists like LeWitt redressed the hegemony of the autonomous object. Interestingly, Winter and Hörbelt have set up a careful balance between the physical vehicle and the ideological content of their work.

4 Combining the cinematic excesses of Hollywood with the absurdities of Surrealism, Pipilotti Rist and Matthew Barney have both made dramatic and sumptuous films suspended somewhere on the brink of popular and high culture. Their work emulates and perpetuates the illusionist qualities of narrative cinema and the lighting and sonorous effects of pop videos. This sets them apart from low-tech video artists who critique the sophisticated sheen of mainstream media through using equipment that exposes the physical process of film making. In this way, their work engages a wider audience extending beyond traditional art audiences. Because its 'look' is accessible, the artists reciprocally influence the very industries

that their work borrows from. Similarly, as their work attains a new level of celebrity so the artists, who often perform in their artworks, become more than artists, they become film stars.

5 Led by the cultural critic curator Nelson Brissac Peixoto, Brasmitte was intended as a highly ambitious series of exhibitions. Winter and Hörbelt's project proposal was a lookout tower out of red Coca-Cola crates looking out at a horizon view stretching across the São Paulo skyline juxtaposed with a bird's-eye view of low-cost housing and factories of the valley below. The city in all its magnitude is revealed in contrast to the sprawling suburbs that lie on its fringes. The crates were a metaphor for the industrial processes of shipping and exchange that have none of glamour of the consumable object: Coca-Cola and the city. Artecidade is a regenerative arts project independent from the Sao Paulo Biennial, and the Brasmitte proposals were not realised due to a lack of funding.

6 Vito Acconci made his name in the 1960s and 1970s with radical performances, body art and interventions into public spaces. In works such as *Following Piece* as part of 'Street Works IV' Acconci followed random strangers in the street, abandoning them once they went into a building. Rem Koolhaas creates architectural and art projects that are vast in scale; many of them have been realised but many of them remain as ideas or are proposed as concepts. His proposal for the renovation of Bankside power station into Tate Modern was shortlisted and he was one of ten architects chosen to tender a proposal for MoMA's rebuild; his ideas were exhibited in MoMA's exhibition entitled *Toward the New Museum of Modern Art*. Both of these artists have careers built on exploring and expanding the potentialities of the environments in which they work.

7 Emerging from the aesthetic asceticism of Minimalism Serra's work is characterised

by its enormity of scale and its heavy industry materials. In 1981, his infamous *Tilted Arc* was installed in the Federal Plaza in New York City. A 120ft curving wall of raw steel cut diagonally across the Plaza: its impact was both overpowering and debilitating. The huge structure enacted an assault on the ergonomics of the plaza, forcing workers to circumnavigate the sculpture rather than walking straight across the public space. Controversial from the start, the sculpture was condemned for disrupting the view, obscuring CCTV cameras, being a bomb hazard and providing shelter for drug dealers. The work was eventually dismantled and scrapped in 1985. At the public hearing to decide the fate of the work, Serra testified that if the sculpture was moved he would remove his name from it. For Serra, the structure's location, in the Federal Plaza, was implicit to the work. The extensive legal, aesthetic and political discourse that surrounded the piece published in *The Destruction of Tilted Arc: Documents* (1990) reflects the extent to which this work could only be understood in relation to its context.

8 Earth or Land Art as it is often called, was a move in the late 1960s and early 1970s to redress the relationship between art and environment. Whether a site-specific construction added to the land, a cut or subtraction from the landscape or the relocation of land into an art gallery, Land Art engaged with the radical eco-politics of the late 1960s and was motivated by a desire to re-mythicise the land. In 1969 Michael Heizer completed *Double Negative* a 1,500ft long, 50ft deep and 30ft wide gash into the slopes of an anonymous plateau in the Nevada desert. Similarly, in 1970, the artist Robert Smithson built *Spiral Jetty* in Utah, an unusable jetty that spiralled into the pink waters of the Great Salt Lake. Two trucks, a tractor and a front loader were required to dig and transport the 6,650 tons of earth that were poured into the lake to create the jetty. Walter de Maria's *Lightning Field* in

1977 harnessed lightning with the aid of special conductors to create spectacular displays that could be witnessed from a small wooden hut. Famous for its electric storms, the elemental forces of New Mexico where the 'event' was held put on their own show. A gallery sets up relational scales between the building and the work, the vast open spaces in which these works were situated dismantled such traditional parameters. Artists such as de Maria addressed the problem of site by bringing the land into the gallery in his *Earth Rooms* in Munich 1968 and New York 1977. The atavistic quality of levelled fresh earth flooding in the white cube of the art gallery powerfully subverted the urbane with the crude. Yet the white walls ultimately defined the space and contained the mud. Land Art was concerned with this struggle between the refined and the elemental.

9 Straddling the gap between Minimalism and Land Art, Rückriem's work, made up of cold, austere and barely modelled blocks of stone, is at once industrial and of the earth. As a first generation Minimalist his work explores scale, space and size and plays with the internal weights of the material he uses. The monolithic quality of his work creates a sense of timelessness; some of his structures could be archaeological burial or ritual sites, yet his work has an edge of transparency that neither ancient ruins nor Minimalist artworks contain. Exposing the manufacturing processes of quarrying and refining stone, he leaves the tell-tale drill holes, splits and cuts that testify to the workmanship of the artist.

10 Ad Reinhardt's nemeses – artists who make interventions – literally use the world as their canvas and their act as their art. With roots stemming back to Dada it was the formation of the left-wing magazine *Internationnale Situationist* in 1957 that gave this urge to engage with and intervene into everyday urban life a theoretical platform. Emerging as a leading theorist, Guy Debord critiqued social freedom as the myth in a capitalist society in his influential book *The Society of the Spectacle* in 1967. As a means of undermining the mechanics of the city and the way it articulates control Situationists mobilised disruptive strategies of *derive* (drift) and *détournement* (diversion) involving mapping new routes around the city according to their desires and disturbing the navigation of others by removing and diverting road signs, street signs and railings. Other artists who use interventionist techniques within their practice are Barbara Kruger, Jenny Holzer, Gordon Matta Clark and, closely linked to performance art, Vito Acconi (mentioned above). Politically and socially engaged, Holzer and Kruger mobilise modes of dissemination closely associated with both covert and explicit propaganda. As a mode of integrating their work into the world both Holzer and Kruger use posters and advertising billboards around major cities and produce merchandising such as mugs, postcards, T-shirts and bags. Where Holzer's work is text-based, Kruger's bold slogans such as WHY ARE YOU HERE and HELP are juxtaposed with images found in magazines. These items once bought or given away infiltrate everyday life. In works such as *Office Baroque* (1977) Gordon Matta Clark took this desire to penetrate the fabric of urban existence beyond the mental and into the physical. Literally breaking down the material world Matta Clark made a series of incisions into a derelict building, carving a large tear-drop shaped hole into every floor and making a hole in the roof so that the building was exposed to the outside world. Matta Clark's interventions break down, examine and reconfigure what exists.

11 Site-specific art, as its name implies, insists that the place the artwork is situated is an essential part of the work as a whole. It asserts that the artwork is not autonomous or independent of its environment, but that context is central. Artworks commissioned with a particular location in mind can respond to this site in

a number of ways, from taking themes such as the histories or mythologies associated with the place as a starting point, to using the fabric of the place within the work as land artists did. Site-specificity goes hand-in-hand with installation art, where artworks embrace whole spaces to create environments. Again, this practice represents another assault against the interiority of art supported by Modernism. It allows the intangible complexities of place to muddy the purity of the autonomous artwork. As Richard Serra's *Tilted Arc* reveals, the artwork can act as a catalyst exposing latent identities bound up with place by presenting a threatening change.

Further Reading

Friederike Wappler (ed.), *Winter/Hörbelt* (Hatje Cantz, 2003).

Florian Matzner (ed.), *Wolfgang Winter, Berthold Hörbelt* (Hatje Cantz, 1999).

Lewis Biggs (ed.), *International 2002* (Liverpool: Liverpool Biennial of Contemporary Art, 2002).

Gust (eds) *The Urban Condition: Space, Community and Self in the Contemporary Metropolis* (Rotterdam: 010 Publishers, 1999).

New Institutions

John Elderfield (ed.), *Imagining the Future of the Museum of Modern Art, Studies in Modern Art 7* (New York: The Museum of Modern Art, 1998).

Kynaston McShine, *The Museum as Muse* (New York: The Museum of Modern Art, 1999).

Sarah Martin and Sune Nordgen (eds), *B.READ/ONE: New Sites – New Art* (BALTIC and the University of Newcastle Department of Fine Art, 2000).

Wu Chin-Tao, *Privatizing Culture: Corporate Art Intervention Since the 1980s* (London: Holding, 2002).

Minimalism

Michael Fried, 'Art and Objecthood', *Artforum*, V (June 1967).

Gregory Battcock, *Minimal Art: A Critical Anthology* (New York: H. E. Dutton, 1995 [1968]).

Kenneth Baker, *Minimalism* (New York: Abbeville Press, 1988).

Modernist Sculpture

Herbert Read, *Modern Sculpture: a Concise History* (London: Thames and Hudson, 1971 [(1964)]).

Andrew Carnduff Ritchie, *Sculpture of the Twentieth Century* (New York: Museum of Modern Art, 1952).

Raymond Williams, 'What Was Modernism?', in *The Politics of Modernism: Against the New Conformists* (London: Verso, 1989).

Anti-art

Lucy Lippard, *Six Years: The Dematerialisation of the Art Object from 1966–1972* (Berkeley, CA: University of California Press, 1997).

Alexander Alberro and Blake Stimson, *Conceptual Art: A Critical Anthology* (Cambridge, MA: MIT Press, 2000).

Gregory Battock, *Idea Art: A Critical Anthology* (New York: Dutton, 1973).

Hans Richter, *Dada: Art and Anti Art*, David Britt (trans) (London: Thames and Art, 1966).

Pipilotti Rist and Matthew Barney

Peggy Phelan, *Pipilotti Rist* (London: Phaidon Press, 2001).

Michael Rush, *Video Art* (London: Thames and Hudson, 2003).

Pipilotti Rist, *Pipilotti Rist: Apricots along the Streets* (Zurich/London: Scalo Verlag/Thames and Hudson, 2001).

Matthew Barney (ed.), *Matthew Barney: The Cremaster Cycle* (New York: Guggenheim Museum, 2002).

Vito Acconci and Rem Koolhaas

Rem Koolhaas with Bruce Mau (eds), 'The Generic City', in *S,M,L,XL* (Monacelli Press 010 Publishers, 1997).

Frazer Ward, Mark C. Taylor and Jennifer Bloomer (eds), *Vito Acconci* (London: Phaidon Press, 2002).

Lea Vergine, *Body Art and Performance: the Body as Language* (Milan: Skira, 2000).

Collaborations

Charles Green, *The Third Hand: Collaboration in Art from Conceptualism to Postmodernism* (Minneapolis, MN: University of Minnesota Press, 2001).

Suzanne Cotter (ed.), *The Rape of Creativity* (Oxford: Modern Art, 2003).

Robin Dutt, *Gilbert and George: Obsessions and Compulsions* (London: Philip Wilson, 2003).

Richard Serra and Tilted Arc

Martha Buskirk (ed.), *The Destruction of Tilted Arc: Documents* (Boston: MIT Press, 1990).

Harriet Seine, *The Tilted Arc Controversy: Dangerous Precedent?* (Minneapolis, MN: University of Minnesota Press, 2002).

Hal Foster with Gorden Hughes (eds), *Richard Serra* (Cambridge, MA: MIT Press, 2000).

Land Art

Gilles A. Tiberghein, *Land Art* (London: Data Art, 1993).

John Beardsley, *Earth Works and Beyond* (New York: Abbeville Press, 1998).

Lucy R. Lippard, *Overlay: Contemporary Art and the Art of Prehistory* (New York: Pantheon Books, 1983).

N. Holt (ed.), *The Writings of Robert Smithson* (New York: New York University Press, 1979).

Ulrich Rückriem

Andrew Causey, *Sculpture Since 1945* (Oxford History of Art, Oxford, New York, 1998).

Ulrich Rückriem, *Ulrich Rückriem* (London: Serpentine Gallery, 1991).

Ad Reinhardt

Barbara Rose (ed.), *Art as Art: The Selected Writings of Ad Reinhardt* (New York, 1975).

Ad Reinhardt, *Ad Reinhardt 1913–1967* (New York/Los Angeles: Rizzoli/The Museum of Contemporary Art/The Museum of Modern Art, 1991).

Intervention

Stewart Home (ed.), *What is Situationism? A Reader* (San Francisco: AK Press, 1996).

Diane Waldman, *Jenny Holzer* (New York: Guggenheim Museum Publications, 1997).

Ann Goldstein (ed.), *Barbara Kruger* (Cambridge, MA/Los Angeles: The Museum of Contemporary Art/MIT Press, 2000).

Site-specific Art

Thomas Crow, 'Site-Specific Art, the Strong and the Weak', in *Modern Art in the Common Culture* (New Haven, CT: Yale University Press, 1991).

Miwon Kwon, *One Place After Another: Site-Specific Art and Locational Identity* (Cambridge, MA: MIT Press, 2002).

Julian Stallabras, *Locus Solus: Site Identity and Technology in Contemporary Art* (London: Black Dog Publishing, 2000).

Nick Kaye, *Site-Specific Art: Performance, Place and Documentation* (London: Routledge, 2000).

8

Art and Empire
Aesthetic Autonomy, Organisational Mediation and Contextualising Practices

JEREMY VALENTINE

Empire and social order

In *Empire* Michael Hardt and Antonio Negri offer a critical description of the contemporary global configuration of culture, politics and economics.[1] The description is controversial because although the Empire to which it refers is a regime of power and rule it is not the property of a particular nation, state, ethnicity, belief system or culture. Empire does not belong to Mogul or Murdoch. For Hardt and Negri the important question is not what Empire is but what it does and how it does it. In this essay I will discuss some of the ways in which Hardt and Negri's account can contribute to understanding some aspects of the contemporary production, distribution and consumption of art.[2] The essay is not particularly concerned with describing and explaining developments in the formal properties of specific works or categories of art, or with evaluating these according to a set of critical criteria. Rather, the essay will try to locate these aspects of art within Hardt and Negri's account of more general changes in processes and structures of organisation and administration that characterise the activity of Empire, and through which aesthetic values and practices are distributed and mediated. In other words, the essay will try to shed some light on the usually unseen but necessary aspects of art that make relations between works of art and audiences possible in the context of Empire.

The decision to use Hardt and Negri to do that might seem a bit redundant. Given the sales and extensive critical coverage of what is a complex and challenging philosophical synthesis, the thesis of *Empire* may have become part of general common sense by the time that this essay is read, or it may have been systematically refuted. The decision might also be unjustified. *Empire* is not a treatise on aesthetics and does not propose any criteria or standards with which to make, display or evaluate contemporary art. Indeed *Empire* is relentlessly political, not simply in terms of subject matter and analysis, but also in that it uses the style and language of political engagement. Both of its authors are political theorists and political activists, one of whom – Antonio Negri – has been in prison in Italy and France for political reasons on and off since the 1970s.[3] Yet the proposal that *Empire* might be of relevance to art is not entirely forced. Two examples might serve to demonstrate this, the first provided by hearsay, the second by luck.

During a coffee break after I had presented the draft of this essay at a conference at Tate Liverpool in November 2002 convened to discuss the Liverpool Biennial, one of the participants informed me that a group of high-powered international art administrators had gathered at the same venue a few weeks earlier to discuss *Empire*, and presumably its implications for them. I took this news as encouragement that my paper was perhaps not quite as eccentric as I had originally feared. Then, during additional research to prepare the essay for publication I discovered that in May 2002, prior to my presentation in Liverpool, the Europäisches Museum für Frieden (European Museum for Peace) in Burg Schlaining had displayed a text, 'Peace and War', written by Antonio Negri, a co-author of *Empire*, and the philosopher Éric Alliez as part of the Frieden *Weltwärts* (Peace Towards the World) exhibition, which had been commissioned by its curator Elisabeth von Samsonow and the Österreichisches Studienzentrum für Frienden und Konfliktlösung (Austrian Centre for Peace and Conflict Resolution). Two versions of the text, in English and German, each of about 5000 words, were projected on a wall in one of the gallery rooms.[4]

Although I have observed neither, these two examples serve to indicate an empirical relation between *Empire* and the art world. In the

first instance *Empire* has stimulated the interests of people who work in the institutions and organisations of art, or 'art world professionals'. In the second instance some of the topics dealt with by *Empire* were mediated through a site-specific installation, one of the established forms of contemporary art. So both of these examples confirmed the vague intuition that *Empire* may have significant implications for the conditions in which contemporary art is produced and experienced that I had proposed in my original presentation. These implications are both empirical, concerning changes in the ways in which the world is organised, and conceptual, concerning the critical and political relations between art and the forces that can be identified as structuring and organising the world. In what follows I will try to explain and develop the implications of these relations between art and *Empire* by concentrating on the changing political and critical significance of the ways in which experiences of art are being organised, or, to put the same thing slightly differently, the ways in which changing institutional and organisational structures mediate the nature and experience of art, or what is normally called aesthetics. In the first part of the essay I shall outline some of the main characteristics of *Empire* and in the second part I shall attempt to relate them to some of the conditions of contemporary art.

The basic position of *Empire*

The intellectual scope of *Empire* is extremely broad and wide ranging and it would be difficult to address all of its themes. In order to get some perspective on the argument we can begin with the observation that *Empire* does not exist in a vacuum but engages with and draws on debates that have characterised critical thought for the last thirty years or so, and that are often described under the heading of postmodern culture, which is associated with the following characteristics: a decline of the idea that truth can be established by criteria which are necessary because they are universal, an emphasis on the positive values of difference and pluralism, and a sense of fragmentation and the general collapse of a centre around which the world is organised. In general, theorists of postmodern culture judge these characteristics to be

opposed to the dominant modern structures and values that organise and subjugate experience. For some this is a good thing as modernity is judged to have done more harm than good, from colonialism and industrialisation to world poverty and the destruction of communities. For others postmodernism is a bad thing because it weakens the modern idea that individuals can improve their lives by gaining control over their collective existence through the application of their reason. The novel contribution of *Empire* to these debates is that it seeks to change their stakes by placing culture in relation to political, social and economic processes, and showing that these have the same characteristics associated with postmodernism. There are two major consequences of this shift.

First, Hardt and Negri weaken the critical force of affirmative postmodernism by claiming that the characteristics that it values are not the exclusive property of culture but are shared with the political, economic and social processes to which it is otherwise usually opposed, in so far as these are characterised by unequal relations of power weighted towards domination. Dominant political and economic forces have no problem with difference and fragmentation. So the idea that postmodernism is an attack on the institutions and values of modernism from a critical position that seeks to support cultural values and forms that modernism excludes or represses distorts how things actually are. In this context, the affirmation of the values of difference and otherness that characterises the critical and oppositional dimension of much postmodern theory finds itself 'pushing against an open door'.[5] If postmodernism tends to celebrate difference and otherness as unpredictable phenomena that challenge the monotony and repetition of identity and sameness, the empirical basis for doing so has dissolved as these characteristics are no longer dominant. Empire is comfortable with difference and relaxed about otherness because these are not stable properties of the world but temporary phenomena. For Empire the world is understood as fluid and hybrid. Hence Hardt and Negri mock the stereotypical slogan of postmodernism: 'Long live difference: down with essentialist binaries'.[6] There is nothing essentially liberatory about difference, nothing essentially oppressive about

essences. This is because Empire is not like a chemical substance, the same thing in each and every instance.

Secondly, Hardt and Negri reject the position of those who criticise the triumph of postmodern global capitalism on the basis that the world can be replaced by something else through a single but universal moment of transformation. They do this by showing, for example, that a tradition of thought such as Marxism, which seeks revolutionary change, ought to recognise that Empire creates the conditions for this achievement, albeit under conditions not of Marxism's own choosing. Thus towards the end of the book when Hardt and Negri say 'What Marx saw as the future is our era'[7] they do not mean that Empire corresponds to communist society. Rather, postmodernism is the continuation of the positive dimension of Marx's logic of history, which emphasised that the destructive force of capitalism was also progressive, eliminating the stabilising force of hierarchies of power. In doing so capitalism revealed that appeals to religious explanations of the world or the authority of tradition in order to justify inequalities were simply tricks to confuse and frighten the gullible. So Hardt and Negri's argument fits quite neatly into the critical and analytical framework of Marx and Engels and especially their diagnosis of the totalising vampiric logic of Capitalism which they summarised in *The Communist Manifesto* with the memorable poetic phrase 'all that is solid melts into air, all that is holy is profaned'.[8] For Marx this was a good thing on the grounds that it created the conditions for progress. Indeed, for Marx one of the benefits of the violence of European colonialism was that it eliminated pre-capitalist social forms in colonised territories such as India.

Empire simply deepens the logical implications of Marx's analysis of capital in which 'The total movement of this disorder is its order'.[9] Capital has always been disorganised and disorganising. In doing so capitalism tended to transform any social and economic formation which it encountered into itself. After all, capitalism did not invent the distinction between those who live off the benefits of the labour of others and those who do not. Capitalism only discovered the means of transforming this relation into a form of social organisation. But with

Empire, capitalism no longer encounters anything to transform. The so-called natural resources of earth and land are already owned and do not exist in a natural state. The earth is property. With the absence of anything left to exploit as raw material for production, capitalism exploits itself. There is no frontier to capital any more, not even one that would separate work and non-work. Value is produced by whatever artifice solves the problem of the tendency of capitalism to collapse into itself. It does not matter how temporary such solutions are. Hardt and Negri summarise this state of affairs in the claim that 'Empire is born and shows itself as crisis'.[10]

So for Hardt and Negri it is not so much that the affirmative or negative position on postmodernism is wrong. Rather, the place of critique has changed because, to put it bluntly, there are no frontiers any more. It is for this reason that the argument of *Empire* is not opposed to the Empire that it describes and analyses, a position that some critics regard as scandalous. The difficulty that many of its critics have with *Empire* is that it accepts the unmasterable nature of the world in order to show how this state of affairs is not a negative disaster but a positive force. The world is always unfinished. The book is thus positioned as opposed to the political, social and economic status quo insofar as this is understood as either support of or opposition to modern relations of power. For Hardt and Negri the material conditions in which such positions make sense no longer exist. Empire is not a stable system that is limited and that can be weakened and overcome by direct attack, or strengthened and defended. Consequently, whereas critical thought can be characterised as an investment in the hope of the arrival of a common enemy against which everyone will be united, or a common friend that everyone will like, *Empire* maintains the position that such aspirations are no longer relevant as, to put it crudely, the enemy has embraced postmodernism and has actually contributed to its existence.

But moral outrage on the basis of the accusation that the argument of *Empire* entails the evacuation of politics in the face of the inevitable onslaught of global capitalism is in fact unjustified. Empire is not the exercise of power and domination over something which is not Empire. There is no position outside Empire and so there is no non- or anti-

Empire that might offer a moral standpoint from which to condemn it or a strategic political position from which to attack; Empire does not establish frontiers but dissolves them. There is no necessary reason to include anything in Empire or exclude anything from it. Yet at the same time relations of power and domination and attempts to monopolise force are not absent from Empire but are produced within it. But this means that the politics of Empire is not a question of a relation between Empire and something opposed to it but of the changing forces within Empire itself through which politics is structured, understood and acted. For Hardt and Negri the spectacle of 'fundamentalism' in its religious, economic, ethnic and political manifestations is a form of rule that is internal to Empire as the expression of a strategy with which to react to this process with weak resources but not to eliminate it or oppose it. By the same token Hardt and Negri refer to the *multitude* as a vague, indeterminate and unrepresentable mass that constantly disrupts any crystallisation or sedimentation of relations of power, although whether this is a matter of accident or design remains a moot point.

Hardt and Negri condense these political characteristics in a theory of politics in which power has no privileged place. It is a non-place.[11] We might say that power is less a matter of 'power over' and more a matter of 'power to' – or not, as the case may be. Power has no substance or content but simply refers to a temporary relation between contingent actions. There is no necessary or structural distinction between domination and subordination as these terms describe temporary states of affairs with no necessary outcome. In this scenario stability is relative, established by the dynamics of organising under conditions of uncertainty which is directed at singular events, such as dispersal as a consequence of economic redundancy or ecological disaster. Hence relations of power are asymmetrical and continuously negotiable, expressed through contracts that are backed up by an authority that is simply the relative stability of the resources that any agent can deploy at any one time and place.[12] If we understand politics as the practice of power then it is no longer confined to a specific domain, democratic or authoritarian, but is simply the generality of organising between contingent nodal points without an authoritative centre that would

establish the distribution of power and resources in advance. Politics is no longer a struggle over power in the sense of something to be lost or gained, but has become a struggle around forming or eliminating relations of power. It is likely that politics is no longer a confrontational 'war of position' but a mobile 'war of movement', to use Gramsci's distinction derived from Machiavelli.[13]

To illustrate the upside of this state of affairs we can refer to Michael Hardt's account of his participation in the World Social Forum at Porto Alegre in 2001.[14] As much a festival as a political conference, the diversity of delegates and events was 'unknowable, chaotic, dispersive'.[15] The issue those adjectives raise is not one of a lack of commonality or unity among participants and their constituencies but of linking differences. The forum was a network. Its value became visible as the price of abandoning a commitment to a clear and distinct ethos of conflict grounded in a distinction between those who championed the cause of stable identities against globalisation, such as representatives of sovereign nations or of interests that wished to become so, and those who sought other de-centred network approaches for both pragmatic and ideological reasons. But this was not transformed into a conflict within the Forum itself precisely because the network form is not a point that can be attacked. 'How do you argue with a network?'[16] A network displaces oppositions because there is always at least one more element to add to it that reacts back on the other elements of the network. Because this process of adding takes place in time and space the network is not a stable object that can be represented. So potential differences between, for example, progressive religious groups and sexual experimentalists do not become actual antagonisms but are 'swept up in the multitude, which is capable of transforming all fixed and centralized elements into so many more nodes in its indefinitely expansive network'.[17]

Empire and cultural politics

It is not difficult to appreciate that *Empire* is a very contentious book. Hardt and Negri exacerbate the controversial nature of their claims in their account of how the state of affairs they describe has come about.

The political significance of Hardt and Negri's thesis is that Empire has not been imposed on a passive and weak humanity. Once again Hardt and Negri challenge the orthodox assumptions of critical thought by emphasising the popular desire for the benefits of capitalism as a force that both sustains and undermines it. Capitalism does not have the capacity to satisfy the desires that it produces and most political conflict stems from this failure. Almost no one is opposed to the achievements of capitalism, they would just like a bit more of it for themselves. Central to this achievement in the sense of a universal object of desire is culture. Through the global cultural industries Empire stimulates escalating demands for enjoyment where the sensation of culture, its purely aesthetic dimension, possesses greater force and authority than any critical interpretation that would attempt to determine the meaning of the experience.[18] No one is in a position to legislate on matters of taste and what was once the oppositional aesthetic of the modernist avant-gardes has become the boundary busting play of popular culture, especially with respect to the grotesque and violent excesses of popular visual culture.

Importantly, art and its institutions are not external to this process. The political significance of art cannot be determined by any established political or aesthetic critical criteria precisely because the relation between the two terms has increasingly become arbitrary. This point can be elaborated by reference to Abigail Solomon-Godeau's famous discussion of the collapse of the distinction between art and art market in New York in the 1980s.[19] One of the casualties of this process was the position of critics as mediators of aesthetic and political values, which was illustrated by the case of the success of the hyper-real photography of 'appropriation art' in the work of artists such as Richard Prince and Sherrie Levine. Initially this work was championed by critics with the claim that it challenged the modern institution of photography and its monopoly over the ways in which the real world is experienced and understood. For example, many critics thought that by photographing the iconic work of modern photographers and commercial advertising in such a way that it was practically impossible to distinguish between original and copy, an artist like Levine was somehow subverting the institution of photography itself. This

judgement had no impact on the success of the art in the art market, an institution which critics supposed would reject the subversive implications of the work. When critics subsequently backtracked and denounced the work for its complicity with capitalism, the aesthetic properties of the art did not change one bit. For their part the artists themselves were comfortably indifferent to the political significance of what they had done.

The case of 'appropriation art' demonstrates the arbitrariness of the relation between the art object and its interpretation or meaning or, to say the same thing differently, the weakening of the ability of critics to establish a necessary relation between object and interpretation, and thus to mediate art. In these circumstances aesthetic experience is simply continuous with a general and indeterminate flow of experience in which art is not marked out as a privileged point. The consequences of this state of affairs can be subsumed within two broader lines of development. Both lines can be summarised by the disintegration of the notion of the autonomy of art, or 'art for art's sake', either as a pure aesthetic experience or as a judgement of such an experience, or as a project to establish the possibility of such an experience.

First, in terms of the political significance of art, the idea of an oppositional sphere defined in terms of the political causality of aesthetics that emerged in the period of European Romanticism towards the end of the eighteenth century, and that was carried forward through the various art manifestos and movements of the twentieth century, has dissolved. This is not to say that art is suddenly without effects, including broader social changes. It is to say that these cannot be determined or guaranteed.

Secondly, and more importantly, the authority of criticism that would establish or validate a relation between art and politics has been subverted. This is illustrated in a practical way by the response of criticism that seeks to protect its interests as autonomous guarantor of the relation between object and interpretation over and above the autonomy of the object itself, which is exactly what Solomon-Godeau does by arguing that 'as a fundamental condition of possibility, critical practices must constantly address those economic and discursive forces

that perpetually threaten to eradicate their critical difference'.[20] That is to say, the purpose of criticism is no longer to establish and regulate the effects of art on economic and discursive forces, but to challenge the effects of these forces on the possibility of criticism itself in order to prevent its redundancy.

It would be mistaken to blame the break in the link between art and politics just on the superior force of the art market and its links with the dynamics of consumer culture over the discipline of criticism. The reason for the decline of the force of criticism is also connected with the political values that it seeks to derive from a relationship between the artwork and its experience, in which the political force of criticism rested on a capacity to make others accept its descriptions of its experience as their own. In doing so criticism attempts to establish the autonomy of art, or at least the critics' experience of it, by putting to one side the interests of politics, economics and society. Art is set up as a good in itself. Yet this is not without political and social significance, as the relation established by this force is categorically opposed to the ordinary interests of politics, economics and society in so far as these block or undermine the autonomy of art. The weakness is that the desire for autonomy is not the exclusive property of art but is more widely present as the democratisation of the desire for autonomy itself. In this context instruction in matters of taste is likely to be ignored.

Organisations and culture

Hardt and Negri attach particular importance to the cultural expression of autonomy and the cultural forms through which autonomy is mediated as drivers of Empire.[21] Thus: 'Local autonomy is a fundamental condition, the sine qua non of the development of the imperial regime'.[22] The triumph of autonomy implies the weakening of its conceptual and empirical opposite, dependency or subjection to the rule and authority of another. However, this is not simply a matter of the transformation of relations between different entities in their attempts to obtain autonomy but of the effects of such attempts on those entities themselves, which go far deeper. Becoming autonomous is not a matter of somehow becoming free but remaining essentially

unchanged once the repression of dependency is removed, as such a transformation alters the entity that has obtained autonomy. It is this process that contributes to the sense of 'crisis' that is routine within Empire. Although within cultural criticism and politics this theme has been addressed through various critiques of the idea of 'identity', Hardt and Negri pay more attention to the mundane phenomena in which it is registered, and in particular to its impact on the organisation and administration of Empire, to which Hardt and Negri attach considerable importance in the light of their account of power and politics.

In much the same way that capitalism has embraced the dynamic of postmodernism, so too has organisation and administration and the institutions that these support, with the result that Empire is not defined with respect to its content but with respect to the fluidity and heterogeneity of its organisational forms. This generalised condition of instability is 'reflexive' in the sense of automatic or without thought, as in the doctor who taps the patient's knee to see if there is a response.[23] As any of the cheap management advice books with titles like *Thriving On Chaos* and *Brand Me* that you can get from any bookseller will tell you, organisations have become increasingly concerned with change with respect to both the environments in which they exist and to themselves. Such texts should not be dismissed on account of their superficiality or gushing aspirational air-head prose style, as they are indicative of how modern structures of power such as the state, the army, the prison, the factory, the hospital, the school, even the museum and gallery, which provided a set of institutional conditions within which people acted, have dissolved.[24] This is particularly true of bureaucracy – literally, the rule of the desk – which, according to the sociologist Max Weber, was structured as a hierarchy of functions or tasks where the order of causality was expressed as rules that descended from the top to the bottom.[25] Through bureaucracy action itself was directed to sustaining the organisation and was therefore, for Weber at least, ethical, in that it sustained a sphere of life that was autonomous from other spheres.

In this way organisations sought to obtain the status of autonomy, both as a fact of existence and as an ethical value to aspire to that could

regulate organisational activities. However, anything that is deemed not to fit with these organisational values was subject to domination or exclusion. With the democratisation of the desire for autonomy the relations of dependence on which organisations relied for security have been broken, whether these are thought of as a legal framework that regulates markets, the guarantee of taxation revenues, or more subjective factors such as employee or customer 'loyalty'. After all, if your employer is free to sack you or change the contractual relations of employment, what obligations do you owe him or her, even if you do put an enormous effort into making yourself appear to be flexible and indispensable or, as the management manuals put it, 'adding value to yourself'? This is one of the reasons why, if you are worker or citizen within Empire – and who isn't? – you find yourself 'empowered' and encouraged to adopt a 'yes I can' attitude.[26] These conditions are recognised in a running joke in the recent film *Pirates of the Caribbean* in Johnny Depp's character Captain Jack Sparrow's explanation that the legendary 'Pirate's Code' is 'not a set of rules, more like guidelines really'. How does one argue with guidelines when they are simply formulated in order to meet the problems of particular circumstances and do not imply any larger commitment?

As with the value of criticism these shifts in the structures of postmodernity have impacted on the problem of the conflict between artistic and organisational autonomy. The dilemma to which this conflict gave rise is encapsulated by the remark of the German philosopher Theodor Adorno that 'Whoever speaks of culture speaks of administration as well, whether that is his intention or not'.[27] Adorno, who coined the phrase 'culture industry', tried to combine Marxism with the organisational theories of the sociologist Max Weber as a basis for explaining the failure of the Romantic notion of the autonomy of art to establish itself as the value through which the world was experienced. Yet even though Adorno accepts that for practical purposes administration is a necessary condition for almost everything, in the sense that in modern societies people cannot subsist without the organisation of their cooperation with others, this does not mean that bureaucracy totally dominates the aspiration to artistic autonomy. For

Adorno, although administration is inescapable, it is vulnerable to the fact that it lacks the ability to plan every detail of every eventuality in advance, and to the extent that it tries to do so administration becomes consumed by its own inefficiency. This limit guarantees the possibility of something different which, because it is not planned, embodies the value of 'hope'.[28] Hence art could, under the right circumstances, secure its commitment to autonomy within an organisational form to which it was, in essence, opposed, through the mediation of administrators who happened to possess a particular sensitivity to the values of aesthetic experience. This sensitivity would be expressed as an affirmation of the value of difference and the unpredictability of events on the basis that these are consistent with the desire for artistic autonomy.

Adorno's position seeks to create a privileged relation between the artwork and its experience within the distorting structures of administration in order to establish its autonomy. With Empire things get much more complicated. What is novel about *Empire's* analysis is the observation that the practices of contemporary administrative and organisational systems are increasingly unplanned and recognised as such by administrative and organisational systems themselves. In other words, administration and organisation is not concerned to impose rigid and constraining structures on the world but instead responds to the changing and unpredictable nature of the world, to the observation that the world is not ultimately controlled and does not possess any necessary order, and that the consequences of actions are largely unforeseen. Instead of eliminating this state of affairs, organisations seek to take advantage of it. They do so by replacing the formal structures of modernity with informal de-structured networks that accept the contingency of their own existence and the purposes to which they are put, and the fact that the consequences of many of their actions are likely to be unintended, and that therefore these consequences will alter the grounds of their future actions, and thus what they are.

If *Empire's* thesis is correct then the idea of an antagonism between art and organisation becomes less clearly defined. The organisational transformations to which *Empire* refers indicate how the conditions of

enunciation of the political dimension of art have changed with respect to both the positions *from which* they emerge and the phenomena *to which* they are directed. Consequently, the political dimension does not make sense, in the two literal senses of the word 'sense': with respect to sensation and experience, and thus to the aesthetic dimension, and with respect to meaning and understanding, and thus to the discursive or critical dimension. Hence the notion of the autonomy of art, where art is supposed to mean the experience that it provides, is dislocated. The hope that a popular front for the liberation of the imagination, in which the distinction between art and life would dissolve, could be constituted through an antagonism with alienating bureaucracy and the crushing repetition of commodified existence becomes a nostalgic fantasy.

We can see the significance of these shifts by considering their impact on the museum, one of the core cultural institutions of modernity. One of the major criticisms of this institution argues that the museum codifies and bureaucratises cultural experience, imposing uniformity and eliminating difference. In so doing museums display a privileged relation to knowledge that Bennett termed the 'exhibitionary complex', which structures a hierarchy of power over that which is known.[29] Hence visitors are encouraged to identify with a superior position of knower over that which the museum represents as known. Given that what is known is very often understood as non-Western and non-Modern, or as a specimen of the natural order of the world that the museum is held to have discovered with the assistance of the specialised knowledge that it draws on for support, the museum is criticised from a perspective that affirms the autonomy of what the museum seeks to know in order to undermine a relation of domination through knowledge.

Yet according to Rogoff the contemporary museum has abandoned this position in favour of what she calls 'multicultural managerialism' which marks a shift from 'xenophobia' to 'xenophilia'.[30] As Rogoff is a critic of the museum's 'exhibitionary complex' this situation presents something of a dilemma, as the museum no longer denies or subjugates the heterogeneity of difference through the implementation of a uniform position of knowledge that is mirrored in the homogeneity of

its organisational form. The distinction and opposition between an organisation and something to which it is opposed has broken down. Perhaps this is why Rogoff finds it so difficult to construct an argument that would preserve the critical force of the affirmation of difference in such changed circumstances, simply offering the rather enigmatic suggestion that the museum should represent itself as mourning for the loss of its former power as this will honour the memory of the differences to which it was formerly opposed.[31]

Perhaps there is another approach to the relations between art and organisations that would avoid institutionalising the mourning and melancholia of a pessimistic nostalgia for a time when critical theory was right. Although writing some years before the publication of *Empire*, Canclini offers such an approach by describing the world in similar terms in order to specify the causality of the relations between art and organisation within it.[32] For Canclini, like Hardt and Negri, the world is characterised by constant reorganisation through the intersection of multiple and simultaneous processes. The purity that defines the borders between political territories, art forms and organisational objectives has dissolved within a general experience of hybridity and oscillation. In particular the antagonism between the desire for autonomous aesthetic experiences and the desire to order the world as a space of control is displaced. For Canclini such a situation requires new conceptual and empirical questions, which are condensed in the following proposition:

> We need to discover if the actual organisation of the aesthetic field (producers, museums, galleries, historians, critics and the public) contributes, and in what way, to the elaboration of shared imaginaries...In posing the problem in this way, it is possible to include in the question something about how art thinks today, even in its innovative gestures: what capacity to think about a world orphaned of paradigms do transgressive or deconstructive works possess that are submitted to the order of the museums and the market?[33]

The question is no longer one of an opposition between artistic and administrative autonomy where each is external to the other, but of the

hybrid combination of both within a 'shared imaginary', a common set of assumptions through which the world is made sense of.

Contextualising practices

One way of approaching Canclini's questions, and in particular the issue of 'how art thinks', could be through the analysis of the aesthetic dimension of administrative and organisational practices themselves, and of how, from logos to office layout, the determinants of aesthetic experience within organisations shape the actions of those who inhabit them.[34] One could even approach this dimension of organisations at the level of a detailed microscopic analysis of things like the design and use of the forms that animate administrative activity.[35] Unfortunately, a discussion of these important themes would diverge too much from the general direction of my argument, although it would probably confirm it. Instead I want to look at how changes in art get 'locked in' to changes in its organisational and administrative environment; that is, at some of the ways in which art and administration negotiate their relations within shifting and fluid distributions of power.

To do this I will look at a class or genre of aesthetic practices that address the distinction between the generality of administrative and organisational systems and the specific contexts in which these take place. Although within contemporary art criticism and commentary these practices are categorised under various descriptive terms such as installation or site-specific, or even performance art, for the sake of argument I shall refer to them as *contextualising practices*. Perhaps Duchamp's urinal is the most famous example which, among other things, called into question the categories through which art was defined and displayed. Historically Duchamp's tactic has been developed to address the organisational forms within which art is located, including such institutional spaces as the gallery,[36] the museum,[37] even the archive,[38] and extending to include both employers and users of such spaces and the public and private conditions that make them possible.[39]

Importantly, such practices do not have any necessary or privileged relation with specific media with respect to both form and substance

and often combine different media. Within these practices aesthetic experience is understood as an intervention or event. Roughly speaking, the point of such practices is to prompt or provoke a series of critical questions which include the following: What is the relation between art and organisation and can this relation be determined by either term of the relation, supposing for the moment that the distinction is tenable, such that a distinction could be made between art and non-art? To what extent does art have a conditional relation with its own organisations and institutions, and is this relation one of determination? Running through these questions is the larger issue of power, both of art and over art, of what art can do and what gets done to it. Sometimes this question takes banal and mundane, perhaps trivial, forms, with issues such as dealers, collectors, critics, curators and administrators. At other times the question is posed in more elevated terms of the relations between art and life. Often both manifestations of the question dissolve into each other. Nevertheless they indicate the main ways in which a political dimension is attributed to aesthetic experience by calling into question the taken-for-granted status of the context in which the experience makes sense.

As with the case of museums, the political dimension of contextualising practices only makes sense if there is a context there against which the art can be opposed. But with the institutionalisation of contextualising practices themselves this critical difference has gradually weakened. For a critic such as Krauss the consequences of contextualising practices are dire because 'the international fashion of installation and intermedia work' is essentially 'complicit with a globalization of the image in the service of capital'.[40] Perhaps we should pause at this point and evaluate the force of the judgement. Krauss's criticism is moral but it is derived from the principle that aesthetic experience should interrupt a world organised by relations of power by the force of its own autonomy which, for Krauss, is secured by the integrity of discrete aesthetic substances. In other words, contextualising practices undermine the autonomy of art because they dissolve the criteria through which a distinction is made between art and non-art. One might say that Krauss attempts to combine the shock

aesthetics of modernism with the critical values of connoisseurship. Yet for the aesthetic experience to work requires a ground for a causal relation with global capital power. In other words the relation must be fixed before any actual experience takes place. Of course if this was so there would be little point to it. The ground for such a relation would be a totally organised world where everything has its place and its causal relations are established, like some sort of community or the way some philosophers have imagined the experience of classical Greece, where fact coincides with value, or the anti-modern notion of a tradition.[41] It is doubtful if capital global power would want to hang around in such an environment just so it could be a target.

So, in criticising the failure of aesthetic experience, Krauss simply verifies the extent to which the world in which it would work does not exist. However, this is not because, as Krauss suggests, capital is simply another undesirable totality that acts uniformly in all times and places, crushing anything in its path. If it was, one could simply point to the existence of its opposite, yet this verification does not take place in Krauss's argument. Like Rogoff's objection to 'multicultural managerialism', Krauss's argument is really about the absence of an opposite. This absence is hardly surprising as no reason is given for its presence. It is simply a rule with which to regulate taste and thus reinstitute the authority of the critic from a threat that is designated as external to critical jurisdiction.

Krauss's position effectively denies the agency and power of contextualising practices simply because they have not gone in the direction that accords with the moral agenda of critical thought. However, other critics have recognised this dimension of agency in explaining the development of contextualising practices. Already in 1976, in an essay originally published in the magazine *Artforum* and subsequently published as a book, O'Doherty traced the development of context as an artistic practice that deliberately overflows the frame, pedestal and institutional space from Monet through Duchamp to Christo, and thus establishes a relation of force through which the distinction between the object and the context that determines it as a specific object becomes almost imperceptible. As a result

of its own interminable particularity. For Kiwon the main event in the development from context-revealing to context-fixing was the 'blowup' over Richard Serra's *Tilted Arc* in 1989 when the affirmation of the autonomy of art lost out against the context of Federal Plaza in Manhattan where the object was sited.[46] Although Serra's monumental steel sculpture deliberately sought to emphasise its intention of obstructing the physical flow of corporate work in the global financial centre of New York by taking up a large spatial area through which people normally walked, the local inhabitants rejected the object on both aesthetic and practical grounds. The context fought back and the object was removed. *Tilted Arc* failed to make Federal Plaza a context for art. After this point interventions in the context of public space have been forced to negotiate with the locality that defines the context itself.

Kiwon relates in some detail how the discipline of site-specificity was subsumed in the process of establishing relations through which a site could be specified as an object of integration or intervention. That is to say, the context became a problem for which aesthetic experience was supposed to provide a solution. The logic of this sequence is confirmed by Kiwon's analysis of the professional consequences of the symbolic economy of site-specific mediation in which the artist becomes 'a cultural-artistic service provider rather than a producer of aesthetic objects'.[47] Art practice takes on the commodity forms of the service and management industries, marked by the replacement within artistic discourse of words for physical activities such as paint, fold and cut with words for managerial relations such as negotiate, coordinate and organise to describe the activity of artists.[48] The practice fixes the context by reference to discursive and utilitarian values that are then inscribed within the context itself. The space of mediation ceases to be dichotomous in conceptual terms – nature/culture, emotion/reason – in practical terms – make/distribute, invent/communicate – and in political terms – us/them.

The dissolution of politics as opposition culminates in attempts to eliminate the distinction between the aesthetics of site and the ethics of community. This is not so much a question of the production of a validating mimetic or symbolic representation of a mythically unified

community – a totem – but of the ability to satisfy a heterogeneous set of demands. It is the process of the site's production that constitutes a homogeneous space of mediation and not the object that marks it. Kiwon succinctly summarises the political and aesthetic algebra of these developments:

> A culturally fortified subject, rendered whole and unalienated through an encounter or involvement with an art work, is imagined to be a *politically* empowered social subject with opportunity (afforded by the art project) and capacity (understood as innate) for artistic self-presentation (= political self-determination). It is, I would argue, the production of such "empowered" subjects, a reversal of the aesthetically politicized subjects of the traditional avant-garde, that is the underlying goal of much community-based, site specific public art today.[49]

The modernist avant-garde strategy of intervention is dissolved in the naturalisation of community and its supposed moral plenitude through which means the performative creation of community is hidden. Community is what gets added to context in order for it to happen. For Kiwon it is this aspect that now constitutes the object of analysis.[50] We could say that the dissolution of the specificity of aesthetic experience and the dissolution of the political coincide in the invention of community, which is the name for what you become if you fail to exercise autonomy and get fixed in place.[51]

Liverpool at the end of the Empire of Art

To illustrate this development we can return to the context of the paper, which was originally given as part of the 2002 Liverpool Biennial. Liverpool is not the only place in which a biennial occurs and so the Liverpool Biennial is a particular implementation of a global aesthetic-administrative form through which a variety of effects are produced. Some of these are common to the form and some will be particular to the place. Thus the biennial is a contextualising practice that creates the local as a particularity. After all, the local can only be specified with respect to something not-local. Hence Liverpool, or anywhere else for that matter that becomes linked with the biennial form, gets fixed in place. For their part local political regimes are receptive to biennialisation as a form of boosterism in the same way as cities

compete to host global cultural events, including sport, with all the speculative economic consequences that this implies and all the speculative calculations that try to prove that there is a point to doing it.[52] Here one must note the administrative contribution played by the so-called 'super curators' who 'frame' the event and mediate relations between display, audiences, artists, administrators, local powers, critics and collectors.[53]

Hence one account of the 2002 Liverpool Biennial placed it in relation to Liverpool's feeling of marginality 'with respect to many of the developments in global capitalist production' and hoped that through the Biennial

> Liverpool will continue to transform itself developing local confidence to support and encourage risk taking, critical ambition and vibrant contemporary art, leading to more informed debate for artists, curators and the movers and shakers in the city. It is certain the Liverpool Biennial will create the climate to facilitate a critical cultural continuum building up its international profile, networks and much-needed resources to develop the cultural infrastructure of Merseyside.[54]

This hope may have been rewarded by the subsequent European City of Culture designation for Liverpool in 2008. Culture is the currency of investment through which the local is articulated with the global as the expression of the desire to be more local. This is confirmed by a subsequent announcement of the programme for the 2004 Liverpool Biennial, already positioned as a precursor of the 2008 City of Culture, for which:

> Sabine Breitweiser (Vienna), Yu Yeon Kim (New York), Cuauht Zmoc Medina (Mexico City) and Apinan Poshyananda (Bangkok) have been appointed as researchers, and have visited Liverpool to examine the city as a context for the exhibition and its commissions. They will recommend artists whose practice has an affinity for the culture of Liverpool, with these invited to research and develop proposals to be delivered collaboratively with local organisations.[55]

With the recent proliferation of biennials this form has been subjected to criticism, but this tends to be on the grounds that it undermines the autonomy of aesthetic experience. For Weiss the

biennial is a further confirmation of the 'instrumentalization of exhibitions' where the autonomy proper to art has been compromised to the extent that it has become a means to an end for something else, such as money or career ambition.[56] Weiss's criticism highlights the agency of biennials as organisational forms and their participation in contemporary regimes of flexible specialisation. As Weiss points out, 'biennales are paradigmatically globalist', not least with respect to the fact that financialisation takes the place of national and local political identifications. Weiss quotes a criticism expressed by Catherine David, a curator of Documenta X, that globalisation is an 'attractive celebration of difference' and at the same time 'an encouragement of standardisation'. Of course, the force of the criticism rests on the contradiction it implies. Something cannot be two different things at the same time and in the same place. Yet this presupposes that the world is organised logically and contains the rational basis of its critique within itself, which is expressed as a judgement.

Yet if the developments Weiss refers to are empirically true then perhaps there is no good reason to suppose the logical nature of the world as the basis for what may or may not happen. Rather, they are contingent relations through which heterogeneous practices and values get 'locked in', albeit temporarily. By the same token the notion of 'instrumentalisation' may work as a judgement but need not accurately represent what takes place, as it presupposes a direct causal and sequential relation that can be contained within one place. Liverpool will have a culture. Yet one has to ask; what is the context here? Anfield, Goodison Park, Aintree, the Liver Building, John Lennon's aunt's house? Or New York, Bangkok, Mexico City? To raise these questions is not to criticise these initiatives. But it is to raise the question of how can it be shown where organisation ends and culture begins. Arguably, the culture is the organisation of the event itself and the culture of Liverpool – assuming that there is one (and only one) – is the raw material or nature. Yet if so then this added cultural dimension is barely visible. To make it so would require regarding the experience and meaning of the biennial as the relationship between the exhibition as process of display and the local and global elements that it articulates.

Such an object would be without spatial or temporal limit and thus impossible to represent. There will always be one more difference to add. Hence the context is not there until these relationships are present, even if they are represented as acting on a pre-existing self-evident locality.

Notes

1 M. Hardt and A. Negri, *Empire* (Cambridge, MA: Harvard University Press, 2001).

2 This paper was originally given at the Critical Forum Annual Conference 'Art, Money, Parties', Tate Liverpool/Liverpool University, Liverpool Biennial, 9 November 2002. A subsequent version was given at Edinburgh College of Art, 5 February 2003. I would like to thank the organisers of these events and the participants for their contributions. I would also like to thank Claire Bishop, Neil Cummings, Eleanor Hartney and Marysia Lewandowski for their helpful comments. I am particularly indebted to Jonathan Harris for his editorial suggestions and patience.

3 S. Lotringer and C. Marazzi (eds), *Italy: Autonomia – Post-Political Politics*, *semiotext(e), III, 3* (1980); S. Wright, *Storming Heaven: Class Composition and Struggle in Italian Autonomist Marxism* (London: Pluto Press, 2002).

4 Éric Alliez and Antonio Negri, 'Peace and War', *Theory, Culture and Society*, 20.2 (2003), 109–18; Alberto Toscano, 'Art Against Empire: On Alliez and Negri's "Peace and War"', *Theory, Culture and Society*, 20.2 (2003), 103–18.

5 Hardt and Negri, *Empire*, 138.

6 Hardt and Negri, *Empire*, 138.

7 Hardt and Negri, *Empire*, 364.

8 K. Marx and F. Engels, *Selected Works: Volume 1* (London: Lawrence and Wishart, 1958), 37.

9 Marx and Engels, *Selected Works: Volume 1*, 77.

10 Hardt and Negri, *Empire*, 20.

11 Marc Augé, *Non-Places: Introduction to an Anthropology of Super Modernity* (London: Verso, 1995).

12 M. Dean, *Governmentality: Power and Rule in Modern Society* (London: Sage, 1999); N. Rose, *Powers of Freedom: Reframing Political Thought* (Cambridge: Cambridge University Press, 1999).

13 A. Gramsci, *Selections from Prison Notebooks* (London: Lawrence and Wishart, 1971); N. Machiavelli, *The Prince* (Harmondsworth: Penguin Books, 1961).

14 Michael Hardt, 'Today's Bandung?', *New Left Review*, 14 (2002), 112–18.

15 Hardt, 'Today's Bandung?', 113.

16 Hardt, 'Today's Bandung?', 117.

17 Hardt, 'Today's Bandung?', 118.

18 S. Lash, *Critique of Information* (London: Sage, 2002).

19 A. Solomon-Godeau, 'Living with contradictions: critical practices in the age of supply-side aesthetics', in J. Evans and S. Hall (eds), *Visual Culture: the reader* (London: Sage, 1999), 224–43.

20 Solomon-Godeau, 'Living with contradictions', 231

21 Hardt and Negri, *Empire*, xvi.

22 Hardt and Negri, *Empire*, 342.

23 U. Beck, A. Giddens and S. Lash, *Reflexive Modernisation: Politics, Tradition and Aesthetics in the Modern Social Order* (Oxford: Polity Press, 1994).

24 T. Bennett, *The Birth of the Museum: History, Theory, Politics* (London: Routledge, 1995).

25 M. Weber, *Economy and Society Volumes 1 & 2* (Berkeley, CA: University of California Press, 1978).

26 G. Deleuze, 'Postscript on Control Societies', in *Negotiations* (New York: Columbia University Press, 1995).

27 T. Adorno, *The Culture Industry: Selected Essays on Mass Culture* (London: Routledge, 1991), 93.

28 Adorno, *The Culture Industry*, 113.

29 T. Bennett, 'The Exhibitionary Complex', *New Formations*, 4 (1988), 73–101.

30 I. Rogoff, 'Hit and Run – Museums and Cultural Difference', *Art Journal* (Fall 2002), 63–73.

31 Rogoff, 'Hit and Run', 73.

32 N. G. Canclini, 'Remaking Passports: Visual thought in the debate on multiculturalism', in N. Mirzoeff (ed.), *The Visual Culture Reader* (London: Routledge, 1998), 372–81.

33 Canclini, 'Remaking Passports', 373.

34 S. Linstead and S. Höpfl (eds), *The Aesthetics of Organization* (London: Sage, 2000).

35 A. P. Carlin, 'Pro forma arrangements: the visual availability of textual artefacts', *Visual Studies*, 18.1 (2003), 6–20.

36 A. Fraser, 'Museum Highlights: A Gallery Talk', in T. Miller (ed.), *A Companion to Cultural Studies* (Oxford: Blackwell, 2001).

37 J. Putnam, *Art and Artifact: The Museum as Medium* (London: Thames and Hudson, 2001); M. A. Staniszewski, *The Power of Display: A History of Exhibition Installations at the Museum of Modern Art* (Cambridge, MA: MIT Press, 2001).

38 R. Hobbs, 'Boltanski's visual archives', *History of the Human Sciences*, 11.4 (1998), 121–40.

39 P. Newkirk, 'Object Lessons: Fred Wilson Reinstalls Museum Collection to Highlight Sins of Omission', in J. Lewis and T. Miller (eds), *Critical Cultural Policy Studies: A Reader* (Oxford: Blackwell, 2003).

40 M. Broodthaers and R. E. Krauss, *A Voyage on the North Sea: Art in the Age of the Post-Medium* (London: Thames and Hudson, 1999), 56.

41 A. MacIntyre, *Whose Justice? Which Rationality?* (London: Duckworth, 1988).

42 B. O'Doherty, *Inside the White Cube: The Ideology of the Gallery Space* (Berkeley, CA: University of California Press, 1999 [1976]), 39.

43 O'Doherty, *Inside the White Cube*, 70–71.

44 T. McEvilley, 'Introduction', in O'Doherty, *Inside the White Cube*, 7.

45 Rosalyn Deutsche, *Evictions: Art and Spatial Politics* (Cambridge, MA: MIT Press, 1996); Kwon Kiwon, *One Place After Another: Site-Specific Art and Locational Identity* (Cambridge, MA: MIT Press, 2002), 3.

46 Kiwon, *One Place After Another*, 81.

47 Kiwon, *One Place After Another*, 4.

48 Kiwon, *One Place After Another*, 51.

49 Kiwon, *One Place After Another*, 97.

50 Kiwon, *One Place After Another*, 154.

51 B. Cruikshank, *The Will to Empower: Democratic Citizens and Other Subjects* (Ithaca, NY: Cornell University Press, 1999).

52 R. Martorella, 'Cultural Policy as Marketing Strategy: The Economic Consequences of Cultural Tourism in New York City', in D. Crane, N. Kawashima and K. Kawasaki (eds), *Global Culture: Media, Arts, Policy and Globalization* (London: Routledge, 2002).

53 A. Farquharson, 'I curate, you curate, we curate', *Art Monthly*, 269 (2003), 7–10; T. Gleadowe, 'Artist and Curator: Some Questions About Contemporary Curatorial Practice', *Visual Arts and Culture*, 2 (2000), 103–16; G. Wade, *Curating In The 21st Century* (Walsall: The New Art Gallery Walsall/University of Wolverhampton, 2000).

54 P. Clarke, 'Independent Spirit', [a-n] *Magazine for Artists* (October 2002), 26–27.

55 'Biennial in Sight', *a-n Magazine* (August 2003), 19

56 R. Weiss ,'Some notes on the agency of exhibitions', *Visual Arts and Culture*, 2 (2000), 117–27.

Contributors

Lewis Biggs studied modern history at Oxford University and history of art at the Courtauld Institute. He absorbed museology and exhibition-making through direct experience at the Whitechapel Gallery, London, the Museum of Modern Art, Oxford, and Arnolfini, Bristol. He was Director of Tate Liverpool 1990–2000, and has been Chief Executive of Liverpool Biennial since November 2000.

Daniel Birnbaum is Rector of the State Academy for the Applied Arts, Frankfurt. He has curated various exhibitions and writes for magazines such as *Artforum*, *Frieze Magazine* and *Art & Text*. His books include *Productions* (with Carsten Höller) (2002) and *Like Virginity, Once Lost: Five Views on Nordic Art Now* (1999).

Laura Britton is Curator of Public Programmes at Tate Liverpool. She studied at the University of York, and has an MA in the History of Art from the Courtauld Institute. Recently she has organised events with Grayson Perry, Antony Gormley, Andy Goldsworthy and Channel Five. She also continues to work as an Associate Lecturer for the Open University.

Rory Francis is an artist and Senior Lecturer in Contemporary Art at Manchester Metropolitan University. He is a member of INIFAE based in Luxembourg and has worked in Poland, Luxembourg, Austria, Italy and Portugal.

Jonathan Harris is Reader in Art History at the University of Liverpool. He is the author of several books, including *Federal Art and National Culture* (1996) and *The New Art History: A Critical Introduction* (2001). He is the co-editor (with Francis Frascina) of *Art in Modern Culture* (1992). His *Writing Back to Modern Art: Greenberg/Fried/Clark* and *Key Concepts in Art History* are both forthcoming from Routledge.

Stewart Home is the author of twenty books of fiction and cultural commentary. His most recent novel, *Down & Out In Shoreditch & Hoxton*, led *The Times* to call him a genius. He is also an occultist, performance and installation artist, film-maker and most importantly an ego-maniac on a world historical scale.

Paul Usherwood is an art historian and critic working at Northumbria University. He has written extensively on northern culture and on nineteenth-century and recent British art, especially public art. His publications include *Lady Butler, Battle Artist, 1846–1933* (Allan Sutton and the National Army Museum, 1987) and *Public Sculpture of North-East England* (Liverpool University Press, 2000).

Jeremy Valentine works at Queen Margaret University College, Edinburgh. He is the co-author of *Polemicization: The Contingency of the Commonplace* and is a co-editor of the monograph series *Taking On The Political*, published jointly by Edinburgh and New York University Presses.